THE ARTIST'S VOICE

Books by Katharine Kuh

THE ARTIST'S VOICE
Talks with Seventeen Artists

LEGER

ART HAS MANY FACES

The Artist's Voice

TALKS WITH SEVENTEEN ARTISTS

by Katharine Kuh

HARPER & ROW · PUBLISHERS

NEW YORK AND EVANSTON

Contents

List of Illustrations

JOSEF ALBERS

IVAN ALBRIGHT

HANS HOFMANN

EDWARD HOPPER

FRANZ KLINE

JACQUES LIPCHITZ

ISAMU NOGUCHI

THE ARTIST'S VOICE

Introduction

"I would like to realize myself. In this sense I would like to be considered a realist. For me, abstraction is real, probably more real than nature," said Josef Albers when asked if he considered himself a realist. Curiously, to the same question Ivan Albright answered, "No I'm not a realist. All I'm trying to do is to achieve my end, and that certainly is not realism. The reason I use an extremely minute technique is to tie down, to fuse, to crystallize various discordant elements so that my painting has a composite feeling." Should we need proof that the term "realism" means something different to each artist, these two statements offer striking provocation, for Albers, who confesses here to being a realist, is generally regarded as a confirmed abstract painter, while Albright, who does not consider himself a realist, is usually judged an inveterate one. To make matters more confusing, Naum Gabo confides, "I not only consider my present work realistic—I have constantly insisted, even in the Manifesto of 1920, that my art has always been realistic." And says Hans Hofmann, ". . . art is sufficient unto itself not on the basis of art for art's sake but on the basis of a neoreality which has its foundations in the artist's direct relationship to his medium." Obviously these two men, both pioneers in the field of nonobjective art, still consider themselves realists, though I suspect that their definitions imply the term depends more on a frank use of materials than on any literal handling of subject matter. In a sense, they herald a new realism, or, in Hofmann's words, "a neoreality." That Edward Hopper and Ben Shahn also insist they are realists is less surprising, since their work has always stressed naturalistic images. Shahn even says, "I consider this one of the noblest designations an artist can be given."

Here, then, are six men working in various directions—Albers, Gabo and Hofmann currently accepted as leaders of abstract art; Albright, Hopper and Shahn, of representational painting. But paradoxically all consider themselves realists except Albright, who, though often described as an uncompromising one, firmly denies the charge. It is astonishing how many different nuances of meaning this simple word can assume, depending on the personal vision, objectives, philosophy and handwriting of each artist.

There is, of course, no one way, no right way to interpret realism or any other aspect of art. There are no rules, no final conclusions. And here precisely is the theme of this book, which presents the candid though often conflicting opinions of seventeen distinguished artists. The fact that so often their aims seem similar, their methods of attaining them diametrically opposed, makes one question the value of any dogmatic judgments, or any formal art training, for in the last analysis what more can such discipline offer than technical guidance or clues to greater tolerance?

The following seventeen interviews are not only authentic records of each artist's attitude toward his own work in his own words, but also are a composite picture of how dissimilar, how irreconcilable, how parallel, how constant, how valid yet varied are their multiple reactions.

Only artists living in America, but not necessarily American, are included, though in recent years both Morris Graves and Mark Tobey have been working in Europe. In every case the artists chosen were established painters and sculptors who have clearly influenced their period and been recognized as outstanding leaders. The idea was not to "discover" (a distasteful word) new names, but to gain greater understanding of already significant ones—indeed, even to "debunk" certain long-accepted theories that clutter and sometimes erroneously freeze reputations. Many of the artists interviewed can look back on prodigious careers, estimating their work with at once the disarming candor and aloof judgment that maturity alone permits.

With only one exception the discussions were not taped, but were taken down verbatim without benefit of literary editing. These, then,

are the exact words of each artist about his own work. Questions were deliberately sparse, concise, simple and nontechnical. Informal language prevailed; it is rarely artists who depend on cant and jargon, but more often the periphery personalities around them. The works illustrated are only those the artists themselves referred to, for this is in no sense a picture book. Most of the interviews took place during 1961.

Over the years, critics and art historians have been busy evaluating these painters and sculptors, discussing their key works, ascribing motives to them, interpreting and "cubbyholing" them. It seems only just that the artists be given a chance to respond, to verify or deny these allegations. Take, for instance, the critics who claim that Edward Hopper's themes are related to loneliness and nostalgia. "If they are," he says, "it isn't at all conscious. I probably am a lonely one. As for nostalgia, that isn't conscious either. People find something in your work, put it into words and it goes on forever. . . . I have no conscious themes." Calder flatly denies a favorite theory that his mobiles have been greatly influenced by modern mechanization. He insists it is nature that was his chief impetus. "I haven't really touched machinery," he notes, "except for a few elementary mechanisms like levers and balances." Repeatedly we hear that Ivan Albright's experiences in World War I as a medical draftsman influenced his meticulous technique, but he claims this is not true, and even questions whether he is as much preoccupied with death and decay as is commonly thought. "Let's say I'm equally interested in growth and death. How can you divide them?" As for critics who feel that Franz Kline is affected by Oriental calligraphy, his answer is categorically, "No, I don't think of my work as calligraphic. Critics also describe Pollock and De Kooning as calligraphic artists, but calligraphy has nothing to do with us. . . . In the first place, calligraphy is writing and I'm not writing. People sometimes think I take a white canvas and paint a black sign on it, but this is not true. I paint the white as well as the black, and the white is just as important." So also David Smith denies the popular report that his work grows out of American folk art. He says, "No, absolutely not. It wasn't American folk art; it was cubism that awoke me."

Only in the arts can convictions, commitments and methods be so heterogeneous as to preclude the possibility of any single or established standard of judgment. In science, business, law, research and medicine, no matter how free the spirit, how acute the vision, certain specified procedures must be followed. The fine arts alone seem to allow the prerogative of complete personal latitude, a fact which undoubtedly explains why this field has become a target for so many vague critical opinions and so much public hostility. Few, if any, specific yardsticks exist to guide the layman and, unhappily, the current language about art often confounds more than it convinces.

Just to compare the radically different techniques and credos advanced in this book is to realize that the work of individual artists has significance chiefly in relation to that ephemeral quality we call "personal expression." The theory that whatever an authentic artist produces is art (though the same methods in the hands of another man can become merely tedious) is an extension of this idea. For the artist as well as the layman, there are no concrete signposts pointing the way. It is only through arduous trial and error stiffened by unwavering convictions that his brand of personal expression is refined and forged. Even in a matter as simple as the use of preliminary sketches we find endless variations. Albright, for example, deliberately avoids all sketches. "That's not the way I work, but I may take two weeks to a month just getting my composition set up. I do this with actual objects in my studio. . . . Next I make a master plan on paper, like a chart. . . ." On the other hand, Stuart Davis makes "a lot of preliminary sketches, but the process of arriving at a satisfactory one takes weeks, even months. Mostly I use black and white drawings as sketches," he says. As for Edwin Dickinson, he bars any preliminary sketch. "Even with a very large canvas I begin without such specific preparations as drawings or planned designs." And says Hans Hofmann, "You ask, do I make preliminary sketches? The answer is never." But the sculptor Noguchi depends on them, sometimes drawings, sometimes three-dimensional clay, metal or even paper sketches. Georgia O'Keeffe confesses to making little drawings that have no meaning for anyone but herself. "They usually get lost when I don't need them any more. If you saw them

When collection is not specified, work of art belongs to the artist.

GEORGIA O'KEEFFE

BEN SHAHN

DAVID SMITH

you'd wonder what those few little marks meant, but they do mean something to me."

Then again certain artists rely on tangible models; others, never. To quote two radically different opinions, Albright says, "I paint only from models, because even when you don't, you're still depending on recollected models whether you know it or not. And I find that using a model directly makes for a stronger statement, like actually having someone you're in love with rather than just dreaming about someone." But Franz Kline does not paint "a given object—a figure or a table." He paints "an organization that becomes a painting."

Only rarely do any of these artists agree even on the basic nature of art, their definitions deviating as widely as their personalities. In fact, at the risk of seeming romantic, I find it extraordinary how often a man's work mirrors his appearance. Mark Tobey's sensitive face seems to reflect the introspective compositions he paints, underlining his contention that "painting should come through the avenues of meditation rather than the canals of action. Only then can one have a conversation with a painting." In contrast, Hans Hofmann, ruddy and exuberant father of "action painting," feels that "painting is painting, sculpture is sculpture and architecture is architecture. The medium itself directs the way. . . ." Here Duchamp would take strong exception; for him the cult of pigment as such is thoroughly distasteful. He says, "One hundred years of the retinal approach is enough. Earlier, paint was always a means to an end, whether the end was religious, political, social, decorative or romantic. Now it's become an end in itself." Precisely what Hofmann endorses, Duchamp deplores. Meanwhile Albers and Gabo seem agreed that ethics and aesthetics are closely connected. Gabo is convinced that "art is not just pleasure; it is a mental activity of the human consciousness from which all spiritual creation derives." And Jacques Lipchitz thinks that "art must illuminate life, must clarify it, like a decanting process," but Noguchi limits himself to more intimate dimensions, asking only that "art have some kind of humanly touching and memorable quality. It has to recall something that moves a person—a recollection, a recognition of his loneliness, or tragedy, or whatever is at the root of his recollection." Calder says, "My whole

theory about art is the disparity that exists between form, masses and movement."

On only a single point does there appear to be some relative agreement. Many of these artists, despite wide differences in background, technique and philosophy, seem to be pursuing at least one common objective when they search for their own elusive images. Here both Marcel Duchamp and Morris Graves take strong issue. Duchamp, in describing how urgently he struggled to escape from himself, says, "My intention was always to get away from myself. . . . I have tried to remain as aloof as possible, and don't think for one minute that this hasn't been a difficult task." Perhaps difficult enough to explain why he happens to be the sole artist in the group who renounced his profession at the height of his career. As for Graves, he admires "any work of art where conceit does not intrude, whether it's architecture, sculpture, painting, writing, music. Anonymity," he adds, "is a state of mind I very much respect." For him, "The painting must paint itself." But no matter how ardent the urge to elude one's own hand, Ivan Albright may well be right when he observes, "Art is a book exposing only the artist himself. . . . Art is his psychoanalysis, and he is his own psychiatrist. . . ."

Whether their interviews were laconic or voluble, specific or general, assured or skeptical, these sixteen men and one woman will always remain best known to us through their art; yet their words can add a dimension that extends our understanding. Merely to look is not necessarily to see, merely to know is not necessarily to understand; but why, when, how and where a work of art was made—these are all clues to greater perception. Even the way an artist uses words is revealing. David Smith puts it well when he says, "I think we artists all understand English grammar, but we have our own language, and the very misuse of dictionary forms puts our meaning closer in context. I think we're closer to Joyce, Genet and Beckett than to Webster." If the words of these painters and sculptors have unveiled even a few of art's baffling secrets, then this book will have served its purpose. To these seventeen artists go my fervent thanks.

KATHARINE KUH

For additional help I am grateful to John Carlis, Otto Gerson, Mrs. Sidney Janis, Mrs. Edith Gregor Halpert, Mr. and Mrs. Samuel M. Kootz, John Marin, Jr., Mr. and Mrs. Klaus Perls, Marian Willard, Betty Anderson and Joan Kahn.

—K. K.

Question: How do you explain the fact that almost all modern artists claim to be realists in one way or another, no matter how abstract their work? Do you consider yourself one?

Albers: You see, for me the word "realism" means the opposite of expressionism. And I very much distrust expression as a driving force and as an aim in art. I've tried to learn why and when the word became so important. For this reason I read everything Cézanne said about art, though ordinarily I don't read such books. But I happen to be a great admirer of Cézanne's attitude. I found the word "expression" used only once by him, for while today this word dominates us, he says instead, "I want to realize." And in this sense I would like to be considered a realist. I would like to realize myself. For me, abstraction is real, probably more real than nature.

Question: Why?

Albers: I'll go further and say that abstraction is nearer to my heart. I prefer to see with closed eyes.

Question: Why are interrelationships of color so important to you? Why are they more important than interrelationships of form or space?

Albers: I think art parallels life; it is not a report on nature or an intimate disclosure of inner secrets. Color, in my opinion, behaves like man—in two distinct ways: first in self-realization and then in the realization of relationships with others. In my paintings I have tried to make two polarities meet—independence and interdependence, as, for instance, in Pompeian art. There's a certain red the Pompeians used that speaks in both these ways, first in its relation to other colors around it, and then as it appears alone, keeping its own face. In other words, one must combine both being an individual and being a mem-

ber of society. That's the parallel. I've handled color as man should behave. With trained and sensitive eyes, you can recognize this double behavior of color. And from all this, you may conclude that I consider ethics and aesthetics as one.

Question: Does this mean that you disapprove of an art that reflects the destructive forces of life?

Albers: No, I believe criticism of life can be constructive. This, of course, presupposes that the criticism is not merely a fashion, but a conviction. Any form is acceptable if it is true. And if it is true, it's ethical and aesthetic.

Question: When your colors vibrate, are you trying to suggest movement?

Albers: I don't accept your term "vibrate," because in my understanding, vibration of color happens only rarely. What I'm after, in a broader term, is interaction. If I can refer again to the parallel with life, the job is to make the unbearable, bearable, or to make that which doesn't behave, behave. This means a different organization of conditions for every color and every situation. A color can be placed among other colors so that it loses its identity. Red looks green or looks like a gas— dematerialized. Gray can look black, depending on what surrounds it. This I call "acting color." I work with the same painting, the same colors over and over—innumerable times. As a rule, I use either three or four colors in a painting. Merely by changing one color, a totally different climate is produced, though all the other colors in the work remain identical in area and hue. With two separate colors in no way overlapping, three are produced through interaction. Each borrows from and gives to the other. Where they meet, where they intersect, a new color results. In science, one plus one is two, but in art it can be three. Often I have to paint a picture ten different times before I reach a realization. I usually start with a very small sketch; then comes painting after painting until I realize what I'm after. What I want is to play staccato and legato—and all the other musical terms, but not for the purpose of expressing myself.

Question: If you're not expressing yourself, what are you doing?

Albers: I'm pleasing myself and educating others to see. If these paint-

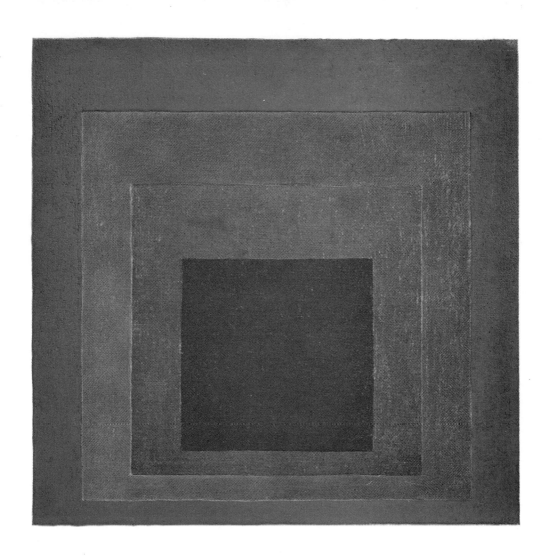

1 Homage to the Square Collection Anni Albers, 1959

2 *Lithograph from the series "Graphic Tectonic," 1957*

ings are me, this is an unavoidable result—not calculated. What I'm calculating is the interaction of color.

Question: Do you consider the most important interactions those of color?

Albers: In my paintings, line doesn't amount to much, but in my linear constructions I use line for the purpose of interaction. According to most color systems, harmony depends on the constellation of colors within a system. I go further in saying that, first, harmony is not the main aim of color. Disharmony is just as important in color as in music. And second, I say that every color goes with every other color if the quantities are right. This, of course, leads to a new seeing of color.

Question: Why are you so interested in making what is, seem what it is not?

Albers: A cow sees grass merely as an edible vegetable—I don't believe it sees a lawn as a carpet and it probably doesn't care about all the greens possible. But a poet putting his nose into grass can see it as a forest. This for me is reality, the myth behind the fact.

Question: I notice you never use canvas.

Albers: I always paint on board because it has the resistance of a wall. I can't stand canvas; it runs away from the touch—an unpleasant feel-

ing for me. It's too evasive. When I was young, I had many interests and worked with many materials from paper to glass, from wire to matchboxes, from wallpaper to furniture, from lettering to graphic design. In the meantime I've grown, and this means limiting the extension of my work in favor of the intensification of it.

Question: In order to say what you want to say, must your work be geometric?

Albers: I don't know whether it's as categorical as that. So far, it is my preference. Submitting to life is like any design—a recognition of restrictions.

Question: Did studying with Klee and Kandinsky at the Bauhaus influence you?

Albers: First of all, I did not attend either of their courses. Secondly, I did everything possible not to fall into their tracks. It would have been too easy. But I have the greatest respect for them.

Question: Do you think it is possible to teach art?

Albers: After having taught for half a century, I believe that art as such cannot be taught, but a lot can be done to open eyes and minds to meaningful form. Teaching can prepare a readiness to reveal and evoke insight.

Question: Do you feel that disorder and the accidental are never important elements in art?

Albers: No, I wouldn't say that. Accidents can be important as points of departure, but not as aims in themselves. Otherwise, art is entertainment. I encounter accidents as does anyone else, but I prefer them as controlling stimuli.

Question: Many artists say they are searching for their own image in their work. Is this true of you?

Albers: The word "image" doesn't exist in my terminology. Sorry.

Question: If you had to select six or seven of your most important works, which would they be?

Albers: This would be difficult, because every day I'd have another preference, thank heavens. At present, as always, I have preferences. I prefer not to say what my present preferences are—maybe I don't know.

Question: Is your approach to drawing different from your approach to painting?

3 Lithograph from the series "Pairs of Constellations," 1959

4 *Interior, 1929*

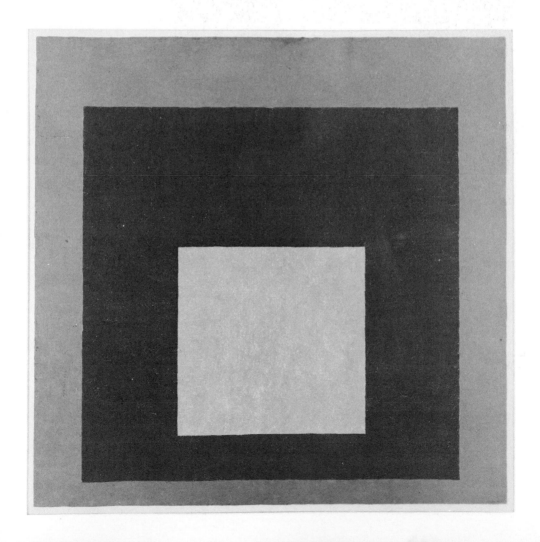

Albers: I think I'm right when I say that though my paintings and linear constructions are not connected, they stem from the same attitude, the same urge to achieve from a minimum of effort a quantitum of effect. While I was still teaching in Europe, I used to say to my students, "Do less in order to get more." For example, take this pair of "structural constellations." Within identical contours, the whole function of the drawings changes by altering only a few inner lines [*Plate 3*].

Question: Why do you insist on a white margin around all your paintings?

Albers: The reason I always keep a white margin is that I want my pictures to have a beginning and an end. However, I do permit the paintings to look larger than they are.

Question: Has architecture played a role in your work?

Albers: In my work there is an architectural element. For a long time I've used windows as a theme. Someone once came to the conclusion that I'm a frustrated architect. Take this painting on glass from 1929 —it's sandblasted directly on glass, not painted. But at times I also used a stained-glass technique. I've stopped working with glass because it's so perishable. Incidentally, this one, called Interior [*Plate 4*], used the window theme and was the fourth in a connected series of twenty-nine works.

Question: Why do you think artists of our century have been so involved with space?

Albers: I doubt the validity of your question. When you think of Swabian and Bavarian baroque artists, you realize they went further with space than we have. After all, I'd like to ask you, how much has abstract expressionism to do with space? But I agree that many artists today talk about space. For me it's not an immediate aim. My aim is action, and if it leads to space, O.K. Action for me means intensity, relatedness, mutual interchanges.

Question: Is interchange, as such, the main idea in your work?

Albers: Yes, I think so. As I said before, art parallels life. And life exists between polarities.

Question: How do you start a totally new painting?

Albers: Sometimes I close my eyes, and slowly certain color ideas begin to take shape. Then I make any number of preliminary sketches—

small, and as a rule not of much importance to start with. Gradually, after innumerable tests, experiments, juxtapositions and slight changes, the picture begins to work.

Question: I notice you work in series.

Albers: I've always worked in periods during which I've concentrated on certain basic problems. To my surprise, these periods grow longer and longer. The reason for this, I believe, is that in my experience any form demands multiple performance. I don't think we ever find *the* solution for form-articulation. For me there is no end to this. For instance, I've worked for years on end with the series called Homage to the Square [*Plates 1 and 5*]—and I'm still working on it as intently as ever.

Question: Is illusion the real content of your work?

Albers: What is illusion? It is, as I said before, the myth behind so-called reality.

ALBERS

1888	*Born, Bottrop, Germany.*
1913–15	*Studied, Royal Art School, Berlin.*
1916–19	*Studied, School of Applied Arts, Essen.*
1919–20	*Studied, Art Academy, Munich.*
1920–23	*Studied, Bauhaus, Weimar.*
1923–33	*Taught, Bauhaus, Weimar, Dessau and Berlin.*
1933	*Came to the United States to live.*
1933–49	*Professor, Black Mountain College, North Carolina.*
1936,'41,'50	*Gave seminars and special courses at Harvard University.*
1936–56	*Periodic visits to Mexico.*
1952–55	*Taught special courses in Chile, Peru, Honolulu and Germany.*
1950–60	*Chairman, Department of Art, Yale University.*

MAJOR EXHIBITIONS

1947	*Palace of the Legion of Honor, San Francisco.*
1949	*Cincinnati Art Museum and Virginia Museum of Fine Arts, Richmond.*

1954	*Academy of Art, Honolulu.*
1955	*Massachusetts Institute of Technology, Cambridge.*
1956	*Yale University and Kunsthaus, Zurich.*
1957	*Karl-Ernst-Osthaus Museum, Hagen, Germany.*
1958	*Landesmuseum, Münster, Germany.*
1961	*Stedelijk Museum, Amsterdam.*

Lives in New Haven, Connecticut.

IVAN ALBRIGHT

Question: Do you think your experience as a medical draftsman in World War I influenced your work?

Albright: Not at all. If I hadn't done that, I would have been doing something else. You know, I studied architecture but gave it up because I figured I might also have to become a salesman. As a painter you don't need a client; you can be truer to yourself. I studied sculpture, too, and still work with that medium from time to time. I've always liked form—I think the best draftsmen in the world are often sculptors. Every plane a sculptor makes is part of a form and represents that form, but with a painter, a line can be just an edge or a line in and for itself—something that doesn't exist in nature. I find this a man-made thought. In nature, colors flow into each other; there is no gap between them. Forms flow into each other; in the entire world there is no separation between forms.

But approaching all this from a different point of view—take two lines on a piece of paper and immediately they're in battle. Every line controls every other line. Every color influences every other color. And a color is as strong as the impression it creates. A straight line is a fragment of a circle. A plane is a spread-out solid. We've been given two eyes; from them comes our sense of space.

Question: Critics often say that your chief preoccupation is with death and decay. Is this true?

Albright: Not exactly. Let me answer that by asking you a question. Are there such things as death and decay? In any part of life you find something either growing or disintegrating. All life is strong and powerful, even in the process of dissolution. For me, beauty is a word without real meaning. But strength and power—they're what I'm after.

Whenever possible I like to create a feeling of the unknown. Any object can be the unknown. In my work I'm dealing with both man-made and natural objects. Let's say I'm equally interested in growth and death. How can you divide them? After all, there is no sorrow like existence, but the thought of anything existing is so marvelous that I doubt its reality.

Question: Do you paint only from models?

Albright: Yes, only from models, because even when you don't, you're still depending on recollected models whether you know it or not. And I find that using a model directly makes for a stronger statement, like actually having someone you're in love with rather than just dreaming about someone. However, when I compose a work, I leave room for future changes of philosophy, for future changes of position, of light, even for the addition or removal of various objects. I'm never a slave to the object or to my model. And as far as a model is concerned—remember that the infinite sees my model from every viewpoint, from every time-point, from every motion-point. The straight-on visual sight of an object is flat, and if you paint with only that one viewpoint, you paint flat. One must think all around an object all the time in order to make it appear solid. That's how I happen to build such elaborate sets for my paintings. The objects, or call them models, I work with are on platforms on casters, on all kinds of movable stands so that I can change their positions, change the light on them, change their relationships at will. I don't want them to be conventional or static in any manner or form. I constantly move them around, even varying their elevations and angles.

Question: Why? What are you after?

Albright: I hope to control the observer, to make him move and think the way I want him to. For instance, in The Window and in many of my other paintings I'm trying to lead the observer back, sideways, up or down *into* the picture, to make him feel tossed around in every direction, to make him realize that objects are at war, that between them there is constant movement, tension and conflict. What I'm really trying to do is make a coherent statement about life that will force people to meditate a bit. I'm not trying to make a pleasant aesthetic experi-

ence; I want to jar the observer into thinking—to make him uncomfortable. But I'm not telling him what to think.

What else am I trying to do? To compose in motion. I've learned that I can walk; I've learned that I have legs and can move and so can see objects from myriad viewpoints, from multiple angles. Look at this pot in The Window [*Plate 6*]. It seems to be falling; its shadows are purposely reversed. Everything in this picture has been painted from different positions, everything seems to move at different speeds, for of course some motions are faster than others. You can see the way I've planned all this by studying the preliminary chart [*Plate 7*] I made for the painting. It's all noted down in advance. Everything in the canvas is fighting; I want it to give a feeling of frustration. In this way I can control the observer. As I said before, one of the reasons I make such elaborate sets and use such authentic props is to facilitate moving my objects wherever and whenever I desire, and also to allow me to study them from all sides. With arbitrary shadows and arbitrary positions I force them to do what I want, to shock and disturb the observer. I concentrate particularly on creating compositions that are dynamic, moving, at war, in conflict. I design with different positions in space rather than merely with related forms. Some objects are falling, others rising, others are spiraling, others moving sideways—in a kind of controlled chaos.

Question: Do you consider yourself a realist?

Albright: I know I've been called one but I do not consider myself a realist. I don't consider myself anything. To join some general movement in art, whether of this period or that, is to join a buffalo stampede. I say, let the artist be the hunter rather than the buffalo. No, I'm not a realist. All I'm trying to do is to achieve my end, and that certainly is not realism. The reason I use an extremely minute technique is to tie down, to fuse, to crystallize various discordant elements so that my painting has a composite feeling. I take well-known objects and handle them so as to make you think this is the old familiar way you have always seen them—but in reality I am forcing you to walk into the picture and to see these objects only in my way. I need this meticulous technique to achieve the impact I want, but don't mistake

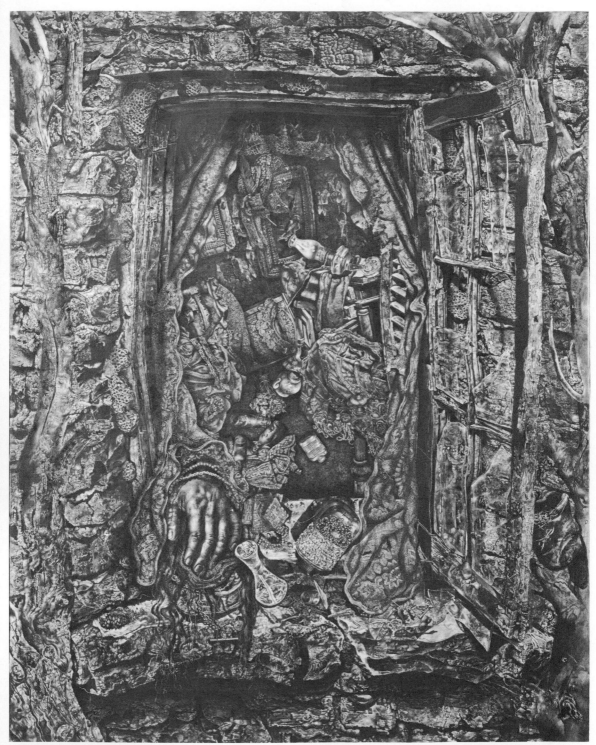

PHOTOGRAPH BY ARTHUR SIEGEL

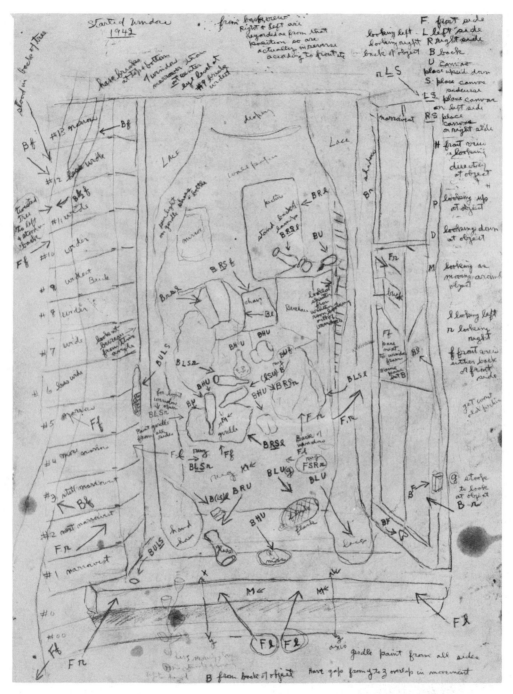

7 *Chart for The Window, 1941*

6 *Poor Room—There is no time, no end, no today, no yesterday, only the forever, and forever, and forever, without end (also called The Window), 1941–1962, still unfinished*

it for a trick. It's not big areas (in either color or space) I'm playing up; instead I'm trying to show the interplay of directions, of conflicts and struggles in even the smallest objects and relationships. It's like walking around for an entire day—looking—experiencing—and then crystallizing everything you've seen and felt in one canvas simple enough, familiar enough, for anyone to recognize. This really becomes a compounding of space and time.

I've never cared for art to hang on the wall. My work is strictly the interpretation of myself, and that's as far as I want to go. I never think of it in terms of exhibitions or sales. In the purest sense, one must paint for oneself alone. In one's dying moment one may wonder—is the shape of a chair important? How much good can a painting bring to the world? Art is a book exposing only the artist himself: who he is, what he is, what he thinks. Art is his psychoanalysis and he is his own psychiatrist, his life experience the theme he works with.

Question: Which do you consider your most important works?

Albright: The Door, but you know the real title is That Which I Should Have Done I Did Not Do, The Dead Doll [*Plate 9*], the painting of the fat man with the bowler hat that I call God Created Man in His Own Image [*Plate 10*], the Portrait of Mary Block [*Plate 11*], and The Window, which I'm still working on. This last one I started in 1941, over twenty years ago. I didn't realize then it would take quite so long. I haven't named it yet; The Window is only a provisional title. I decide on the final name when a painting is finished, because you can't know in advance exactly what it's going to mean. Something like taking a trip around the world—you can't know what you're going to see until you've been there, unless you're willing to let a travel agent make all your plans ahead of time. And I'm not that type.

In 1931 I painted a canvas called Wherefore Now Ariseth the Illusion of a Third Dimension. Already then I was trying to give a clue to what I was after.

Question: Has living your entire life in the Middle West affected your work?

Albright: If I lived on the moon it wouldn't matter. The strongest influence on my work comes from nature—from a belief in its wonders

8 *That which I should have done
I did not do (detail), 1931–1941
The Art Institute of Chicago*

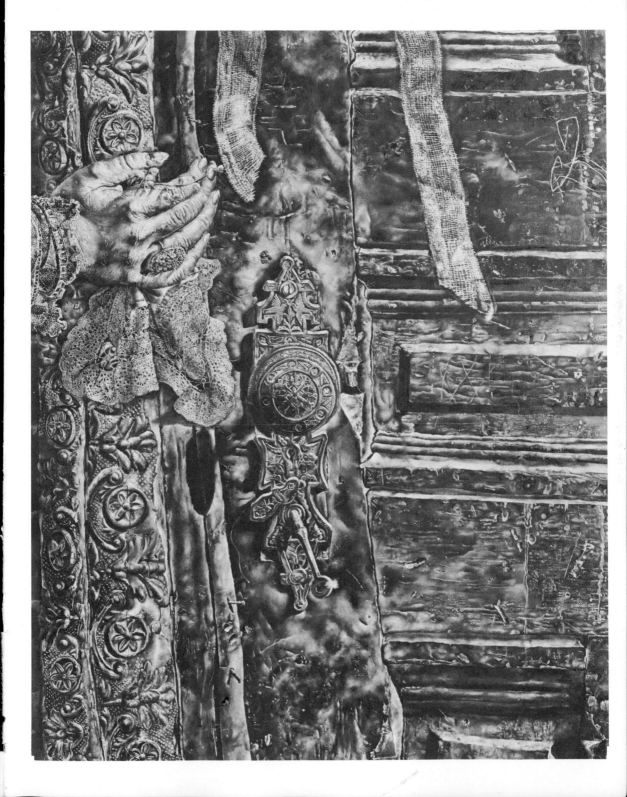

9 The Dead Doll (also called Showcase Doll), 1931–1932

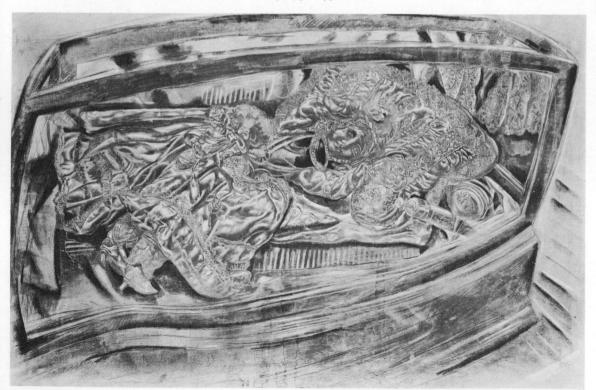

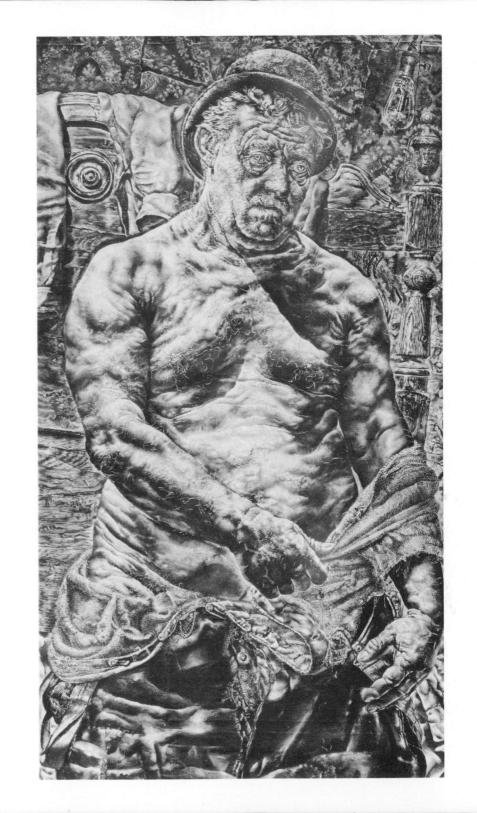

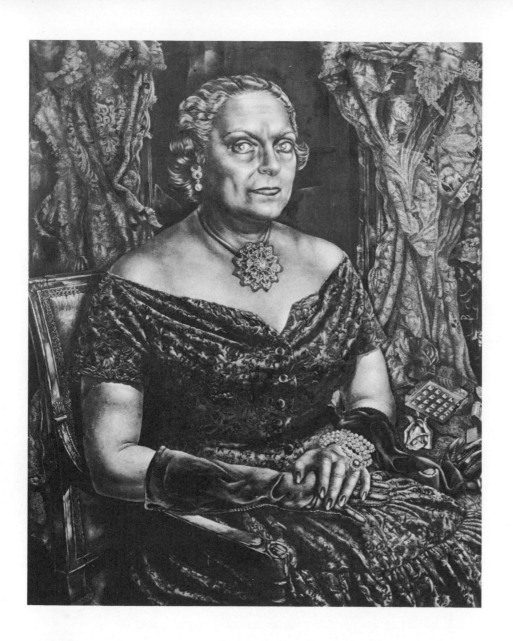

11 *Portrait of Mary Block, 1955–1956 The Art Institute of Chicago*

and the feeling that anything is possible. Four inches of blanket before me is infinite; the heavens are infinite. That which is at your feet, at a distance becomes the horizon.

Question: To go back to The Window—why did you include the hand?

Albright: I wanted part of a human being in there, not just an inanimate still-life. A room is made by man, and the hand is included to add life as a foil for all the dead inanimate material in the painting. I think it adds meaning. The minute a thing is fully seen, it loses its full impact. That's why so many of my objects are only partly shown. The hand as part of a human being is a case in point. After all, visual representation is always only partial representation.

Question: Do you make careful preliminary sketches?

Albright: No, I don't make any sketches. That's not the way I work, but I may take two weeks to a month just getting my composition set up. I do this with actual objects in my studio, finding them and arranging them one by one on movable stands and platforms. Here you see all my real props for The Window [*Plate 12*]—the bird nest, the fungus, the old lamp, the pots, vases, torn curtains, broken glass, scarred bricks, even the dead tree. Everything is here. Next I make a master plan on paper, like the chart I showed you for The Window. Naturally, as the painting advances, changes are bound to take place, but the master plan still controls the picture. Next I work out a complete finished charcoal drawing on the canvas. For The Window this alone took a year. Finally I start painting. As a rule, once a small area is finished I never change it, but go on to other parts of the picture. I'll paint a brick until I get sick of it—glass, wood, any material until I'm utterly fatigued. As with eating, I've got to change my diet as I work or everything becomes tasteless. But the first conception for any painting is in the mind. One should paint a picture so that it is still in the mind. Never let what you put on canvas be the all in all.

Question: How do you feel about commissions?

Albright: The only commissioned portrait I ever painted was of Mary Block, and that is the only one I am ever going to paint. She was a marvelous sitter; she sat for two years three times a week and never

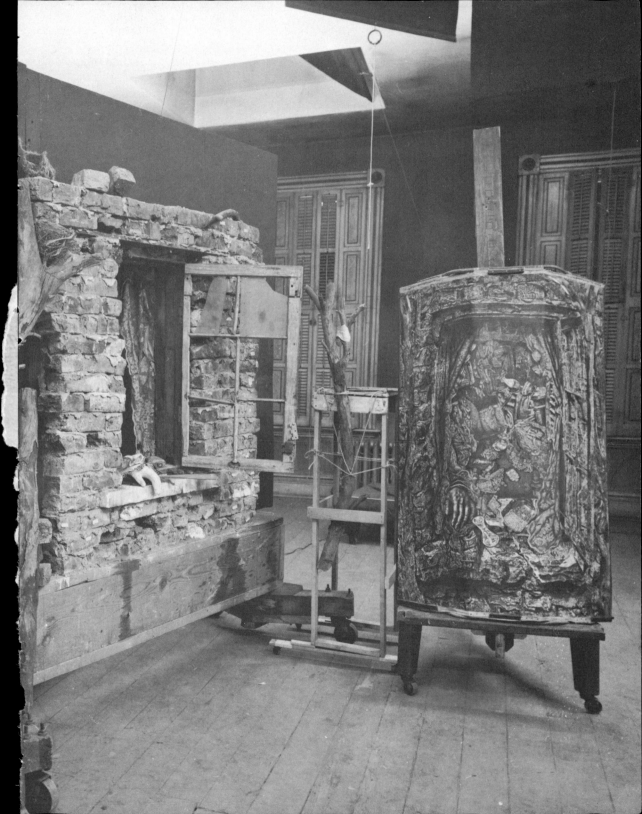

came late. I put the torn curtains behind her as a foil for the rest of the setting and also because I wanted to make the painting a real Albright.

Question: You write poetry, don't you?

Albright: I used to. Once in a while I still do. I chiefly use the sub-conscious in my poetry—something of a rest from or a reaction to my painting. Usually the poems take less than a minute to write. Once I wrote one about being a painter.

A painter am I
Of all things
An artist who sees
The door and chair
And sees on smooth things a flaw there
And sees on round things a hollow there
And colors are to him
But the form within
He knows nought
But that the world is colored and strong
With light and shadow
And forms that intertwine
And the sky is not blue to him
As it runs over the meadows and trees
And the river is not held within its banks
As the colors swim over the land
And the tree is not a tree to him
But a song of beauty in the sky
And colors are not just colors to him
But each a dream in a fantasy
That makes unreal this world of yours to him
To this painter man.

(Another poem by Albright)

Burns the candle in the room
Silent dripping thing
Of tallow and flame
Lighting the room
I used to call home

With one dark window
With green shade drawn
And a bare carpet
Blue like a flower on the floor
Burning candle—tell me
Who now is in my room
Is he as lonely as was I
When I was on earth
I have been dead a year now
But I still find
Myself in a new room
And lonely—lonely.

ALBRIGHT

1897 *Born, Chicago.*

1915–17 Studied architecture, Northwestern University and University of Illinois.

1918–19 Served in World War I as medical draftsman.

1919–23 Studied, School of the Art Institute of Chicago.

1923 *Studied, Pennsylvania Academy of the Fine Arts, Philadelphia.*

1924 *Studied, National Academy of Design, New York.*

1931–41 Painted That Which I Should Have Done I Did Not Do.

1942 *Temple Gold Medal, Pennsylvania Academy of the Fine Arts. First prize, Artists for Victory, Metropolitan Museum.*

1943–44 Painted portrait of Dorian Gray for motion picture, "The Picture of Dorian Gray."

1941–61 Worked on canvas provisionally entitled The Window.

1950 *Northwest Territory Centennial Award, Northwestern University.*

Innumerable other awards. Member, National Institute of Arts and Letters. Lives in Chicago.

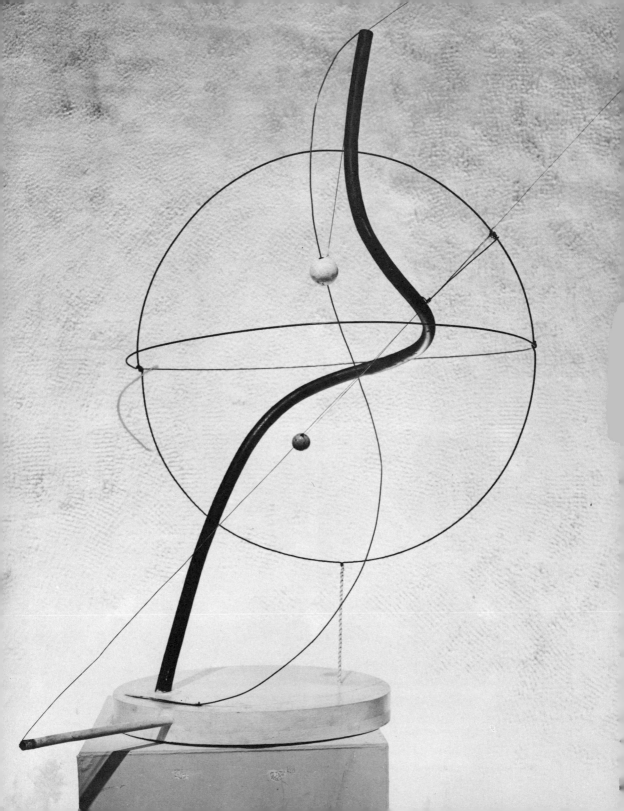

ALEXANDER CALDER

Question: Does your work satirize the modern machine?

Calder: No, it doesn't. That's funny, because I once intended making a bird that would open its beak, spread its wings and squeak if you turned a crank, but I didn't because I was slow on the uptake and I found that Klee had done it earlier with his Twittering Machine and probably better than I could. In about 1929, I did make two or three fish bowls with fish that swam when you turned a crank. And then, of course, you know about the Circus. I've just made a film of it in France with Carlos Vilardebo.

Question: Which has influenced you more, nature or modern machinery?

Calder: Nature. I haven't really touched machinery except for a few elementary mechanisms like levers and balances. You see nature and then you try to emulate it. But, of course, when I met Mondrian I went home and tried to paint. The basis of everything for me is the universe. The simplest forms in the universe are the sphere and the circle. I represent them by disks and then I vary them. My whole theory about art is the disparity that exists between form, masses and movement. Even my triangles are spheres, but they are spheres of a different shape.

Question: How do you get that subtle balance in your work?

Calder: You put a disk here and then you put another disk that is a triangle at the other end and then you balance them on your finger and keep on adding. I don't use rectangles—they stop. You can use them; I have at times but only when I want to block, to constipate movement.

Question: Is it true that Marcel Duchamp invented the name "mobile" for your work?

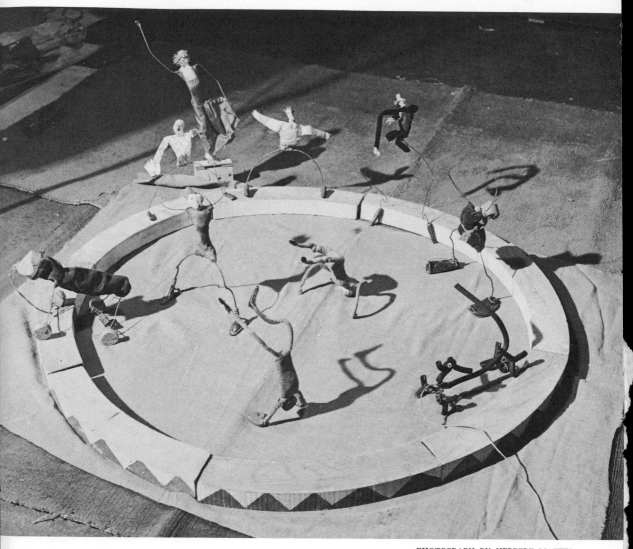

14 The Acrobats from the Circus, 1927

Calder: Yes, Duchamp named the mobiles and Arp the stabiles. Arp said, "What did you call those things you exhibited last year? Stabiles?"

Question: Were the mobiles influenced by your Circus?

Calder: I don't think the Circus was really important in the making of the mobiles. In 1926 I met a Yugoslav in Paris and he said that if I could make mechanical toys I could make a living, so I went home and thought about it awhile and made some toys, but by the time I got them finished my Yugoslav had disappeared. I always loved the circus—I used to go in New York when I worked on the *Police Gazette*. I got a pass and went every day for two weeks, so I decided to make a circus just for the fun of it.

Question: How did the mobiles start?

Calder: The mobiles started when I went to see Mondrian. I was impressed by several colored rectangles he had on the wall. Shortly after that I made some mobiles; Mondrian claimed his paintings were faster than my mobiles.

Question: What role does color play in your sculpture?

Calder: Well, it's really secondary. I want things to be differentiated. Black and white are first—then red is next—and then I get sort of vague. It's really just for differentiation, but I love red so much that I almost want to paint everything red. I often wish that I'd been a *fauve* in 1905.

Question: Do you think that your early training as an engineer has affected your work?

Calder: It's made things simple for me that seem to confound other people, like the mechanics of the mobiles. I know this, because I've had contact with one or two engineers who understood my methods. I don't think the engineering really has much to do with my work; it's merely the means of attaining an aesthetic end.

Question: How do you feel about your imitators?

Calder: They nauseate me.

Question: Do you make preliminary sketches?

Calder: I've made so many mobiles that I pretty well know what I want to do, at least where the smaller ones are concerned, but when I'm seeking a new form, then I draw and make little models out of

sheet metal. Actually the one at Idlewild (in the International Arrival Building) is forty-five feet long and was made from a model only seventeen inches long. For the very big ones I don't have machinery large enough, so I go to a shop and become the workman's helper.

Question: How do you feel about commissions?

Calder: They give me a chance to undertake something of considerable size. I don't mind planning a work for a given place. I find that everything I do, if it is made for a particular spot, is more successful. A little thing, like this one on the table, is made for a spot on a table.

Question: Do you prefer making the large ones?

Calder: Yes—it's more exhilarating—and then one can think he's a big shot.

Question: How do your mobiles differ from your stabiles in intention?

Calder: Well, the mobile has actual movement in itself, while the stabile is back at the old painting idea of implied movement. You have to walk around a stabile or through it—a mobile dances in front of you. You can walk through my stabile in the Basle museum. It's a bunch of triangles leaning against each other with several large arches flying from the mass of triangles.

Question: Why walk through it?

Calder: Just for fun. I'd like people to climb over it but it isn't big enough. I've never been to the Statue of Liberty but I understand it's quite wonderful to go into it, to walk through.

Question: Léger once called you a realist. How do you feel about this?

Calder: Yes, I think I am a realist.

Question: Why?

Calder: Because I make what I see. It's only the problem of seeing it. If you can imagine a thing, conjure it up in space—then you can make it, and *tout de suite* you're a realist. The universe is real but you can't see it. You have to imagine it. Once you imagine it, you can be realistic about reproducing it.

Question: So it's not the obvious mechanized modern world you're concerned with?

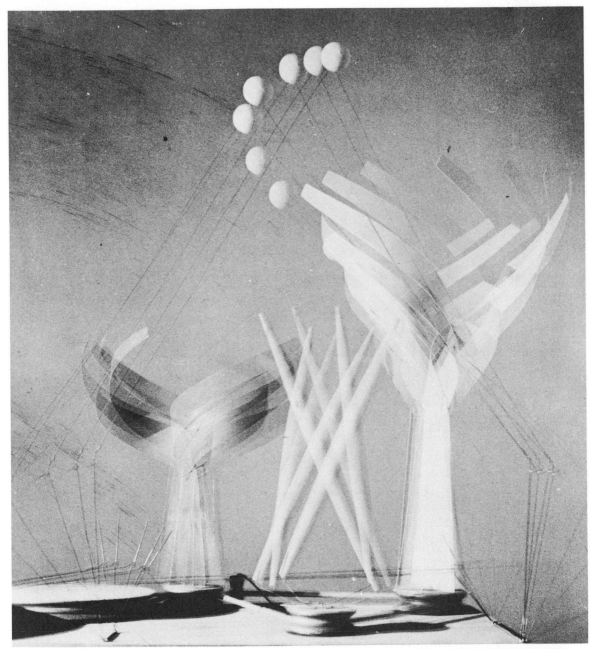

15 Dancers and Sphere, 1936 Motorized mobile

Calder: Oh, you mean cellophane and all that crap.

Question: How did you begin to use sound in your work?

Calder: It was accidental at first. Then I made a sculpture called Dogwood with three heavy plates that gave off quite a clangor. Here was just another variation. You see, you have weight, form, size, color, motion and then you have noise.

Question: How do you feel about your motorized mobiles?

Calder: The motorized ones are too painful—too many mechanical bugaboos. Even the best are apt to be mechanically repetitious. There's one thirty feet high in front of Stockholm's modern museum made after a model of mine. It has four elements, each operating on a separate motor.

Question: How did you happen to make collapsible mobiles?

Calder: When I had the show in Paris during 1946 at Louis Carré's gallery, the plans called for small sculptures that could be sent by mail. The size limit for things sent that way was 18 x 10 x 2 inches, so I made mobiles that would fold up. Rods, plates, everything was made in two or three pieces and could be taken apart and folded in a little package. I sent drawings along showing how to reassemble the pieces.

Question: You don't use much glass any more, do you?

Calder: I haven't used it much lately. A few years ago I took all sorts of colored glass I'd collected and smashed it against the stone wall of the barn. There's still a mass of glass buried there. In my early mobiles I often used it.

Question: Are there any specific works that you prefer and would like to have reproduced?

Calder: What I like best is the acoustic ceiling in Caracas in the auditorium of the university. It's made from great panels of plywood—some thirty feet long—more or less horizontal and tilted to reflect sound. I also like the work I did for UNESCO [*Plate 17*] in Paris and the mobile called Little Blue under Red [*Plate 18*] that belongs to the Fogg. That one develops hypocycloidal and epicycloidal curves. The main problem there was to keep all the parts light enough to work.

Question: Do you consider your work particularly American?

16 Acoustic Ceiling, 1953
Great Auditorium, Ciudad Universitaria, Caracas

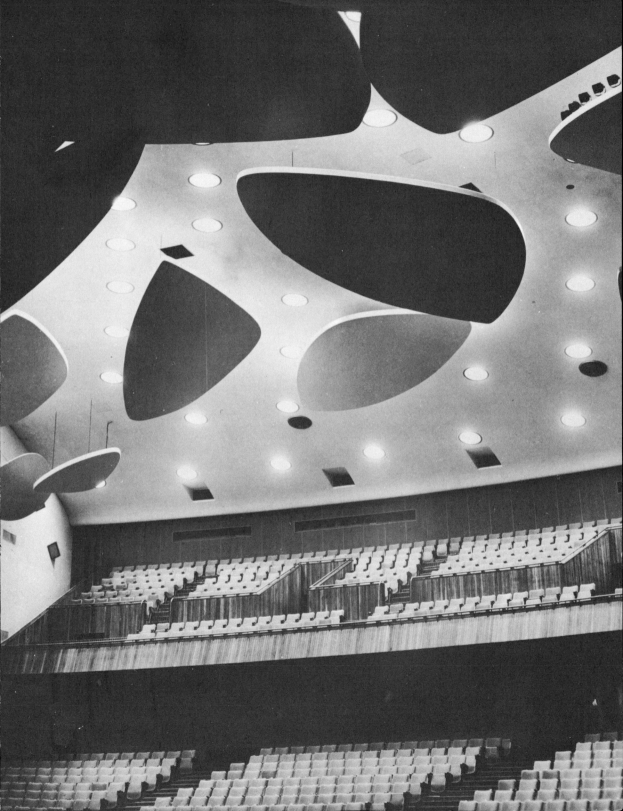

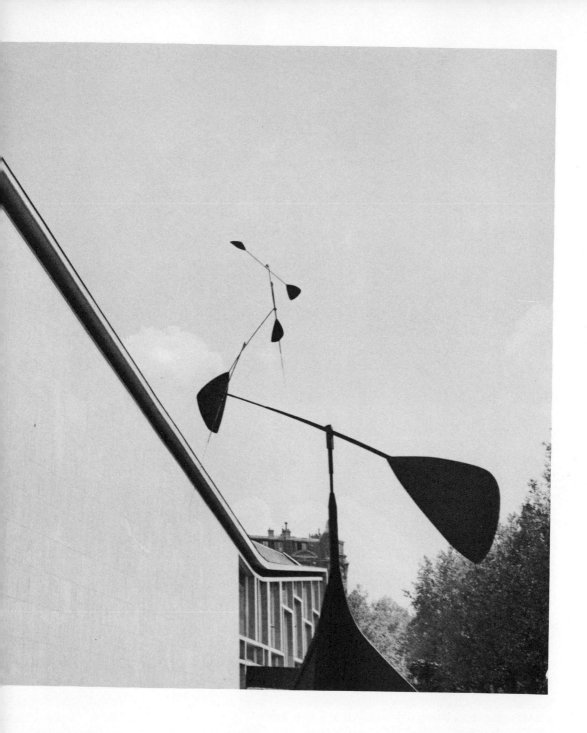

17 *Mobile, 1958* **UNESCO, *Paris***

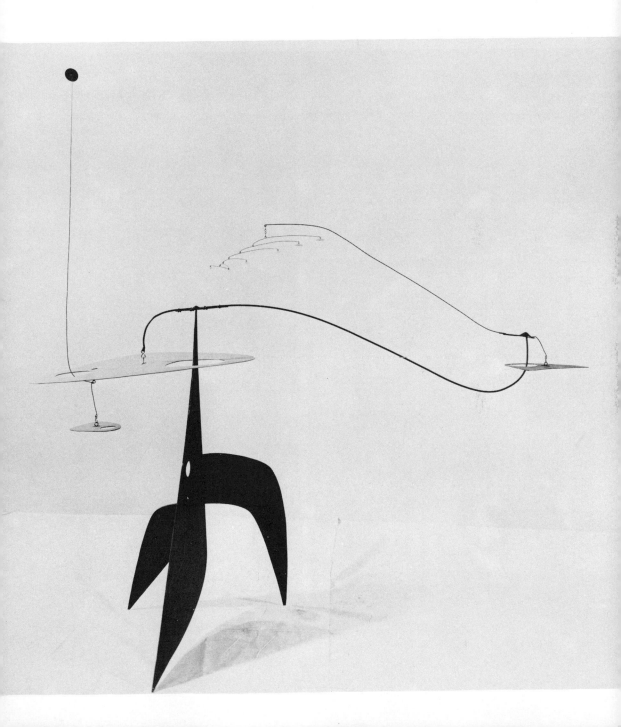

19 *The City*, 1960
*Museo Nacional
de Bellas Artes, Caracas*

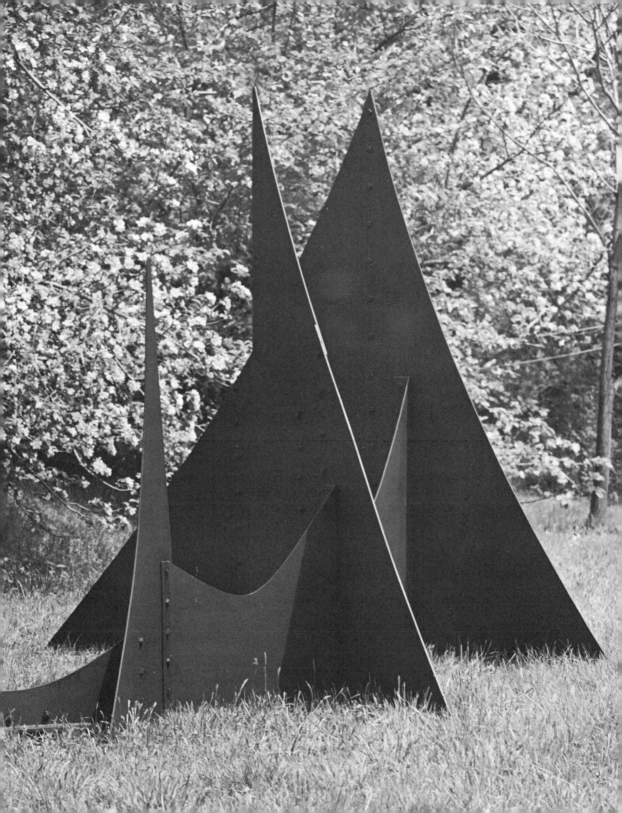

Calder: I got the first impulse for doing things my way in Paris, so I really can't say.

Question: Have American cities influenced you?

Calder: I like Chicago on the Michigan Avenue Bridge on a cold wintry night. There used to be no color but the traffic lights, occasional red lights among the white lights. I don't think that looking at American cities has really affected me. We went to India and I made some mobiles there; they look just like the others.

Question: What's happened to that large sculpture, The City?

Calder: The City [*Plate 19*] was purchased by the Museo de Bellas Artes in Caracas through the kind offices of my good friend, the architect Carlos Raul Villanueva.

Question: I found it great. What do you think of it?

Calder: I'm slowly becoming convinced. I made the model for it out of scraps that were left over from a big mobile. I just happened to have these bits, so I stood them up and tried them here and there and then made a strap to hook them together—a little like *objets trouvés.* ["Found objects" usually refers to articles in nature and daily life, like shells, stones, leaves, torn paper, etc., which the artist recognizes and accepts as art. Ed.] I decided on the final size by considering the dimensions of the room in the Perls Galleries where the work was to be shown.

Question: What artists do you most admire?

Calder: Goya, Miró, Matisse, Bosch and Klee.

CALDER

1898 *Born, Philadelphia. His mother a painter, his father and grandfather sculptors.*

1919 *Graduated as mechanical engineer from Stevens Institute of Technology.*

1919–22 Apprentice work as an engineer.

1922 *Started studying drawing.*

1923–26 Studied painting, Art Students League, New York.

1924–26 Drawings for "National Police Gazette."

1926 England and Paris. Began Circus.

1928–32 Divided time between Paris and New York.

1932 First exhibition of mobiles.

1934 Moved to Roxbury, Connecticut.

1935 Exhibition, Renaissance Society of University of Chicago and Arts Club, Chicago.

1937 Exhibition, Honolulu Museum.

1938 Retrospective exhibition, George Walker Vincent Smith Art Gallery, Springfield, Massachusetts.

1940 First exhibition of jewelry.

1942 Exhibition, Cincinnati Art Museum and San Francisco Museum of Art.

1943 First exhibition of Constellations, Museum of Modern Art, New York.

1948 To Brazil and Mexico. Exhibitions in Rio de Janeiro and São Paulo.

1949 Exhibition, Stedelijk Museum, Amsterdam, and Massachusetts Institute of Technology, Cambridge.

1954 One-man show, Biennale, Venice.

1958 First Prize, Carnegie International, Pittsburgh.

Has traveled widely. Lived for long periods of time in France, where he has two homes. Lives in Roxbury, Connecticut.

STUART DAVIS

Stuart Davis died June 24, 1964

Question: Why do you use words so often in your paintings?
Davis: I paint my pictures spontaneously, but not in a technical sense. In a technical sense I work on them for months. It's spontaneous content I'm interested in, and by this I mean the direct reaction of the spectator to the finished painting and the continuous reaction of the artist himself as he's working on it. There's the consciousness of a considered design and its re-formation over and over, but there's also the continued immediate response of the artist as he works and changes the painting. Then a delightful thing happens at the time an artist finds his painting satisfactory, and also finds thousands of other people responding to the same satisfaction. I paint for myself, but I'm pleased to know that my own interests correspond to those of many other people.

But to return to this idea of words. The artist sees and feels not only shapes but words as well. We see words everywhere in modern life; we're bombarded by them. But physically words are also shapes. You don't want banal boring words any more than you want banal boring shapes or a banal boring life. You've always got to make a choice. In choosing words I find that the smallest idea is equal to the greatest. I've used insignificant words and drawn insignificant objects because at times these were all that were at hand. By giving them value as experiences and by equating great with little, I discovered that the act of believing was what gave meaning to the smallest idea. For instance, take my paintings that grew out of cigarette packages, or the canvas called Champion [*Plate 20*]. The idea for that picture came from a package of matches—an insignificant inspiration, but what made it work was a great belief in the possibilities of any inspiration.

For years I went out of doors and painted landscapes. The kind of

paintings I'm making now (I think of them as structural continuities) are not particularly different; they just take less walking around on my part. I conceive the structural continuities as not confined by time limits. I have no sense of guilt when today I use a design I made forty years ago or last year. The past for me is equal to the present because thoughts I had long ago and those I have now remain equally valid—at least the ones that were really valid, remain valid.

Question: What are the most important forces behind your work?

Davis: I wrote about this almost twenty years ago in *Art News,* and what I said then still holds. "Some of the things which have made me want to paint, outside of other paintings, are: American wood and iron work of the past; Civil War and skyscraper architecture; the brilliant colors on gasoline stations, chain-store fronts and taxicabs; the music of Bach; synthetic chemistry; the poetry of Rimbaud; fast travel by train, auto and airplane which brought new and multiple perspectives; electric signs; the landscape and boats of Gloucester, Mass.; five-and-ten-cent-store kitchen utensils; movies and radio; Earl Hines' hot piano and Negro jazz music in general. In one way or another the quality of these things plays a role in determining the character of my paintings."

Question: How has jazz influenced your work?

Davis: You just saw my young son, Earl. I named him after Earl Hines. For a number of years jazz had a tremendous influence on my thoughts about art and life. For me at that time jazz was the only thing that corresponded to an authentic art in America. Mondrian also felt its impact; I talked to him about this several times. He responded to the basic rhythms of jazz in a direct physical way; they even made him want to dance. For me—I had jazz all my life—I almost breathed it like the air. I knew a lot of anonymous giants of jazz—I found them in Newark on Arlington Street. I think all my paintings, at least in part, come from this influence, though of course I never tried to paint a jazz scene. As a child my parents took me to Negro revues and shows; my sense of musical rightness probably stems from that education. But you could take some other child and he might just as well have hated it—I loved it and followed it up. It was the *tradition* of jazz music that affected me.

Question: Do you feel your work is basically American?

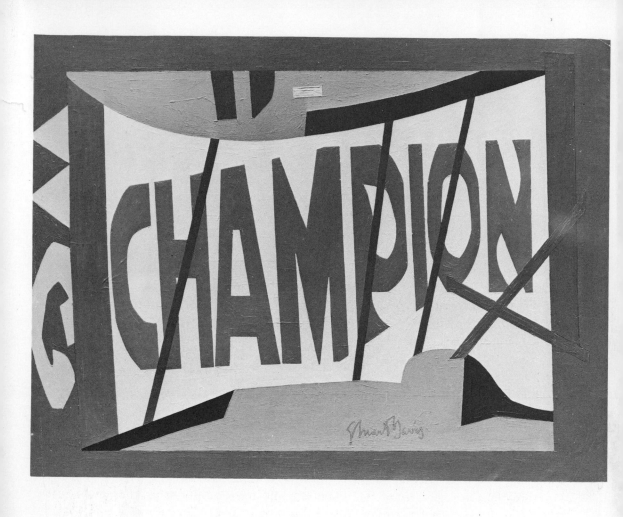

20 *Little Giant Still Life (also called Champion), 1950* *Virginia Museum of Fine Arts,*
Richmond

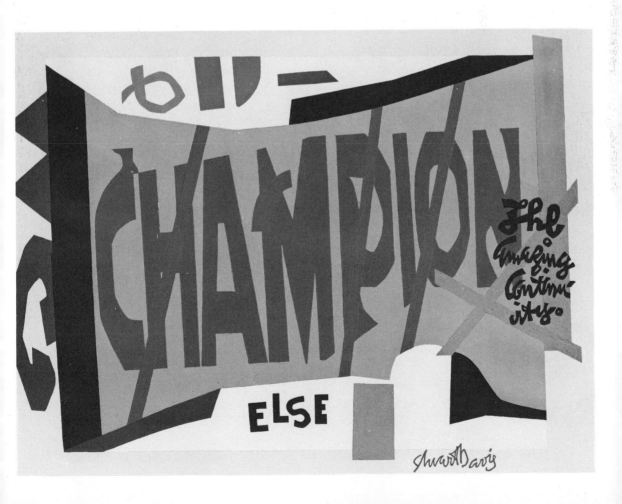

Davis: I've never lived anywhere else for an extended length of time—only once in Cuba for a few months and in Paris for a year and a half. Otherwise I've always lived here. Of course my work is American—it couldn't be anything else, but America is increasingly part of the world. It's the big cities here, I suppose, that have impressed me the most. I've accepted the noise, the cacophony (to use a big word) of present-day life as subject matter. I'm a thorough urbanite—one hundred per cent. New York City and my warm affection for Philadelphia have played a strong part in my paintings. One reason I liked Paris was because it reminded me of Philadelphia in the 1890's. You know I was born in Philadelphia. But all this isn't too conscious. You're born with a genetic tape that has a coded prescription for your behavior throughout your entire life—and never forget that it's in code.

Question: Do you name your pictures before or after you paint them?

Davis: I name a picture both before and after I paint it—in the same way I use letters and words in a canvas. I consider part of the spontaneous subject matter I use as the basis for a painting. Now take Ready-to-Wear—that had to do with newsreels and radio programs. I consider shapes and words with all their multiple meanings as the normal content from which the intuitional premise of a painting originates. The picture called Visa [*Plate 21*], as you know, was the second version of Champion. Though the idea for the original painting came from a matchbox cover, I made another version because I had the possibility of using the same idea in, what I felt, was a better form. Why did I call it Visa? Oh—that's a secret. Because I believe in magic.

Question: Do you make preliminary sketches?

Davis: Yes, I make a lot of preliminary sketches, but the process of arriving at a satisfactory one takes weeks, even months. Mostly I use black and white drawings as sketches. The next step is to put the black and white drawing on the canvas. Then I define the larger areas in color.

Question: I notice that you use your name as part of the design.

Davis: Yes, because in the past it was customary for artists to sign their

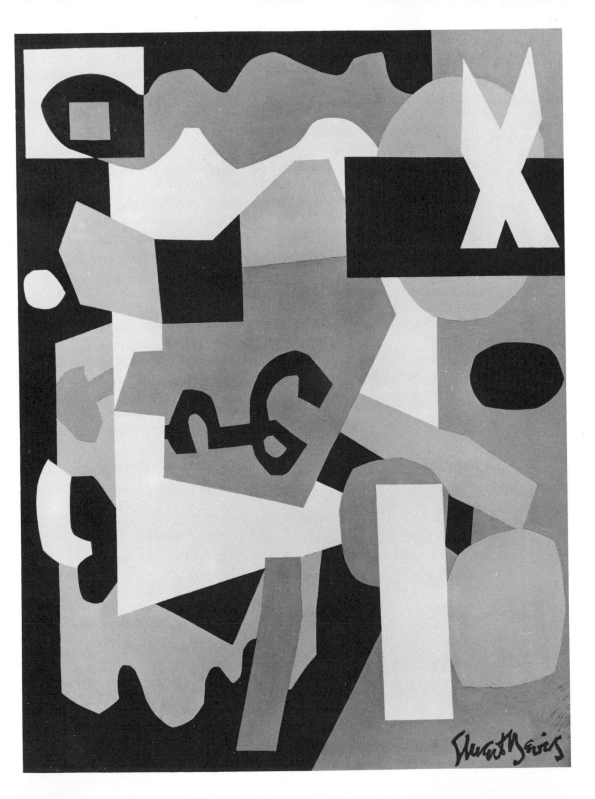

names on the front of paintings. I got the idea it ought to be integral, or else on the back of the canvas. People sometimes say—"that egotistical bastard," but after all if you're going to sign your work, why not make it a part of the composition? Refrigerator and automobile companies are not modest—why should the artist be?

Question: What part does color play in your work?

Davis: It doesn't play any part in and by itself; my color is not decorative. But I consider that visual images exist only through color and the artist always has the choice of two or more colors. Even just two colors can define a front and back space, though which is front and which is back is irrelevant. What is important is that the two colors are not in the same place. When I taught, my students used to ask, "Is the red tablecloth in Matisse's painting in the front or back?" I'd always answer, "It's neither; it can be miles away or on top of you —like ordinary tiles in a bathroom floor. They're either in front or in back but they change as you look at them." It's a common optical experience to differentiate between front and back. In daily living it's practical and necessary to do this; but in a painting, space doesn't involve practical hazards. You can't break your neck in a painting. Even though you use the same sense of space in a picture that you use in crossing a street, you don't have the same obligations. With a painting you're completely *free* to *appreciate* your optical faculties.

An artist can make a phenomenon with only two colors. The reason it's meaningful is because the two colors are not in the same place. I'm referring here only to the physical fact that to make a visual image exist, you must use at least two colors. They have significance for us because we can identify them with daily optical experiences. We interpret everything in terms of daily experiences, don't we? When you're talking about the space in a painting, you're hung up because it's not real space, but our life experience gives us clues that help us to see. The painting is never practical—it's a painting of space.

Question: But what are you really doing with color—not just as a physical tool?

Davis: The point is that different temperaments respond to the outside world in different ways. Some like prize fights; some don't. Some

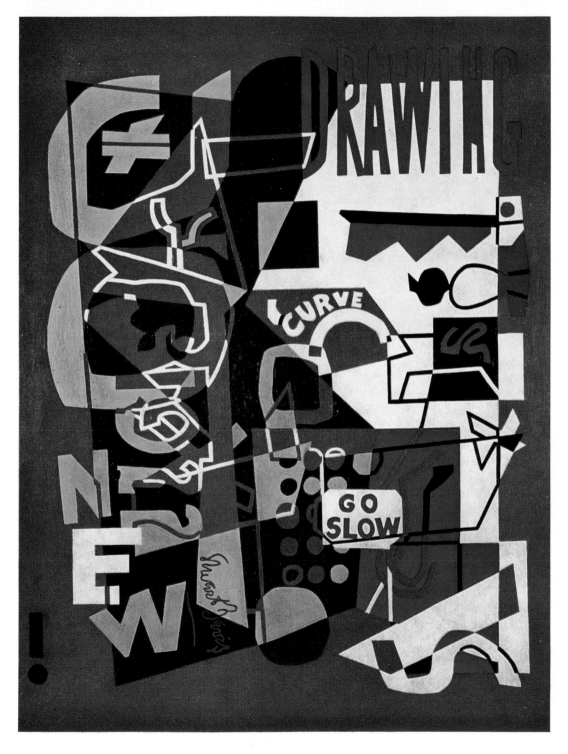

23　*Combination Concrete No. 2, 1958*　*Collection Mr. and Mrs. Earl Wade Hubbard*

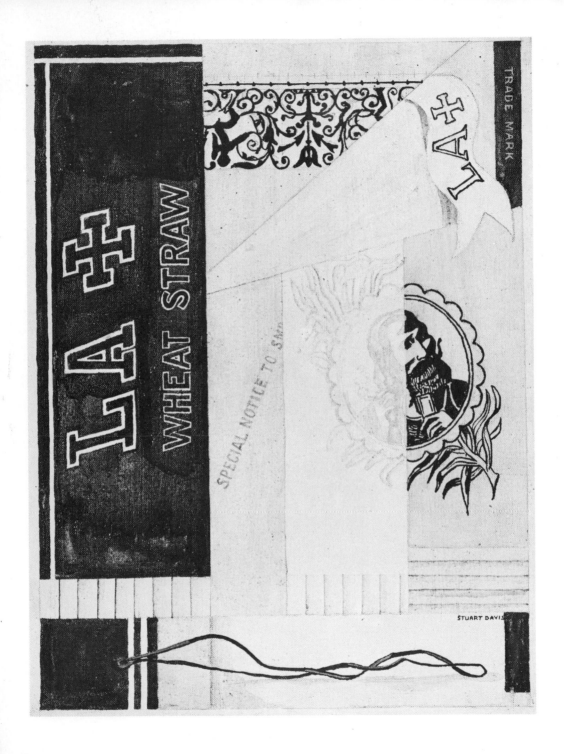

24 *Cigarette Papers (Wheat Straw), 1921 Private collection, U.S.A.*

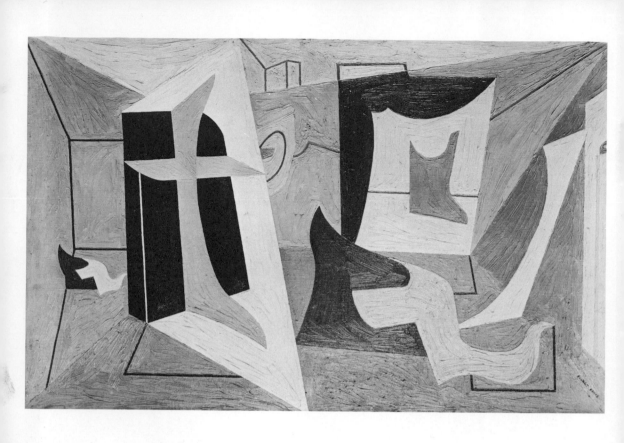

25　*Eggbeater No. 3, 1928　Collection William H. Lane Foundation*

27 *Allée, 1955* *Drake University, Des Moines*

like football games; some don't. Those who incline toward simple physical things respond to experiences in that same simple direct spirit, and consequently their image of the world will tend toward structural simplicity. What I'm trying to point out is that the colors I choose from the spectrum are appropriate to the purpose of my paintings, appropriate to the attitude in which the work was designed. Certain artists love to crawl in texture—this is a psychological thing. On the other hand, certain artists like myself choose simplicity and directness in color. Anybody can buy the colors I use in a store; it's how they're used that makes the difference. To me they are always integral to the purpose and the meaning of each painting. I prefer vigorous materials. By materials I mean canvas and paint. It is the interrelationship of these two that finally makes the structure of a picture.

Question: How do you feel about texture?

Davis: Years ago I decided that texture was a refuge for people who couldn't draw. If you pressed me, I'd say that any painter has a right to be a sculptor if he wants. I'm a refugee from sculpture. As a student

I once went to a school of sculpture and stayed for a couple of weeks. When finally the teacher came around and looked at my work he said, "A monkey could do better." From that day to this I've been an enemy of any kind of statuary.

Question: If you had to choose a few of your most pivotal works, which would they be?

Davis: The Tobacco pictures [*Plate 24*] I painted around 1921–22, the Egg Beater series [*Plate 25*] of 1927–28 and the Paris paintings [*Plate 26*], as far as my earlier work is concerned. For me, though, my entire work is all part of the same interest. People are born in a certain way; they have certain ability. All one can do is objectify it. If you live long enough you learn something. Now here's a watercolor I did in 1912, almost fifty years ago. It has the same kind of structure and composition I still use, but I've learned something since then. I've learned how to make my work a public object—a universal communicative currency.

The Tobacco paintings came out of the Armory Show, though they were done nearly ten years later. The Armory Show had great

impact on me. The Egg Beater series was important because at that time I began to think of a painting as an object in itself. I'd always felt this way, but with the Egg Beaters it became clearer to me just how to go about it. As to the Paris paintings—I didn't go over there to paint scenes of Paris but that's exactly what I did when I got there. Personally I find these paintings do not differ in purpose from any of the other works I've done.

Question: Do your murals (I'm thinking especially of the one at Drake University) [*Plate 27*] present different problems than the easel paintings?

Davis: Yes, because I must take architecture into consideration. I was out in Des Moines twice looking at the interior of the building at Drake, at its color, shape and even at the color of the sky through adjacent windows. I painted that mural right here in my studio in three eleven-foot parts. I made careful preliminary designs but there were endless physical problems connected with it. There was the problem of finding large enough canvas of the right quality; there was the problem of temporary stretchers for use in the studio; the problem of permanent stretchers for final installation. Those have a built-in weather device to keep the canvas taut.

Question: What artists do you especially admire?

Davis: To my mind Seurat is the grand artist of all times. Here's the rest of my list: van Gogh, Gauguin, Matisse (Cézanne is too intellectual for me), Picasso—I think he's a genius—and Léger. I guess that runs the gamut.

Question: What do you most want to get across?

Davis: You're asking Socrates to answer the riddle of the Sphinx in three minutes. I'll try to answer it in less. What I'm trying to do is resolve my daily intuitive questions into a practical visual logic that will last through the night. And if it lasts through the night it will last forever.

DAVIS

1894 Born, Philadelphia.

1901 Moved to East Orange, New Jersey.

1910–13 Studied with Robert Henri.

1913 Made covers and drawings for "The Masses." Exhibited watercolors in Armory Show. Made cartoons for "Harper's Weekly."

1915–34 Summers in Gloucester.

1918 Made maps for Army Intelligence.

1928–29 Paris. Egg Beater series.

1931–32 Taught, Art Students League, New York.

1933 With Federal Art Project.

1940–50 Taught, New School for Social Research, New York.

1941 Retrospective exhibition, Cincinnati Modern Art Society and University of Indiana.

1945 Retrospective exhibition originating at Museum of Modern Art, New York.

1952 One-man show, Biennale, Venice.

1952 Guggenheim Fellowship.

1956 Elected member National Institute of Arts and Letters.

1957 Retrospective exhibition, Walker Art Center, Minneapolis, Whitney Museum, New York, etc.

1958, 60 Guggenheim International Award.

Lives in New York City.

28 *Self-Portrait, 1946 Collection Mr. and Mrs. Earle Ludgin*

Question: Do your larger compositions differ radically from your smaller portraits and landscapes?

Dickinson: I've always thought, regardless of seeming differences, that all my works stem from the same source and thus there's not much disconnection among them.

Question: How did you happen to do so many self-portraits?

Dickinson: In fifty years I've painted twenty-seven. I don't believe there's any symbolism in them. Take the Self-Portrait in Civil War Costume that you were asking me about earlier. I've had a number of hobbies; one was the Civil War. For about nine years I was particularly interested in this subject and the portrait comes from that time. Another interest was architecture of the Mediterranean basin. Ruin at Daphne, the Metropolitan Museum's painting, grew out of an interest in Roman architecture when I was living in Arles. I like to sail; I enjoy also target shooting with high-powered rifles; I buy obsolete army rifles and presently have several good ones.

About the self-portraits; they're all done from one or two mirrors. The best one I think was the 1946 painting with a villa in the background and a stovepipe. My 1914 portrait [*Plate 29*] was a *premier coup* (first strike). It's the one in which I breached the painter's rule of never painting against the light. The face is in shadow but one eye does emerge. Charles W. Hawthorne liked this one.

Question: Do you make preliminary sketches?

Dickinson: I do not. Even with a very large canvas I begin without such specific preparations as drawings or planned designs. But I often make drawings for the details in a painting. If I'm going to need an iceberg, let's say, I make a drawing of it right on the scene if I can.

And sometimes I use sketches in paintings that they were not originally made for.

The canvas for the piece in the Museum of Modern Art called Composition with Still Life [*Plate 30*] stood on its easel for one year before I started to work on it. I build my own easels. In this case I made a separate stand of four steps on casters so that I could wheel it around and paint on the picture at different levels. It is the largest canvas I've done. A painter wishes his spots, small and large, to be equally successful. A small spot, one by three inches for example, is taxing because of his best aspiring. A spot one by two feet requires the same best aspiring, but it takes longer to concoct because a good deal of heavy paint is not refinable through perhaps fifteen modifications without a very felt tax on the painter's strength. This taxing is beneficial and strengthening; his large spots have succeeded and doubtless the smaller ones are improved because he taxed himself hundreds of times with large ones. If I'd had a larger door to my studio I would have painted even bigger pictures. It's probably merciful that the diagonal measurement of the door was no larger than it was. My large pieces were a disappointment to me, but *they* were the best I could do and I was going to do them for better or for worse.

Almost all the landscapes done directly from nature are *premiers coups,* and range in size from 30 x 36 inches to 8 x 10 inches. These are usually painted in about two to four hours. I almost never touch them again. If they're not good, one merely paints another the next day. In Europe a few years ago I did sixty as consecutively as I could. The *premier coup* is a great teacher. With me the larger paintings take anywhere from twenty to five hundred sittings.

Question: What about watercolors?

Dickinson: I've done very few. I made quite a number in 1914 and again in 1920. I haven't done any since then. Oil is called "the father medium" and oil is the natural medium for me.

Question: Do you work both out of doors and in the studio?

Dickinson: I work anywhere, in studios and out of doors, both from

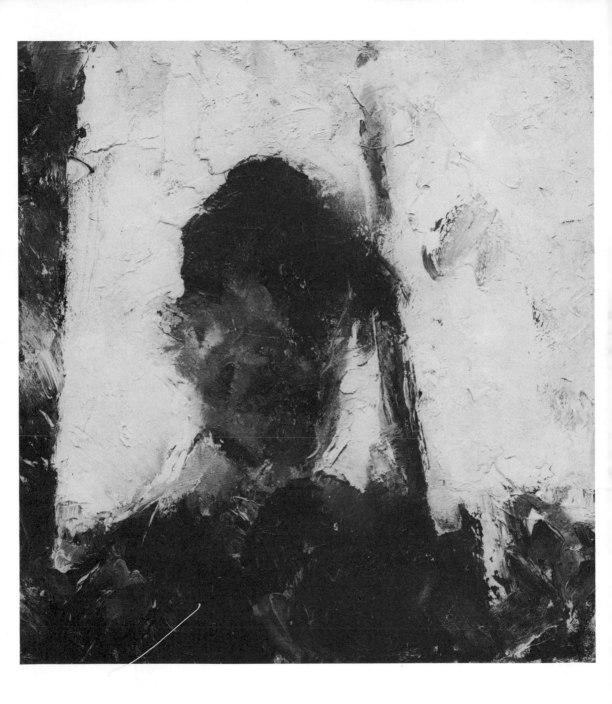

29 *Self-Portrait, 1914*

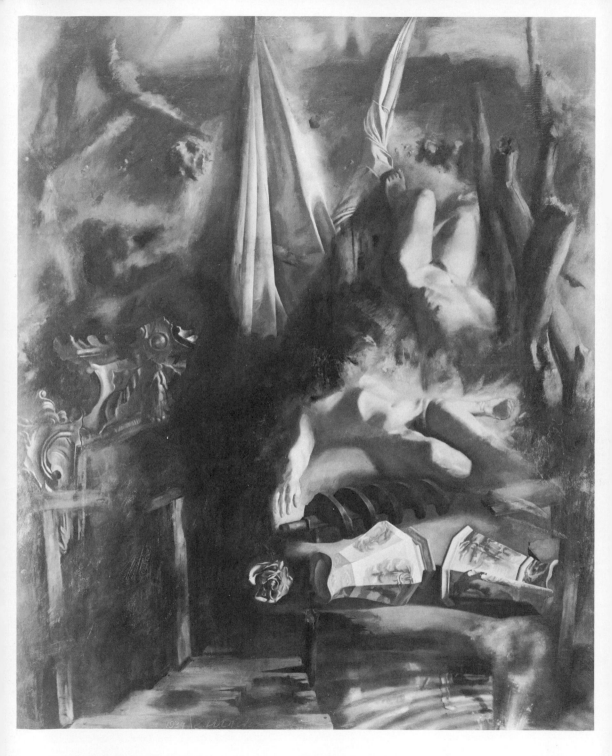

30 *Composition with Still Life, 1934–1937* *The Museum of Modern Art*

nature and from recollection and imagination. All the large paintings naturally have been done in the studio.

Question: Are the large ones symbolic?

Dickinson: I wouldn't be able to say.

Question: How about The Fossil Hunters? [*Plate 31.*] What were you after there?

Dickinson: At the time I painted it, my side interest was fossils. The name of the picture came from the fact that I put in a few fossils and some people lying on rocks. I was born in a highly fossiliferous region in the Finger Lake district of New York. This painting was never finished. Neither was Ruin at Daphne [*Plate 32*]. The red areas around the edges of that picture are the basic underdrawing still showing because the canvas was not completed. The painting fell through before I could finish it. And, by the way, this was the only large picture for which I did a preliminary drawing directly on the canvas—but I didn't stick to the drawing; I cut out the whole left side and painted in something else. I used red because there had been a full-length self-portrait on the canvas before I started this particular composition. I scraped it off partly with a jackknife, but then the canvas was no longer a new white one—so I had to draw in a color that would show.

None of the large paintings is really finished. There comes a time when I stop—because to go on would mean reorganizing the canvas from the bottom up. I can't throw away the investment of so many years—nine years in the case of Ruin at Daphne. So I make the best of a bad job by finishing them as well as I can. In other words, they all topple over when they're about three-fifths done.

Question: Why?

Dickinson: That's easy. If a painting takes many years, one hasn't stood still from the beginning to the end. As time goes on, one starts to disapprove of the earlier work. But even so, I prefer doing long ones to short ones. It took three years to paint Composition with Still Life, about 150 sittings more than to paint The Fossil Hunters. As I use the word "sitting," it means execution time only, not the considerable additional time given to planning. I'm presently working on a composition I began in 1950.

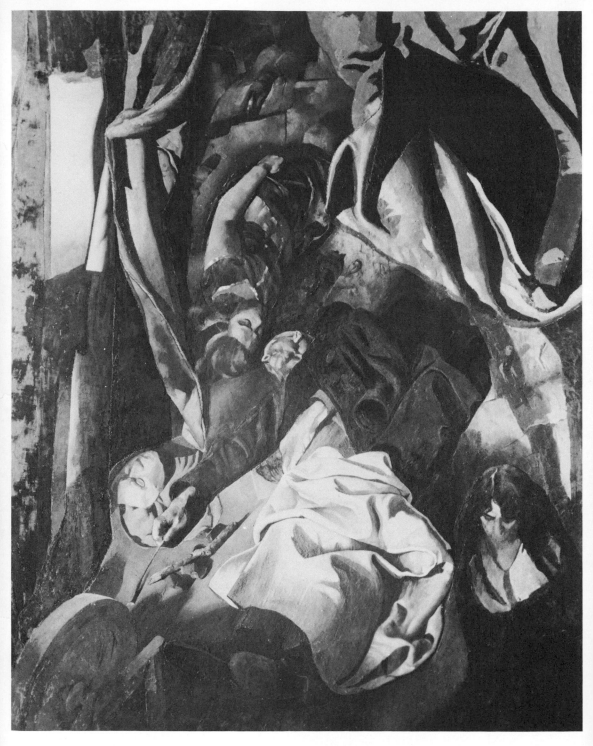

31 *The Fossil Hunters, 1926–1928 Whitney Museum of American Art*

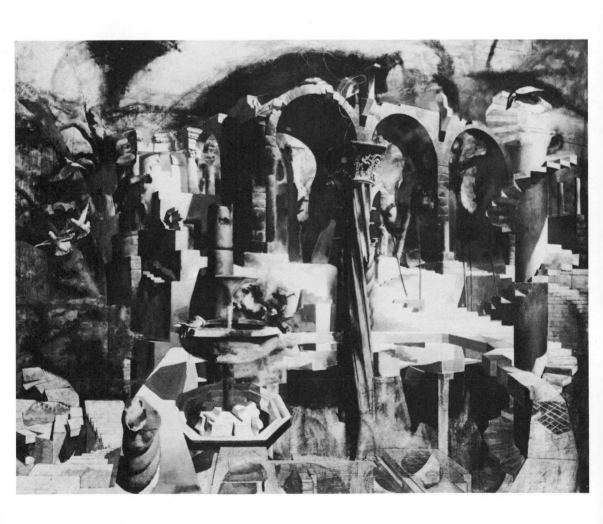

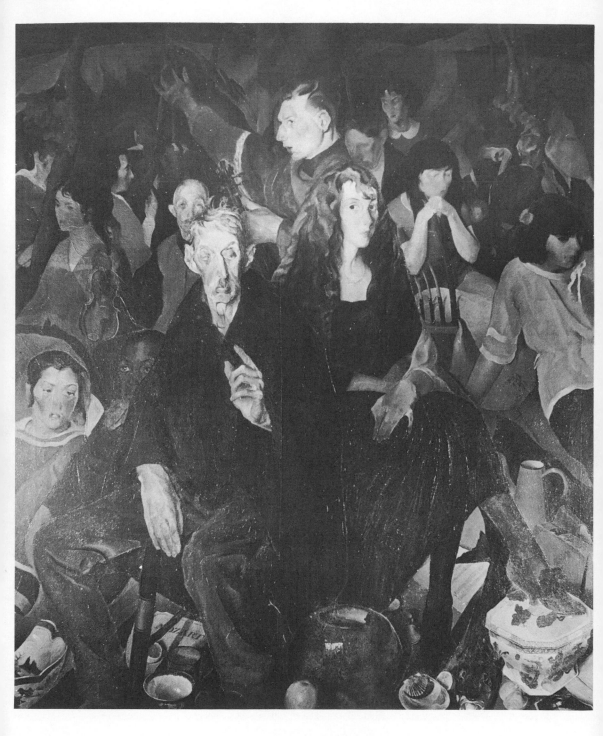

33 *Anniversary, 1920 Albright-Knox Art Gallery, Buffalo*

Question: I'd like to ask you about the early painting called An An-
niversary that belongs to the Albright-Knox Art Gallery in Buffalo.

Dickinson: This was not a specific event. I named the picture after it
was painted, as I've done with all my canvases. When I was working
on Ruin at Daphne (it became a family affair because it took nine
years) we always referred to it as the "sixty forty-eight." These were
its dimensions. Width comes first; in the past it always came first.
The figures in the foreground of An Anniversary were all painted
from models, sometimes friends; those in the rear were either invented
or done from drawings. The still-life in the foreground was painted
from nature—from objects I owned or had borrowed. The name of
the picture makes no difference whatsoever; I merely needed a title
for identification.

Question: Has your work changed as you've grown older?

Dickinson: I would hope so. I would have quit long ago if it hadn't.
The more you practice the better you get, presumably. For anyone
who gets less good as he goes on—it's just hard luck.

Question: What have been the greatest influences in your development?

Dickinson: I suppose being alive and awake. I've been stimulated by
about the same range of influences that have affected artists histori-
cally. Living on Cape Cod as much as I have has been beneficial. I
can think of many places that would not have done as well for me. I
lived there a long time; I went there because I thought I would like
it and I did. One of the reasons: there weren't many towns with so
very many artists' studios in them; all of which were not good, of
course.

Question: How do you feel about teaching art?

Dickinson: I've always done it first for pleasure and secondly as a means
of earning a livelihood. If I could, I would have quit the minute I
stopped enjoying it. But I've done a lot of teaching—too much. It
interrupts one's week. For most people, the time lost working a few
things out for themselves is lamentable. In a few weeks of teaching I
can save a student almost a year's time. The number of unnecessary

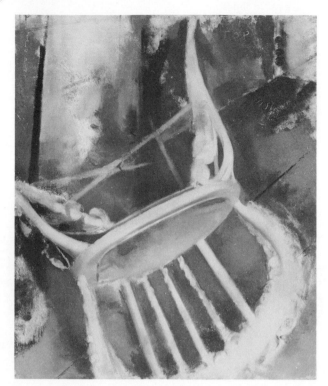

blind alleys one has to climb through alone is wasteful. I owe so much to my masters. I was a pupil of William M. Chase and Charles W. Hawthorne. We kept pretty quiet when Chase was around and learned a lot from him without his speaking long. His manner, his eminence were impressive. He didn't waste our time talking of trifles. But the man who taught me the most was Charles W. Hawthorne.

Question: Do you enjoy commissions?

Dickinson: For me, they're miserable. I never did a commission except for the money I needed. If I have a model, he must not pay me; I pay him. In the Renaissance the best portraits were painted by people whose better work was not portraits. That accounts for Titian, Tintoretto—

Question: What about the early Flemish?

Dickinson: I realize there are many exceptions to this statement. I,

of course, respect the world of commissioned portraiture; but it doesn't fit me.

Question: I'm curious about the way you almost always tilt your objects so that one sees a familar scene in a new way.

Dickinson: I'll tell you about that. Most of our experience in seeing is connected with our own eye level, but you can get tired of always seeing things from the same height. We're accustomed to looking at ceilings from down below. That's the way we expect to see them. I've gotten tired of always looking at everything on my own eye level. Take that tipped-over chair. It wasn't a chair to be sat in; it was a chair to be painted, so it wasn't a chair but a painting of a chair.

I rarely paint a still-life without tilting the objects in it. Why? Because if I expect the object to be upright I am deprived of seeing where it is, of asking—where is it? It's diverting to look at nature physically from viewpoints that are not the usual ones. The drawing of a hand in the usual elevation is true but no truer than a hand foreshortened. But a hand like this (greatly foreshortened) will probably not be memorized. The minute an object is out of its usual position, reaction to observation must stop when one stops looking. Where drawings from customary positions are concerned, at least half are coasting on the memory of previous experience. For me, the drawing that purports to be from observation but in reality was done from expectation is just about meaningless.

DICKINSON

1891 *Born, Seneca Falls, New York.*

1910–11 *Studied, Pratt Institute, New York.*

1911–13 *Studied, Art Students League, New York, with William M. Chase and Frank V. DuMond.*

1912–14 *Studied with Charles W. Hawthorne, Provincetown.*

1916 *Taught, Buffalo Academy of Fine Arts.*

1917–19 *United States Navy, Radio Electrician.*

1919–20 *Painted in Europe: Paris, St. Tropez, Spain.*

1921–37 *Lived and painted in Provincetown.*

1922–23 *Taught, Art Students League, New York.*

1927 *One-man exhibition, Albright Art Gallery, Buffalo.*

1929–30 *Taught, Provincetown Art Association.*

1936–43 *Five one-man exhibitions, Passedoit Gallery, New York.*

1937–38 *Painted in Europe: Paris, Toulon, Brittany.*

1939 *One-man exhibition, Wood Memorial Gallery, Provincetown.*
 Taught, The Art Institute of Buffalo.

1939–44 *Lived and painted in Wellfleet, Massachusetts.*

1940–41 *Taught, Stuart School, Boston.*

1941 *One-man exhibition, Stuart School, Boston.*
 Taught, Association of Music and Art, Cape Cod.

1942 *One-man exhibition, Farnsworth Museum, Wellesley College.*

1943 *One-man exhibition, Nantucket Museum.*

1944 *Moved to New York City.*

1945–49 *Taught, Cooper Union, New York.*

1945–61 *Taught, Art Students League, New York.*

1946–47 *Taught, Midtown School, New York.*

1950 *Taught, Pratt Institute, New York.*

1951 *Taught, Dennis Foundation, Dennis, Massachusetts.*

1952 *Exhibited, "15 Americans," Museum of Modern Art, New York.*
 Painted in Europe: Paris, Montignac.

1954 *Grant, National Institute of Arts and Letters.*

1957 *Cornell University (visiting instructor).*

1958 *Retrospective exhibition, Cushman Gallery, Houston.*
 Retrospective exhibition, Boston University.

1959 *Ford Foundation Grant.*

1959–60 *Visits to the East Mediterranean: Greece, Syria, Lebanon, Turkey*
 and Libya.

1961 *Boston University (visiting instructor).*
 Retrospective Exhibition, Graham Gallery, New York.

Lives in New York City and Wellfleet, Massachusetts.

MARCEL DUCHAMP

Question: As you look back, which of your works do you find the most important?

Duchamp: As far as date is concerned I'd say the Three Stoppages [*3 stoppages étalon, Plate 35*] of 1913. That was really when I tapped the mainspring of my future. In itself it was not an important work of art, but for me it opened the way—the way to escape from those traditional methods of expression long associated with art. I didn't realize at the time exactly what I had stumbled on. When you tap something, you don't always recognize the sound. That's apt to come later. For me the Three Stoppages was a first gesture liberating me from the past. However, in my opinion the Large Glass [The Bride Stripped Bare by Her Bachelors, Even, *Plate 36*], was a departure from anything I had learned before and was the most important single work I ever made. I spent eight years on it (1915–1923). This time element alone illustrates what I mean by getting away from traditional, more rapid techniques. But far more important was the intention behind the Large Glass, the intention of getting away from even the idea of painting a picture. Instead, I purposely introduced elements considered anathema to art, at least at that time, nearly fifty years ago. I refer to purely mental ideas expressed as part of the work but not related to any literary allusions.

I never finished the Large Glass because after working on it for eight years I probably got interested in something else; also I was tired. It may be that subconsciously I never intended to finish it because the word "finish" implies an acceptance of traditional methods and all the paraphernalia that accompany them. Originally I had planned to finish the glass with a catalogue like the Green Box, except,

of course, the Green Box is a very incomplete realization of what I intended. It only presents preliminary notes for the Large Glass and not in the final form which I had conceived as somewhat like a Sears, Roebuck catalogue to accompany the glass and to be quite as important as the visual material.

Question: Why were you so anxious to avoid the traditional?

Duchamp: I think that's usual for almost any artist. Tradition is the great misleader because it's too easy to follow what has already been done—even though you may think you're giving it a kick. I was really trying to invent, instead of merely expressing myself. I was never interested in looking at myself in an aesthetic mirror. My intention was always to get away from myself, though I knew perfectly well that I was using myself. Call it a little game between "I" and "me."

Question: Why do you think the Nude Descending a Staircase [*Plate 37*] caused a greater furor than some of your other works?

Duchamp: Probably because of the shock value due to its title, which by the way already predicted the use of words as a means of adding color or, shall we say, as a means of adding to the number of colors in a work. You know at that time, in 1912, it was not considered proper to call a painting anything but Landscape, Still-Life, Portrait, or Number Such-and-Such. I think the idea of describing the movement of a nude coming downstairs, while still retaining static visual means to do this, particularly interested me. The fact that I had seen chrono photographs of fencers in action and horses galloping (what we today call stroboscopic photography) gave me the idea for the Nude. It doesn't mean that I copied these photographs. The futurists were also interested in somewhat the same idea, though I was never a futurist. And of course the motion picture with its cinematic techniques was developing then, too. The whole idea of movement, of speed, was in the air.

The controversial side of the Nude was not my concern. I was only involved with painting a picture. As a matter of fact, in my opinion, I've made other works far more controversial. I, myself, was most surprised at the public reaction. I hadn't anticipated the furor. Personally, I find The King and Queen Surrounded by Swift

36 *The Bride Stripped Bare by Her Bachelors, Even, 1915–1923 Louise and Walter Arensberg Collection, Philadelphia Museum of Art*

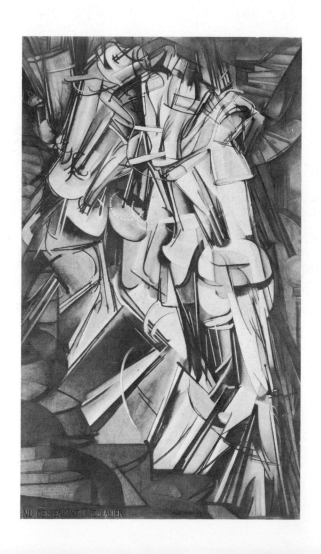

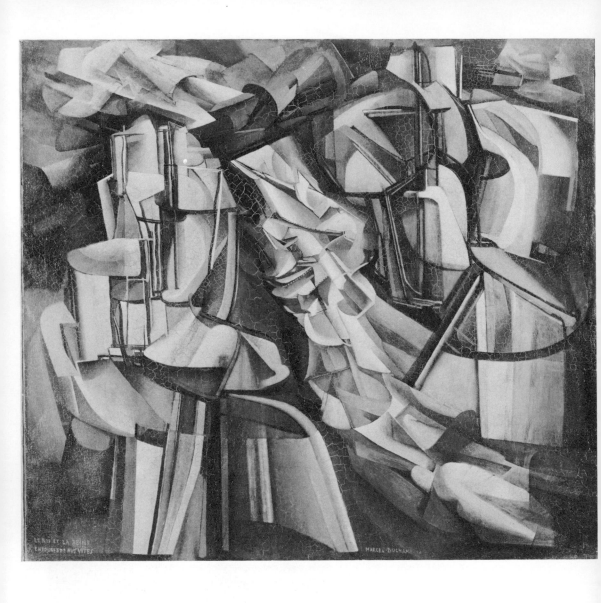

*38 The King and Queen Surrounded by Swift Nudes, 1912 Louise and Walter Arens-
berg Collection, Philadelphia Museum of Art*

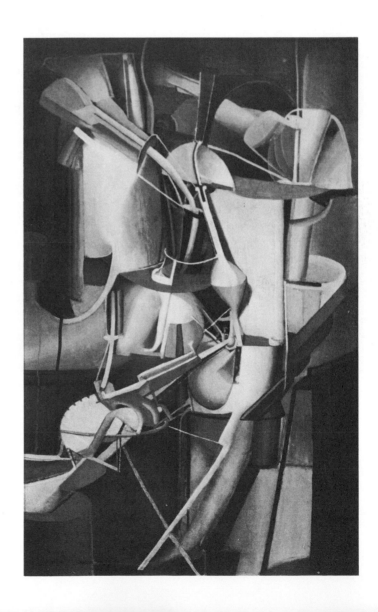

Nudes [*Plate 38*] just as interesting as the Nude Descending a Staircase, even though the public evidently doesn't. You know this was a chess king and queen—and the picture became a combination of many ironic implications connected with the words "king and queen." Here "the swift nudes," instead of descending, were included to suggest a different kind of speed, of movement—a kind of flowing around and between the two central figures. The use of nudes completely removed any chance of suggesting an actual scene or an actual king and queen.

Question: Which of your painted works do you prefer?

Duchamp: The Bride [*Plate 39*] in the Arensberg collection. This was one of many preparations for the Large Glass. It was not until 1913, a year after I painted The Bride, that I began to elaborate the glass idea, in order to get away from all traditional oil mediums.

Question: Why do you think you and the other cubists were so involved with decomposing and reassembling form at that particular time (1912)?

Duchamp: This is a very curious problem. Distortion is not decomposition. Distortion came first and in great measure came from the *fauves* who in turn were under the strong influence of primitive art. Their willingness to distort, to take any liberty with anatomy or nature led to the next step—a breaking up of form. In the beginning, the cubists broke up form without even knowing they were doing it. Probably the compulsion to show multiple sides of an object forced us to break the object up—or even better to project a panorama that unfolded different facets of the same object. Here the word "gradual" is important and so is the word "blindfolded." It was only later we discovered that we were breaking something; it didn't make a noise when it happened.

Question: Why have words, puns and the interrelationships of words and objects interested you so deeply?

Duchamp: I like words in a poetic sense. Puns for me are like rhymes. The fact that "Thaïs" rhymes with "nice" is not exactly a pun but it's a play on words that can start a whole series of considerations, connotations and investigations. Just the sound of these words alone begins a chain reaction. For me, words are not merely a means of

communication. You know, puns have always been considered a low form of wit, but I find them a source of stimulation both because of their actual sound and because of unexpected meanings attached to the interrelationships of disparate words. For me, this is an infinite field of joy—and it's always right at hand. Sometimes four or five different levels of meaning come through. If you introduce a familiar word into an alien atmosphere, you have something comparable to distortion in painting, something surprising and new. The other evening we were at the Egyptian Gardens here in New York and there was a girl doing a belly-dance; her name was Thaïs. That started me on this speculation of "Thaïs" being "naice." It was as simple as that.

Question: Why were you so interested in getting away from the actual physical aspects of painting? How did you happen to become anti-art?

Duchamp: That's where the retinal comes in. That famous liberation of the artist at the time of Courbet changed the status of the artist from the employee of a patron or collector to a free individual. By "free," I mean the artist was able to paint what he wanted and impose it on the collector, who in turn had the right to accept or refuse, but only on equal social terms. This liberation in the nineteenth century took the form of impressionism, which in a way was the beginning of a cult devoted to the material on the canvas—the actual pigment. Instead of interpreting through the pigment, the impressionists gradually fell in love with the pigment, the paint itself. Their intentions were completely retinal and divorced from the classical use of paint as a means to an end. The last hundred years have been retinal; even the cubists were. The surrealists tried to free themselves, and earlier so had the dadaists, but unfortunately these latter were nihilists and didn't produce enough to prove their point, which, by the way, they didn't have to prove—according to their theory. I was so conscious of the retinal aspect in painting that I personally wanted to find another vein of exploration. Today abstract expressionism seems to have reached the apex of this retinal approach. It's still going strong but I doubt whether this is the art of the future. One hundred years of the retinal approach is enough. Earlier, paint was always a means to an

end, whether the end was religious, political, social, decorative or romantic. Now it's become an end in itself. This is a far more important problem than whether art is figurative or not.

Question: Would you comment on the use of modern machines and science in your work?

Duchamp: People living in a machine age are naturally influenced either consciously or unconsciously by the age they live in. I think I was conscious enough when I introduced derision into that sacrosanct era. Humor and laughter—not necessarily derogatory derision—are my pet tools. This may come from my general philosophy of never taking the world too seriously—for fear of dying of boredom.

Question: Do you advocate an anonymous art?

Duchamp: No, I don't want an anonymous art. We had an example of that in the WPA. I still believe in individualism in art. But from a purely technical angle, I always wanted to get away from the worn-out cult of the hand—the cult of the legerdemain. Though I still enjoyed the magic of an eighteenth-century pastel, I wanted to avoid past models and, in accordance with my decision to find a new vein, I wanted to avoid constantly looking back.

Question: What were you after when you invented the Ready-Made?

Duchamp: The curious thing about the Ready-Made is that I've never been able to arrive at a definition or explanation that fully satisfies me. [Any made object, isolated from its functional meaning, can become a Ready-Made, either with or without further embellishment. Ed.] There's still magic in the idea, so I'd rather keep it that way than try to be exoteric about it. But there are small explanations and even certain general traits we can discuss. Let's say you use a tube of paint; you didn't make it. You bought it and used it as a ready-made. Even if you mix two vermilions together, it's still a mixing of two ready-mades. So man can never expect to start from scratch; he must start from ready-made things like even his own mother and father.

My Ready-Mades have nothing to do with the *objet trouvé* because the so-called "found object" is completely directed by personal taste. [See page 50.] Personal taste decides that this is a beautiful object and is unique. That most of my Ready-Mades were mass produced and

40 *Ready-Made, Ball of Twine, 1916*
Louise and Walter Arensberg Collection,
Philadelphia Museum of Art

41 *Ready-Made, Why Not Sneeze Rose Sélavy?, 1921*
Louise and Walter Arensberg Collection, Philadelphia Museum of Art

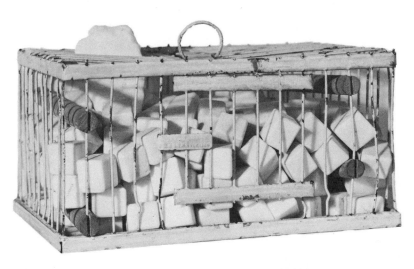

could be duplicated is another important difference. In many cases they were duplicated, thus avoiding the cult of uniqueness, of art with a capital "A." I consider taste—bad or good—the greatest enemy of art. In the case of the Ready-Mades, I tried to remain aloof from personal taste and to be fully conscious of the problem. Hence the result is that over a period of almost fifty years, I have accepted only a small number of Ready-Mades. If I'd been producing ten a day, the whole idea would have been destroyed because large numbers alone would immediately produce a personal taste. By adding as little as possible to my Ready-Mades I try to keep them pure. Of course all this scarcely sustains a transcendental discussion, because many people can prove I'm wrong by merely pointing out that I choose one object rather than another and thus impose something of my own personal taste. Again, I say man is not perfect, but at least I have tried to remain as aloof as possible, and don't think for one minute this hasn't been a difficult task. I'm not at all sure that the concept of the Ready-Made isn't the most important single idea to come out of my work.

Question: Has the accidental played a role in your work?

Duchamp: My first accidental experience (what we commonly call chance) happened with the Three Stoppages, and, as I said before, was a great experience. The idea of letting a piece of thread fall on a canvas was accidental, but from this accident came a carefully planned work. Most important was the accepting and recognizing of this accidental stimulation. Many of my highly organized works were initially suggested by just such chance encounters.

DUCHAMP

1887 *Born, Blainville, France.*

1904 *Studied painting, Académie Julien, Paris.*

1911 *Formally joined cubists. First sketches for Nude Descending a Staircase.*

1912 *Painted Nude Descending a Staircase.*

1913 Showed five works at Armory Show, New York.

1913 Made first painting on glass.

1914 Created first Ready-Made.

1915 In New York.

1915–23 Worked on Large Glass.

1918 In Argentine.

1919 In Paris.

1920 In New York. Organized Société Anonyme with Katherine Drier.

1923 Gave up art to devote himself to chess and optical experiments.

1925 In Paris. Produced film, "Anemic Cinema."

1926 In Paris. Wrote book on chess.

1934 Started making roto-reliefs. Made the "Box," a portfolio containing ninety-three documents of his work in facsimile.

1937 First one-man show, Arts Club of Chicago.

1942 Published suitcase with reproductions of his work called Boîte-en-Valise.

1942–61 Organized various surrealist and dada exhibitions in United States and Europe.

1955 Became American citizen.

Lives in New York City.

NAUM GABO

Question: Do you still consider yourself a constructivist? And what do you mean by this term?

Gabo: In my lecture at Yale last week I answered that question. I said that I not only still adhere to the idea of constructive art, but that I'm more convinced than ever that this ideology is the soundest and best way to save ourselves from the present chaotic state of society. I believe strongly that art has an important function to fulfill in this respect. Art is not just pleasure; it is a creative activity of human consciousness from which all spiritual creation derives. Art is everything. Everything we make or even think about is art.

Question: What about war?

Gabo: War is a negative act. War is murder and murder is against life. Wars are made by people whose minds are disturbed. If people consider war an art, it is a negative kind of art. A work of art can be constructive and it can be destructive. The frame of reference for evaluating an action depends on whether as art it enhances or destroys life. War has no creative element in it. It belongs to the category of human convulsions; it belongs to the field requiring medical or psychiatric treatment. Real creative art can be a good remedy for it.

Question: Do you feel that artists who are preoccupied with dissolution are necessarily destructive?

Gabo: Yes, whether their work is abstract or not. Yes, I do.

Question: Do you consider your work abstract?

Gabo: I have never insisted that it is necessary to be abstract in order to be constructive. And in this respect I always disagreed with even my closest colleagues. I not only consider my present work realistic— I have constantly insisted, even in the Manifesto of 1920, that my art has always been realistic.

Question: In what way?

Gabo: In this way—that I think a painting or sculpture must create an image of an experience. If an artist has no experience before he makes a painting or a sculpture, he is not an artist. If he has no experience, his work becomes little more than an exercise. And an image of an experience is an image of reality. For instance, if you see a landscape or an event or even an object, you have had a visual experience and you must create an image of this experience if you are an artist. Otherwise you just take it in with no desire to transmit it to others. But in the transmission of that image, the artist is free to say how he feels about it in any way he finds adequate. He's not obliged to paint or sculpt the actual event or object which caused his experience, because what he does is to transmit an image of an experience—not an image of the object or event itself. It is his personal associations accumulated during his entire life that form this experience.

Question: In what way has constructivism gone beyond cubism?

Gabo: In every way. In the Realistic Manifesto I rejected cubism in no uncertain terms. Cubism was an important experiment but its analytical approach to the world was not constructive.

Question: Why—because it broke everything up?

Gabo: Yes, and because it was more concerned with the actual making of a painting than with creating an image of an experience. It's true that the cubists put together the elements of a composition after they had broken up the object, but the image that resulted was an image of a chaotic world. They analyzed but didn't organize the world. We were more realistic than the cubists because our consciousness did not and does not tolerate amorphous deformities.

Question: Did cubism influence your work?

Gabo: Certainly, but it was secondary because the technique of cubism was known to us in Russia through the work of Mikhal Vrubel, who lived at the end of the nineteenth century and who had a decisive influence on my generation. He was not, you understand, a cubist but he anticipated this technique in his painting. So did Cézanne, but not as much.

Question: Are your paintings, watercolors and drawings conceived as designs for sculpture?

Gabo: They are works in themselves, but sometimes I paint the image so realistically that it can be taken as an image of a sculpture. However, I often turn to painting when the image of my experience becomes so involved in structure, in form and in color that there is no possible way for me to execute it in three-dimensional material. So when I cannot make it, I paint it on a two-dimensional surface.

Question: What do you mean by that word "kinetic" you use so often in your titles? Does this refer to motorized art?

Gabo: I experimented with kinetic ideas while I was still in Russia over forty years ago. The purpose was to introduce the element of *time* into our human experience, the point being that in visual experiences time is a constantly active element. Our vision does not proceed statically—and since what we do is to transmit an image of an experience, then no experience is ever conceived without a time element involved. I think this is an important constructive contribution the artist must not neglect in order to make human consciousness more aware of time and what time can mean. It's important because the function of art is to enrich and develop human consciousness.

Question: Isn't this a somewhat missionary idea?

Gabo: No more so than science is. Everything has a mission. Why should we be ashamed of missionary zeal? The word has become unfairly vulgarized—and intellectuals are almost afraid of "doing good" these days. As a constructive artist I believe that there must be some sort of coordination in the world.

Question: Then you don't believe that the artist's role is to express himself?

Gabo: No. Absolutely no. But to go back to the idea of kinetics. As a matter of fact, by this word I don't necessarily mean motorized movement, though I have often used motors in my sculpture. Take for instance this recent transparent sculpture [*Plate 43*]. When it moves, there are literally innumerable ways of seeing it. You simply can't perceive it properly from one static angle. I planned to have it rotate slowly by motor. Even in a painting which does not actually move (though you know that some of my paintings have also been motorized) there are ample opportunities to transmit the experience of movement through the language of painting—line, shape and color. I

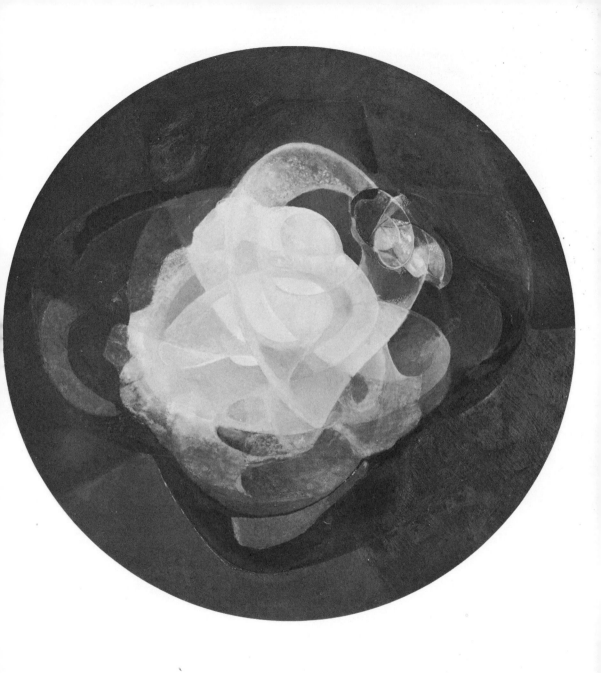

42 *Kinetic Painting, 1946–1952 Wadsworth Atheneum, Hartford*

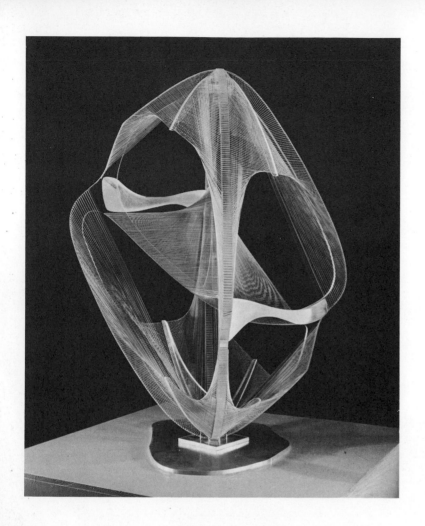

43 *Linear Construction in Space, No. 4, 1957–1958*
Whitney Museum of American Art

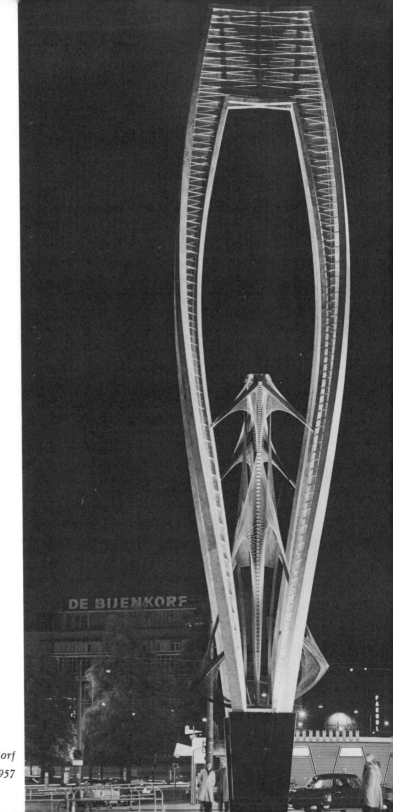

*44 Construction for the Bijenkorf
Department Store, Rotterdam, 1957*

find no difference between suggested movement and real motorized movement, other than a technical difference. Both are acts of our consciousness, occurring in our experiences. So both then become realistic to the artist—and to the observer if he really sees the painting and sees what the artist is after. Of course one must add that this also depends on how successfully the artist has communicated his experience.

Question: Did your early training as an engineer affect your work?

Gabo: To a great extent it helped me. You see, I make all my works myself with the exception of those that are too large to handle, like the sculpture in front of the Bijenkorf department store in Rotterdam [*Plate 44*]. But of course I made an exact model for this, though at first the building engineers doubted that it could actually be carried out, because of certain new structural principles too complicated to explain here. Only after the engineers had submitted my model to tests lasting three months could they successfully work out the necessary mathematical formulas and calculate the structure. They followed the model in every detail, only asking for one centimeter more than my original dimensions demanded—for the sake of additional security. The monument is eighty-five feet high—the highest known sculpture by a modern artist. It was commissioned by both the department store and the city of Rotterdam.

Question: Does it have any symbolic connection with the destruction of Rotterdam during the last war?

Gabo: Yes, because the city engineers and the directors of the store took me on a yacht trip around the docks of Rotterdam before I started working on the project. At that time the docks were already reconstructed from ruins left by the Germans. My experience, my reaction was profound admiration for the life energy of the Dutch nation. Also at the same time I saw a monument there by the sculptor Zadkine that emphasized the horrors of Nazi destruction. I felt that this was related to the past and that my experience in Rotterdam was related to the present—to a feeling of hope and admiration for human vitality. My monument is the image of that experience.

Question: Without the invention of certain new materials, like plastics, would your work have taken the course it has?

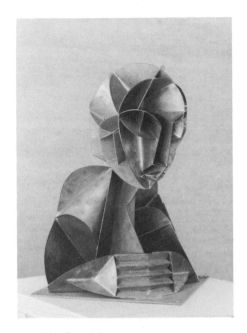

45 *Head, 1916*

46 *Repose, 1953*

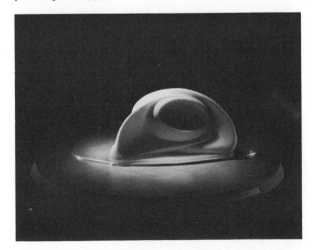

Gabo: From the very beginning of my career I did not stick to any particular material. As a matter of fact, the first heads I constructed, in 1916 [*Plate 45*], were made sometimes of iron sheets, sometimes of cardboard and sometimes of glass. Later I did a great deal of work in plastics for only one reason: to accentuate the transparent character of space.

Question: Why has space become so important in twentieth-century art? And what do you mean by space?

Gabo: Just what I said about time is true also of space. Space for me is exactly what it is for every one of us living people. It is not what it is in the minds of scientists today. In science it's a formula. But for me it is a real element of vision; it is as material as any concrete material. Without space there is no vision—nothing is flat in our vision. Space is a reality in all of our experiences and it is present in every object, in every event which comes into our vision. It is even present in a material that seems to us monolithic. That's what I've tried to show in certain of my stone carvings [*Plate 46*]. When they turn, observe how their curved forms seem interpenetrated by space. We not only live in space, and objects not only exist in space, but space is always penetrating every material body. And don't forget that it was neglected by artists before our time. In their work they only recognized the simple fact that bodies do exist in space and that space surrounds them, whereas in my constructive sculptures I am trying to show the penetration of space through everything—through every body, so that space becomes a part of the sculpture, a visual element equivalent to the actual material from which the sculpture is made. It plays the same role as shape, line, color and form.

Question: How and when do you use color in your constructions?

Gabo: I use color in a sculpture when the image of my experience color in it. Even when I make a work in only one material, that terial inevitably has color in it—and I choose my materials in rela to their color.

Question: What about the car you designed for Jowett Cars Ltd. in 1944?

Gabo: It never materialized because it was considered too radical. I

introduced many features that were completely new then, but that now are frequently found in automobiles. For instance, I put the engine in the back; the hood declined toward the ground and the whole design was contrary to the then prevailing streamlined style. It was just too radical in every detail at that time.

Question: Which artists of the past do you admire?

Gabo: Actually, I went through Italy as a student on foot. My final destination was Rome, but I saw so much en route that by the time I arrived in Florence I'd had enough. I never really saw Rome but I saw a great deal of classical and medieval art. All of that, of course, made a strong impression on me, but even then I knew that classical and medieval art had fulfilled itself to the utmost and that if the art of my time was to be alive, it would have to look to other means than the past.

Question: Am I right that your concern as an artist is more with the world around you than with yourself?

Gabo: Of course I look into myself and try to understand clearly my experiences, but my experiences definitely come from connections with the outside world.

Question: Are you at work now on any special project?

Gabo: Yes. I promised to show my students at Harvard University, where I taught for a time, what new ideas for architecture could be found in my sculpture and how they could be used practically. You see, these were architectural students—not art students. I've been working on this idea and the model for it for more than three years. It should be ready shortly. It incorporates many new ideas about design, form and structure.

GABO

1890 *Born, Briansk, Russia.*

1909 *Student in medical faculty at University of Munich.*

1912 *Engineering School, Munich.*

1912 *Walking trip, Italy.*

1914	*To Scandinavia at outbreak of war.*
1915	*Made first constructions.*
1917	*Returned to Russia, lived in Moscow.*
1920	*Along with his brother, Antoine Pevsner, wrote Realistic Manifesto.*
1922	*In Berlin.*
1926	*Made model for La Chatte, ballet for Diaghilev.*
1932	*Left Germany for Paris.*
1935	*First visit to England.*
1937	*Edited "Circle" with L. Martin and Ben Nicholson.*
1938	*Visited United States.*
1939	*At outbreak of war moved to Cornwall, England.*
1944	*Member of Design Research Unit. Commissioned to design car for Jowett Cars Ltd.*
1946	*Left England for United States.*
1952	*Became American citizen.*
1953	*Awarded second prize for monument to "Unknown Political Prisoner."*
1953–54	*Professor, Harvard University Graduate School of Architecture.*
1954	*Awarded Guggenheim Fellowship.*
1957	*Bijenkorf sculpture in Rotterdam completed.*

Since 1920 has had innumerable one-man exhibitions in Europe and the United States. Lives in Middlebury, Connecticut.

Question: I hear you're making sculptural constructions now. Are they related to your paintings? How did you happen to turn to this medium at this time?

Graves: They aren't related to the paintings except to the paintings of the last year—oils that I title New Icons. They followed the strange urge for scale that seems to have some importance right now. The sculptor John Flannagan once said, "There are monumental miniatures but there are also miniature monuments." Something has occurred to make scale become important. Rothko, for example, gives you something to inhale—an enormous inhalation. You expand to capacity breathing in his paintings; it's an expansive experience. Their scale doesn't specifically overwhelm, but one breathes differently in front of them. As for me, I began large-scale oils only to have the experience of spaciousness and physical scale.

Question: Can we reproduce one of these new works?

Graves: I'm honestly too involved in them right now. I'm in the process of them. You know, the painting paints itself. You can't run out and hail your friends to come in. You can't start photographing them when they're in process. You'd only intrude on an incomplete experience. I've painted on Japanese and Chinese paper for so long and found a delight in the fragility, the transiency of the material. If you see morning grass with a fabric of cobwebs holding dew, part of the delight is because it's fleeting. I've delighted in the use of Chinese and Japanese paper with some of that same feeling. Such materials are not as physically present as canvas and oil. Mid-twentieth-century scientific culture has produced the magic of space exploration and I had a need for the absolute opposite of fragility, a need to produce something that

47 *Spring with Machine Age Noise, No. 4, 1957*
Collection Dr. and Mrs. Edmundo Lassalle

would withstand the effect of nature for decades and decades and decades—something related to the magic side of our scientific culture that would endure under any circumstances in nature. So I turned to sculptural constructions of cast bronze and steel, marble, stone, glass, materials of our technological search—quite different from cobwebs and dew.

Question: Do you think that where you live influences your work? For instance, Ireland or Seattle?

Graves: This was true in the past, but no longer. In the past, what receptivity I had was, of course, responsive to what was available in my immediate environment. It sustained my thoughts as a painter. Now, I could be in Moscow, Tokyo, Rome, Seattle or New York and the demands of scientific culture would have their impact regardless of where I was. You see, years ago in Seattle I lived quite remotely in the country. It would have taken a long time for me to hear of, let's say, the space shots. Now, were I living in that same place, they would come into my experience immediately. You simply can't keep that world out any longer. Even Ireland is not a haven for a nature-romantic now. The result is I can no longer be a solitary romantic. Some friends regret it. They want me to remain a solitary—as a respite for themselves. They want to feel that everyone is not caught in the mad race, though I don't believe that what we've been caught in could really be called the mad race. Like everyone else I've been caught in our scientific culture. I thought when I went to Ireland in 1954 that it would be a haven for me; I was then reacting violently against the machine age. The machine age is now universal and that's what affected my state of mind. My earlier impulse was to recede, withdraw into nature and nature's quietude. It's no longer possible.

Question: Do you think you could stand living in New York or one of our large cities?

Graves: I don't know, but more and more I feel that I don't want to turn my back on our times. The city is a concentrated dose of it. A city is physically superenergized. Air travel is creating a city of our earth.

Question: What about your Noise paintings?

Graves: I've learned something from them. What I learned was that

I could do nothing about the quality of experience in our machine age but that I could do something about the quantity. I have learned that the noise of our machine age is not altogether negative and destructive. It's a dynamic experience in itself. I don't reject it; I don't embrace it totally. I can control the quantity in which I take it, but not the quality. I just couldn't live at Idlewild, but to be there to board a plane has a music and a miracle all its own.

Question: What medium do you prefer? Which do you find most sympathetic?

Graves: The medium I've grown to like best is leisure and doing nothing. I'm in turmoil continuously with that side of my nature that requires leaving a record of my desire for order and for communication. The urge to communicate in a tangible medium is all tied up with urges of personality, ego, ambition, economy and name-fame— all, after all, synonymous. Why do I keep the paintings I make and send them on to the New York gallery except for these reasons? Otherwise I'd be free to let my life be a trackless medium.

Question: Did your trips to Japan noticeably affect your work?

Graves: Yes, very much. I went as a merchant sailor. The Japanese had a culture centuries old that had had time to reflect their whole mind and spirit. You know, we couldn't say that was exactly true of the Pacific Northwest when I was growing up there. During my childhood in Seattle, nature was our museum, but Japan had an evident overlay of its aesthetic-spiritual life. For me, it was like a seventeen-year-old from the far West being suddenly set down in Paris. However, Japan was more potent than Europe for my kind of mind.

Question: Why?

Graves: Because my childhood had been spent in nature (that was my education in the far West) and the Japanese history of cultivating the mind and spirit (which is for us also religion and the arts) was a translation of nature refined by centuries of discrimination, so that all over Japan there was a record of this process—this essence.

Question: What artists do you particularly admire?

Graves: I admire all artists who let the painting paint itself. Thus there is no such thing as a secular "art." I include the four or five most honored impressionists, the artists of so-called primitive cultures and

48 *Spirit Bird Transporting Minnow from Stream to Stream, 1953*
The Metropolitan Museum of Art

the anonymous Sienese, Byzantine and Gothic artists. I like any work of art where conceit does not intrude, whether it's architecture, sculpture, painting, writing, music. Anonymity is a state of mind I very much respect.

Question: Then you're not after your own image?

Graves: What's wrong with being after one's own image in this sense is that our culture has taught us to individually coddle and own it. Almost any look into the record of man's activity, just under the surface, gives no emphasis to "I" and "Me." Take this Tlingit carving on your table—it's neither signed nor claimed. At the time it was carved it was the artist's contribution for the cultivating of his community. That's the only art you and I honor. And I know all of my work doesn't bear this out. Look at what the man does and don't bother with what he says and you'll know the man.

Question: Are you interested in Jung's writing? Have you been influenced by him?

Graves: I'm aware of Jung's writings but feel wary of reading them, because a painter can so easily acquire an overlay of personality that interrupts his being a part of precisely what Jung is exploring. Not being an intellectual, I haven't the quality of mind to not get lost under the spell of another individual's intellectual processes.

Question: Are you ever satisfied when you've finished a work?

Graves: No, but I rarely see it clearly until years later. But there are rare occasions when I come on one of my paintings unexpectedly in a museum or home and find something in it that delights me.

Question: I notice you work as a rule in series. Why?

Graves: Now as I look back over twenty-five years of work I realize that this is a trait. Somehow I feel things metamorphose. When I think of the Purification series, I realize that's what it was—the same idea, the same image presented with yet another aspect. Years ago I did a whole series of oils on an identical subject as a way of communicating the fact and the miracle of change—change—change. Yesterday I saw a painting of a Japanese poet-hermit looking at a waterfall. The waterfall is continuously a waterfall and continuously full of change. In my work there's often an identical subject—vision—idea, but it's always

a chimera. In the world of inner experience there are many facets. These reflect with variation one's consciousness. It's like this: you paint it—there it is almost; then you try again—there it is almost again. Science would like to freeze into facts what is apprehended as the "external" world, but it can't. I wish it could.

Question: Why?

Graves: Every religious system has as its central image and ultimate goal a single unchanging state—anything man has been able to search out as the ultimate aim of life is unchanging quietude, conclusion, rest, inalterable equilibrium, termination. That's why I say laughingly that I wish science could perform this.

Question: If you had to choose, what specific works of yours do you feel best express what you want to say?

Graves: I can't choose. We change from year to year. There's that chimera again. I can't go back and pick out any specific works. If I were required to repossess some of my works, I'd be able to pick out certain ones and those invariably would be paintings of ideas. I don't think I'd take back the ones that were records of experiences in nature. The nature ones fail, because when you are continually experiencing nature and then compare what you experience with what you've done, you can't help seeing the limitations in your work. But paintings of ideas continue to be ideas. And these ideas, of course, bear on the way we consciously direct our lives. Buddhism has a marvelous saying— very condensed, "Thought alone was, is, abides."

Question: Do you use preliminary sketches?

Graves: Rarely.

Question: Is your work symbolic?

Graves: I've used known symbols and discovered personal symbols. I have found that personal symbols come to be more than personal symbols. They become, after a while, meaningful to others. I have used the chalice [*Plate 50*] as an accepted universal symbol. You, Katharine, asked me about the meaning of my use of the "minnow" [*Plate 48*]. This is an example of a personal symbol that's become meaningful to others.

Question: Did you have any formal training?

50　*Moon Chalice, 1938　Collection Charles Laughton*

51 *Each Time You Carry Me This Way*, 1953
Collection Mr. and Mrs. James S. Schramm

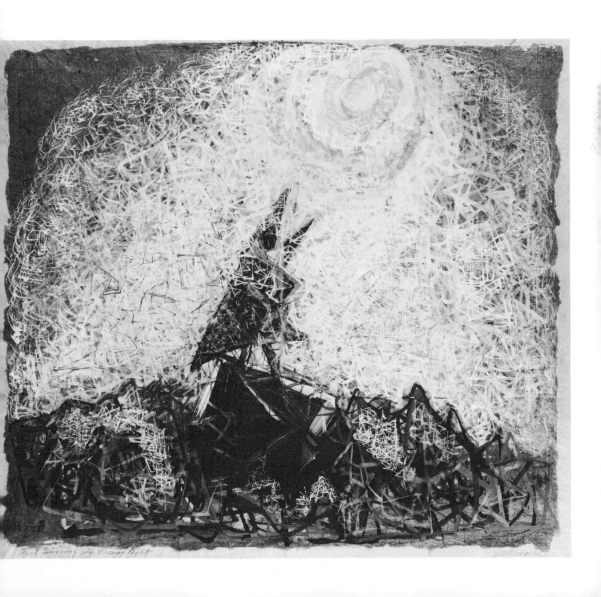

Graves: No, maybe I should say unfortunately, though, of course, teaching myself contributed something to my own processes of concentration. You had to keep discovering. You had to keep a focus. And, too, somebody else's point of view and technique weren't there to interrupt. The first artist who specifically influenced me was a man (for the moment I've forgotten his name) who painted murals at Yale. I saw them reproduced in color in an old *Century* magazine when I was about ten. (I've never seen the originals, though several times I've thought I'd visit Yale to see them.) There was something about the volume of these forms on a two-dimensional plane that impressed me greatly. For a long time it was this artist's vision-like spaciousness and color that affected me. It created a condition in my mind; I looked at things differently. Then, of course, one work of art grows from another. I see things in museums, and have all my life, that give insight, suggest ways to do. The technical act of painting primarily grows from other works of art.

Question: You've lived in Ireland on and off for seven years, but I notice that you scarcely mention its influence.

Graves: One takes one's images during childhood. My images were closer, as I told you before, to Chinese and Japanese attitudes about nature. European man somehow has an ability to tame the free spirit of nature.

Question: Is your work closer to meditation than action?

Graves: The act is a meditation in itself.

Question: What would you say you want most to communicate? What do you want to get across to others?

Graves: I want to get across to me. A brother of mine once said to me when he was doing some short stories, "Publishing is not my aim. Your aim is not an audience. Writing my short stories is like someone talking on the telephone and suddenly, unexpectedly, finding someone on the other end saying, 'I agree, that's marvelous, that's my experience, too.' " People occasionally say to the painter, "What you've said in the painting is my experience, too. I agree; it confirms me." That's the communication, but it's not the first aim.

Question: Then you're painting for yourself?

Graves: Painting is a way of knowledge. So are all the arts. That magnificent, ancient and enlightened civilization of India specifically names more than eighty Fine Arts—cooking, wheel-making, carpentry, gardening, love, weaning the child, et cetera. For them, these activities demand the discipline and concentration necessary to perform a work of art.

GRAVES

1910 *Born, Fox Valley, Oregon.*

1910–29 Lived Puget Sound region.

1928 *Seaman, American Mail Line to Tokyo, Shanghai, Hong Kong, Philippines, Hawaiian Islands.*

1930 *Cadet, American Mail Line. Two trips to Orient.*

1936 *One-man show, Seattle Art Museum.*

1936–37 Worked for Federal Art Project, Seattle.

1938 *Settled in town of La Conner, north of Seattle.*

1940–42 On staff, Seattle Art Museum.

1942 *Shown in exhibition "18 Americans from 9 States" at Museum of Modern Art. Inducted into Army. Shown at Phillips Memorial Gallery, Washington, in exhibition "3 Americans—Weber, Knaths, Graves."*

1943 *Returned to Seattle after discharge from Army. One-man shows, Arts Club of Chicago and Detroit Institute of Arts.*

1946–47 Guggenheim Fellowship.

1948 *One-man shows, San Francisco Palace of the Legion of Honor, Santa Barbara Museum, Los Angeles County Museum, Art Institute of Chicago.*

1954 *Moved to Ireland.*

1956 *Retrospective show at the Whitney Museum, Phillips Memorial Gallery, Boston Museum of Fine Arts, etc.*

Has traveled widely. Lives in County Dublin, Ireland.

HANS HOFMANN

Question: Do you consider yourself an abstract painter?

Hofmann: Basically I hate categorical labels. As a young artist I already was very clear about this—that "objectification" is not the final aim of art. For there are greater things than the object. The greatest thing is the human mind. I must insist that there is immense confusion in the attitudes that make art opinion. Now I have to state a terrible truth—that no one can give a correct explanation of what art really is.

There is definitely, however, an abstract art. Not everything that sails under the name "abstract" is actually abstract. The word's meaning is too loosely considered these days. What goes on in abstract art is the proclaiming of aesthetic principles. As time went on, in figurative painting the aesthetic basis of creation was almost completely lost. It is in our own time that we have become aware of pure aesthetic considerations. Art never can be imitation. But let's go further. Art is not only the eye; it is not the result of intellectual considerations. Art is strictly bound to inherent laws dictated by the medium in which it comes to expression. In other words, painting is painting, sculpture is sculpture, architecture is architecture. All these arts have their own intrinsic qualities.

I worked for a long time directly from nature, never with the intention of being imitative but of being creative. This consistent effort led me to certain discoveries which convinced me that art is sufficient unto itself, not on the basis of art for art's sake, but on the basis of a neoreality which has its foundations in the artist's direct relationship to his *medium.* In this way he is not dependent on exterior contacts with nature. For as I just said, painting is painting, sculpture is sculpture and architecture is architecture. The medium itself dictates the

way, but always, of course, depending on the sensibility of the individual artist.

Still, you must realize that there are no physical facts in a work of art. In the process of creation we deal only with *aesthetic* facts. These facts lie in the inherent nature of the medium. In painting it is color, line, planes, et cetera. And it is crucial how these factors are made dynamic—are enlivened by the sensitive faculties of the artist.

Question: Do your paintings reflect your own personal immediate moods and emotions?

Hofmann: My paintings are always images of my whole psychic make-up. You cannot deny yourself. You ask, am I painting myself? I'd be a swindler if I did otherwise. I'd be denying my existence as an artist. I've also been asked, what do you want to convey? And I say, nothing but my own nature. How can one paint anything else? You can't deny your nature, but as an artist neither can you be dependent on your daily moods, because once involved in your work you very quickly forget your troubles. Least of all can you think of yourself, for then it all becomes too personal. I can't understand how anyone is able to paint without optimism. Despite the general pessimistic attitude in the world today, I am nothing but an optimist.

Question: Has your work changed as you've grown older?

Hofmann: You have youth only once. Youth is replaced by wisdom, so figure out for yourself the results. I don't really think I've changed with age; when I analyze my nature I don't see great emotional changes. My work may seem freer, but for me, freedom is much mis-interpreted. Freedom really is the result of maturity, yet wisdom is the quintessence of maturity. I personally find my work constantly progressing.

Question: How do you title your paintings?

Hofmann: When I name a picture, the title comes from the feeling the painting suggests. I work constantly toward poetic suggestion and I choose the names for my paintings accordingly, but only after they are finished.

Question: Has coming to America changed your point of view?

Hofmann: When I came to America I presented myself not as a painter

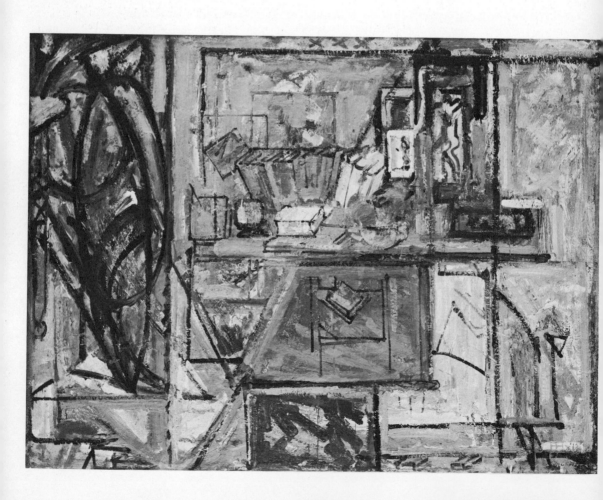

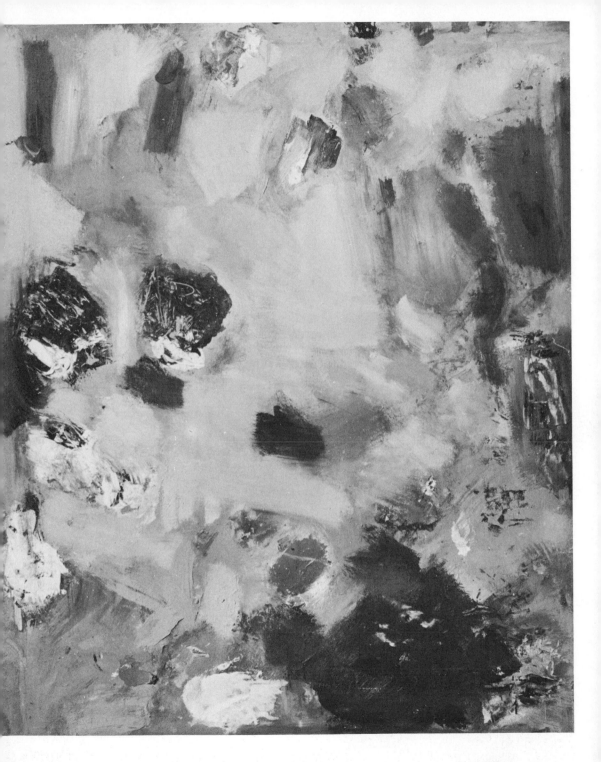

54 *Oracle, 1959*

of a certain style but through the fame of my Munich school. What greatly influenced my personal development was living in Paris for ten years in close contact with artists like Braque, Picasso and Delaunay. I remember a very nice episode at that time—there was a dance hall in Montmartre where some of the better known artists used to go and it was there that I first saw Léger. I was with Delaunay when he pointed Léger out to me and that was an obvious sign that Delaunay was already interested in him; this must have happened long before 1914.

Living in America has made a great difference in my attitude toward art in general and this naturally has reflected on my work. But nothing can really change me because everything is deeply rooted in myself. I can be objective about all outside happenings as I am objective about the nature of myself. You are born as you are and you cannot change yourself. There's something in one's nature that is unchangeable; wherever one goes, it is always the dominating factor. It doesn't make any difference where you live. I would be the same person anywhere. You are born with a certain kind of sensibility, in relation to which you constantly react. And today in this era of easy communication one is almost at home anywhere.

Today art has become international—almost too much so. Impressionism was really the first international modern movement and actually the first modern movement. Art has become international not just because of speeded-up communication and transportation but also because of a different aesthetic approach. What do I mean by "aesthetic"? I'll give you an example. Take a line. Now a line can have millions of variations—thin, thick, short, long, sinuous, staccato; but heretofore a line always represented something else. Today it is the line for itself, and that's what I mean by the aesthetic experience. The same is true of color—color as an expressive force in itself, as a language in itself. Both Kandinsky and Klee were among the first to realize this. In my work I have further tried to clarify the same idea. These examples of line, of color that I've mentioned are merely samples. The new outlook makes us understand that nature is not limited to the objects we see—but that everything in nature offers the possibility of creative transformation, depending of course on the sensibility of the artist.

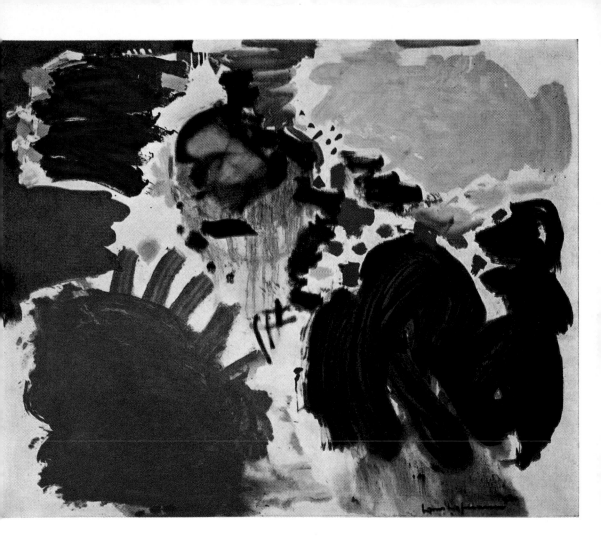

55 *Rising Sun, 1958*

Question: How do you feel about teaching art?

Hofmann: I don't think my long years of teaching have hurt my work too much. They have only taken up my time. I taught for so long—too long. You can teach art but you can't make an artist. People talk about academic training. I can only say that the word "academic" has had very little meaning in my artistic life. I understand as academic the pursuit of form in a limited objective sense. By this I mean merely a handling of pure physical form.

Question: What artists do you particularly admire?

Hofmann: Rembrandt in the first line. He's universal. In him you can find everything. Then there's Titian! I think of that painting by him in Munich. The Flagellation of Christ. When I was ten years old I already knew this picture. And I also love Rubens. Only in Munich and in Vienna can you see him fully. As an artist, you love everything of quality that came before you. In Venice the Tintorettos are fantastic, and I also admire the Italian primitives. Then there's Grünewald —he stands alone, but Rembrandt is even greater.

Question: How do you feel about drawing?

Hofmann: An artist who works nonfiguratively in an absolute sense is a man who doesn't care about drawing but cares about composition in a pictorial sense. A man who can draw often hasn't the slightest idea about composition. He considers composition an arrangement of definite figures and objects; exactly the opposite of what we today understand composition to be. I've made hundreds of drawings— really thousands—all of which were done in order to free me so that I could understand the meaning of composition, not in an imitative but in a real sense of pictorial creation.

Question: Does the accidental play a part in your work?

Hofmann: My work is not accidental and is not planned. The first red spot on a white canvas may at once suggest to me the meaning of "morning redness" and from there on I dream further with my color. You ask, do I make preliminary sketches? The answer is never.

Question: Have you worked much in watercolor?

Hofmann: Watercolor is a far easier medium than oil because it offers less resistance to one's artistic intentions. It dries very fast, and with it

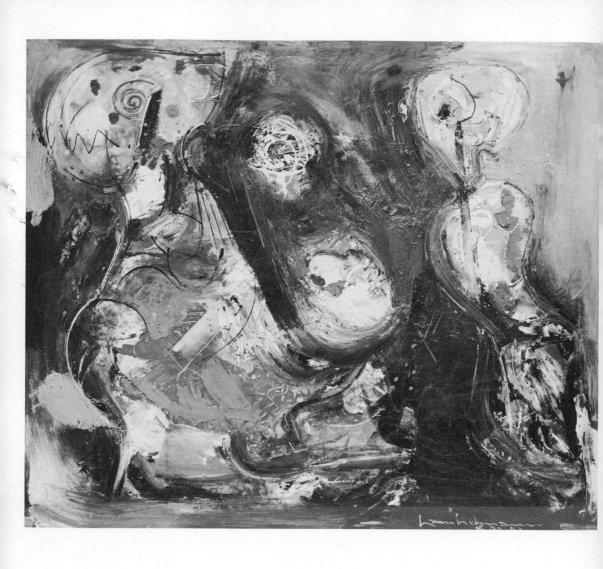

56　*Apparition, 1947*　**The Krannert Art Museum, University of Illinois, Urbana**

57　*St. Etienne's glorious light emanated by its windows, as remembered, 1960*
Collection Mr. and Mrs. Lee Ault

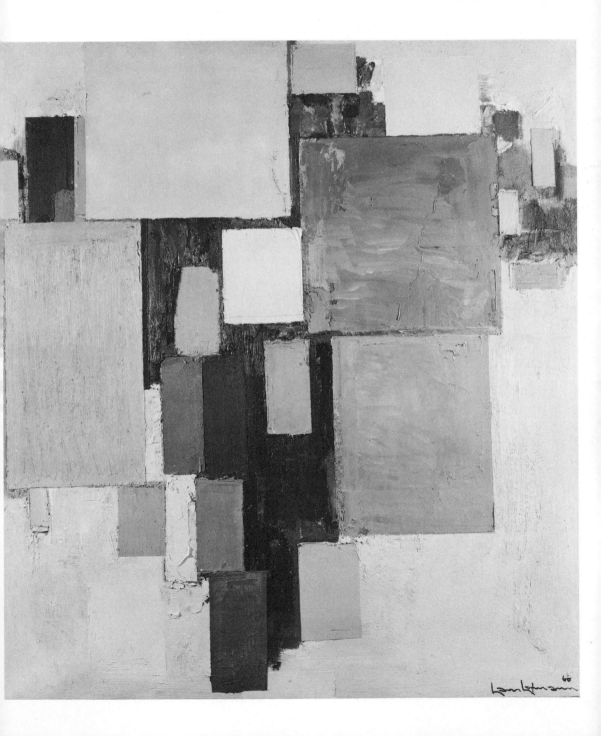

you don't have the trouble of handling a wet medium like oil. Still I paint more oils because watercolors can never achieve the powerful expression that oil has. And watercolor lacks the textural substance which oil provides.

Question: Do you prefer large to small canvases?

Hofmann: I always stretch my own canvases, glue them and prepare them in every way. It takes time but I simply cannot paint on commercial canvases. Nothing will come out. So you see, I've been working on a canvas for a long time before I start to paint it. Right now in my studio there are twenty canvases ready to paint. They're all large —five to eight feet. It's just that I take greater pleasure in working with big ones. But I still consider myself a miniature painter in comparison with Tintoretto.

Question: What would you say that you're really after?

Hofmann: My aim in painting as in art in general is to create pulsating, luminous and open surfaces that emanate a mystic light, determined exclusively through painterly development, and in accordance with my deepest insight into the experience of life and nature.

HOFMANN

1880 Born, Weissenberg, Germany.

1886 Moved with family to Munich.

1904–14 In Paris.

1915 Opened art school in Munich.

1924–29 Traveled in summers to Ragusa, Capri and St. Tropez.

1930 Taught summer school, University of California, Berkeley. Returned to Germany.

1931 Taught, Chouinard Art Institute, Los Angeles, and during summer, University of California, Berkeley.

1932–33 Taught, Art Students League, New York, and summer at Gloucester.

1933 Started own school in New York.

1934 Started summer school in Provincetown.

1941 Became an American citizen.

1944 *Retrospective exhibition, Arts Club of Chicago.*

1948 *Retrospective exhibition, Addison Gallery of American Art, Andover, Massachusetts.*

1955 *Retrospective exhibition, Bennington College, Vermont.*

1956 *Retrospective exhibition, Art Alliance, Philadelphia.*

1957 *Retrospective exhibition, Whitney Museum of American Art, New York. This exhibition traveled widely throughout the United States.*

1960 *One-man show and Honorable Mention, Biennale, Venice.*

Lives in New York City and Provincetown, Massachusetts.

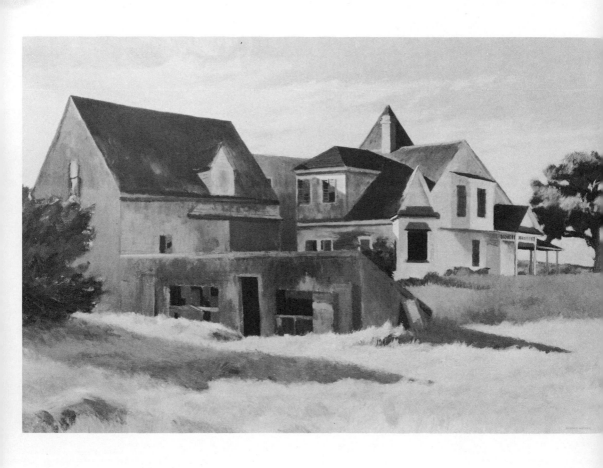

58 Cape Cod Afternoon, 1936 Carnegie Institute, Pittsburgh

EDWARD HOPPER

Question: At lunch the other day you suggested that a book dealing exclusively with the lives of artists would be valuable.

Hopper: I didn't mean that. I meant with their characters—whether weak or strong, whether emotional or cold—written by people very close to them. The man's the work. Something doesn't come out of nothing.

Question: You also mentioned that most of your paintings are not transcriptions of known scenes.

Hopper: Early Sunday Morning [*Plate 59*] was almost a literal translation of Seventh Avenue. Those houses are gone now. But most of my paintings are composites—not taken from any one scene. There was a canvas, though, I did on the Cape called Cape Cod Afternoon—just a house and shed done directly from nature. There have been a few others which were direct translations—but earlier.

Question: Do you make sketches first?

Hopper: Yes, usually pencil or crayon drawings. I never show these. They're more or less diagrams. I make preliminary drawings of different sections of a painting—then combine them. My watercolors are all done from nature—direct—out-of-doors and not made as sketches. I do very few these days; I prefer working in my studio. More of me comes out when I improvise. You see, the watercolors are quite factual. From the oils I eliminate more. It's an advantage to work in a medium that can take corrections and changes as oil paintings can.

Question: Does this mean you prefer to work slowly?

Hopper: I don't think that's the reason I do fewer watercolors. I think it's because the watercolors are done from nature and I don't work

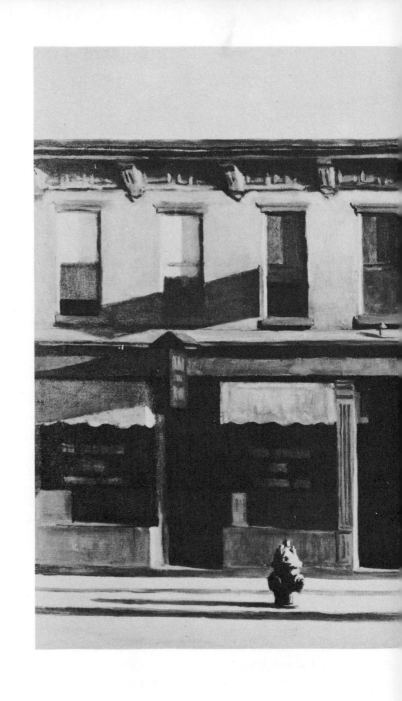

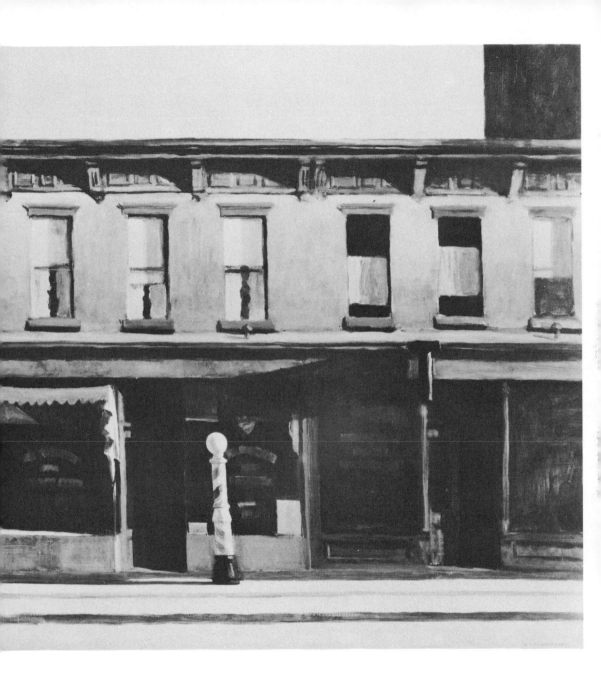

59 *Early Sunday Morning, 1930* *Whitney Museum of American Art*

from nature any more. I find I get more of myself by working in the studio.

Question: Which of your works do you prefer?

Hopper: Perhaps the latest picture I painted last summer—Second Story Sunlight [*Plate 60*]. It shows the top stories of two houses with an upper porch and two figures, a young and an older woman. I don't think there was really any idea of symbolism in the two figures. There might have been vaguely; certainly not obsessively so. I was more interested in the sunlight on the buildings and on the figures than in any symbolism. Jo [Mrs. Hopper] posed for both figures; she's always posed for everything.

Two other paintings I also like very much are Cape Cod Morning [*Plate 61*] and Nighthawks [*Plate 62*]. The latter was suggested by a restaurant on Greenwich Avenue where two streets meet. Nighthawks seems to be the way I think of a night street.

Question: Lonely and empty?

Hopper: I didn't see it as particularly lonely. I simplified the scene a great deal and made the restaurant bigger. Unconsciously, probably, I was painting the loneliness of a large city. I'm fond of Early Sunday Morning, too—but it wasn't necessarily Sunday. That word was tacked on later by someone else.

Question: What about Cape Cod Morning? Why did you particularly mention it?

Hopper: I think perhaps it comes nearer to what I feel than some of my other paintings. I don't believe it's important to know exactly what that is.

Question: Has living on Cape Cod in the summers affected your work?

Hopper: I don't think so. I chose to live there because it has a longer summer season. I like Maine very much, but it gets so cold in the fall. There's something soft about Cape Cod that doesn't appeal to me too much. But there's a beautiful light there—very luminous—perhaps because it's so far out to sea; an island almost.

Question: Do you feel your early trips to Europe influenced you?

Hopper: I really don't know. I did a lot of work there—paintings that will be shown some day, I suppose. They are in a high key, somewhat

like impressionism or a modified impressionism. I think I'm still an impressionist.

Question: Why?

Hopper: Maybe simplification has something to do with it. For me impressionism was the immediate impression. But I am most interested in the third dimension, of course. Some of the impressionists were too, you know. French painting, even when trivial and slight, is three-dimensional. Take Fragonard.

Question: What painters from the past do you admire?

Hopper: Rembrandt above all, and the etcher Meryon. His sunlight is romantic; there's absolutely the essence of sunlight in that etching of his called Turret in the Weavers Street. Rembrandt is tremendous. I also like Degas very much.

Question: What influences are strongest in your work?

Hopper: I've always turned to myself. I don't know if anyone has influenced me much.

Question: Do you feel your work is essentially American?

Hopper: I don't know. I don't think I ever tried to paint the American scene; I'm trying to paint myself. I don't see why I must have the American scene pinned on me. Eakins didn't have it pinned on him. Like most Americans I'm an amalgam of many races. Perhaps all of them influenced me—Dutch, French, possibly some Welsh. Hudson River Dutch—not Amsterdam Dutch.

Question: Whenever one reads about your work, it is always said that loneliness and nostalgia are your themes.

Hopper: If they are, it isn't at all conscious. I probably am a lonely one. As for nostalgia, that isn't conscious either. People find something in your work, put it into words and then it goes on forever. But why shouldn't there be nostalgia in art? I have no conscious themes.

Question: What do you mean by that? For instance, didn't you have a theme for Second Story Sunlight?

Hopper: This picture is an attempt to paint sunlight as white with almost no or no yellow pigment in the white. Any psychological idea will have to be supplied by the viewer. But to paint light was not my

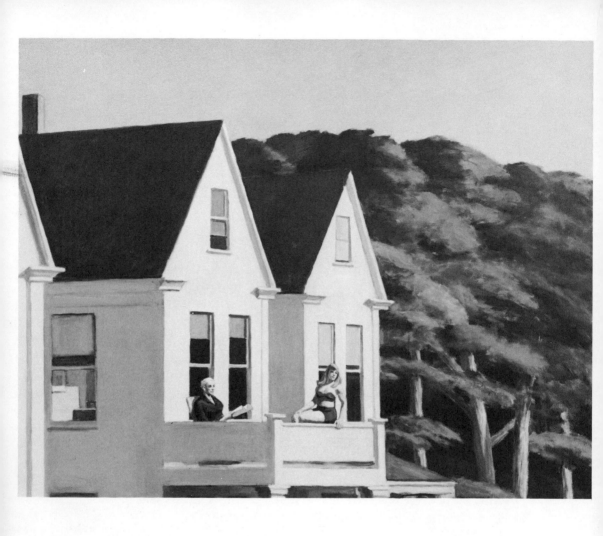

60 *Second Story Sunlight, 1960* *Whitney Museum of American Art*

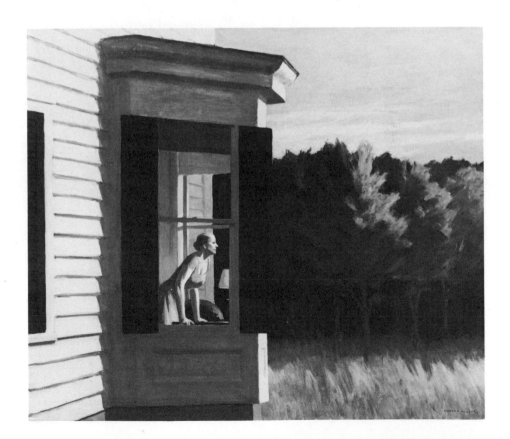

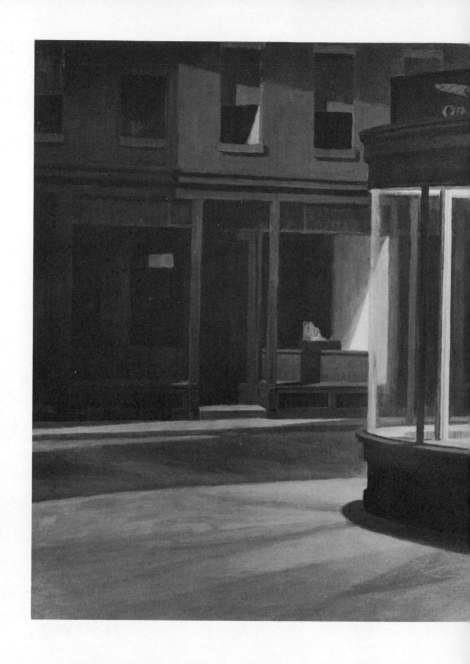

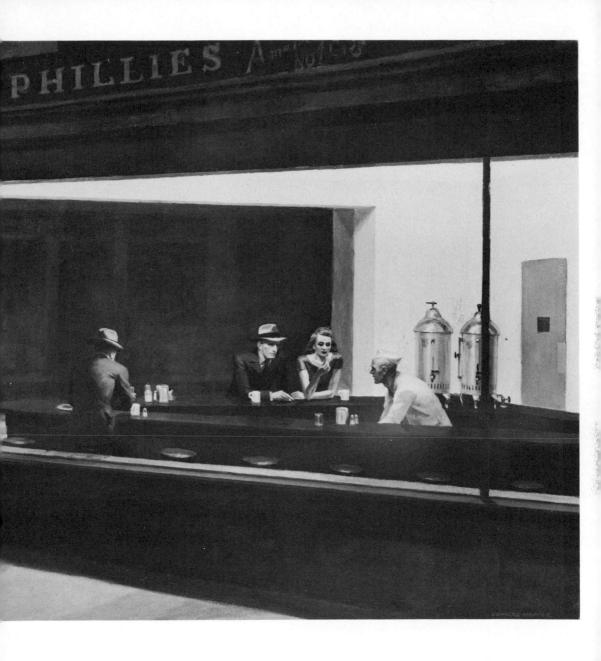

62　*Nighthawks, 1942*　*The Art Institute of Chicago*

initial impulse. I'm a realist and I react to natural phenomena. As a child I felt that the light on the upper part of a house was different than that on the lower part. There is a sort of elation about sunlight on the upper part of a house. You know, there are many thoughts, many impulses, that go into a picture—not just one. Light is an important expressive force for me, but not too consciously so. I think it is a natural expression for me.

I heard about a symposium in Provincetown last summer where a member of the "new academy" said that "it" just comes from the heart through the arms, through the fingertips, onto the canvas. Now some of it does comes from the heart, but it has to be amplified by cerebral invention. It's not as easy as just coming through the fingertips. It's a hard business. It's like everything else in art and life; it's hard.

Question: What made you turn from the figure to landscape and architecture?

Hopper: In art school you paint the figure because the model is there to work from. Afterward you're free to do what you want. Maybe I include figures sometimes because I feel it's a duty to "do" humanity. Though I studied with Robert Henri I was never a member of the Ash-Can School. You see, it had a sociological trend which didn't interest me.

Question: Is there any social content in your work?

Hopper: None whatsoever.

Question: What part does color play in your paintings?

Hopper: I know I'm not a colorist. I mean I'm not very much interested in color harmonies, though I enjoy them in nature. I'm more concerned with light than color.

Mrs. Hopper: You should be careful what you say about color.

Hopper: Why, because I might offend color? I don't think my work is colorless, but my color schemes are pretty simple and almost always the same. I don't think I have a formula. It's just that I use what happens to correspond to my sense of color. I'm sure I couldn't do in monochrome what I do in color.

Question: You said you were a realist.

Hopper: Yes I am. I guess the popular conception of a realist is one who imitates nature.

Question: What is your definition?

Hopper: I'm not sure. I feel Rembrandt was a realist but there's a great deal more than factual reporting in him. You know Renoir said the essential element in a painting cannot be explained. I hope I'm not a realist who imitates nature, though I'm very interested in the phenomena of nature. They are so far beyond what man can invent.

Question: What about texture?

Hopper: I try for certain kinds of texture. Trees have a different texture than houses or human flesh. But I think heavily painted brushstrokes are a by-product as they are with Rembrandt. I feel they are not necessary. Among more superficial painters, heavy impasto is not even involved with their end efforts, while with great artists like Rembrandt it's a logical by-product—not an end in itself.

Question: How do you finally choose the subject for a painting?

Hopper: Once I talked to Guy Pène du Bois about this. He used the word "inspiration." I said, "That's a terrible word." He said, "That's a fine word." Well, maybe there is such a thing as inspiration. Maybe it's the culmination of a thought process. But it's hard for me to decide what I want to paint. I go for months without finding it sometimes. It comes slowly, takes form; then invention comes in, unfortunately. I think so many paintings are purely invention—nothing comes from inside. You have to use invention, of course; nothing comes out without it. But there's a difference between invention and what comes from inside a painter.

Question: Has your work changed in the last twenty-five years?

Hopper: I think so. The paintings are less literal, perhaps.

Question: Do you paint to satisfy yourself or to communicate with others?

Hopper: I paint only for myself. I would like my work to communicate, but if it doesn't, that's all right too. I never think of the public when I paint—never.

Question: You say you are painting for yourself. Could you amplify?

Hopper: The whole answer is there on the canvas. I don't know how I could explain it any further.

HOPPER

1882 *Born, Nyack, New York.*

1899–1900 Moved to New York City. Studied illustration.

1900–24 Supported himself as illustrator.

1900–05 Studied with Robert Henri and Kenneth Hayes Miller.

1906–07 Paris. Painted in impressionist style.

1909–10 France and Spain.

1913 Exhibited in Armory Show. Sold his first canvas from this exhibition.

1915 Made first etchings.

1930 Since 1930 has lived in Truro on Cape Cod during summer.

1933 One-man exhibition at Museum of Modern Art, New York.

1937 One-man exhibition, Carnegie Institute, Pittsburgh.

1950 Retrospective exhibition at Whitney Museum, Boston Museum of Fine Arts and Detroit Institute of Arts.

1952 One-man exhibition, Biennale, Venice.

1955 Gold Medal, National Institute of Arts and Letters.
 Gold Medal, American Academy of Arts and Letters.

1960 Award, "Art in America."

Lives in New York City and Truro, Massachusetts.

FRANZ KLINE

Franz Kline died May 13, 1962

Question: Do you think that great artists have always been innovators?
Kline: Throughout the history of painting there have been great figures—usually innovators. In fact, all the greatest artists, I suppose, have been innovators. I've never consciously thought of myself as one. As to the contemporary artists I've been around—some of them have influenced me and I've influenced some of them. I realize that certain artists claim that being influenced detracts from their reputation. A painting doesn't have to look like another person's work to have been influenced by it. The average artist maturing around the age of forty, as I did, for instance (I had my first one-man show at Egan's gallery when I was that age), has been influenced by both the old masters and by his contemporaries. As for me, I've always liked Tintoretto, Goya, Velásquez and Rembrandt. Rembrandt's drawing is enough in itself! Then, too, people like Earl Kerkam have affected me; I've talked a lot about drawing with him. I think the reason his work hasn't caught on more is because he's always been so out-and-out honest about the artists he's been influenced by. He hasn't hidden them. If he liked Cézanne, he used Cézanne. He definitely believes in influences, but naturally he's not an imitator.
Question: Do you prefer Velásquez to El Greco?
Kline: Yes, I much prefer him. Talk about painting! With Velásquez there's a solidity—there's a lot more than that, but so much has been said about him you don't need my comments.
Question: Critics claim you've been influenced by Oriental calligraphy. Is there any truth in this?

Kline: No. I don't think of my work as calligraphic. Critics also describe Pollock and De Kooning as calligraphic artists, but calligraphy has nothing to do with us. It's interesting that the Oriental critics never say this. The Oriental idea of space is an infinite space; it is not painted space, and ours is. In the first place, calligraphy is writing, and I'm not writing. People sometimes think I take a white canvas and paint a black sign on it, but this is not true. I paint the white as well as the black, and the white is just as important. For instance, in this canvas we're looking at right now, you can see how I've painted out areas of black with my whites.

Question: What was your early training and has it affected your work?

Kline: I had an academic background—studied and drew from the model. I don't really know whether this is important or not. There's a lot of stuff you've learned that you've got to eliminate as you go along. I happen to like drawing. I can't very well estimate how much my training helped me. I suppose what you've really got to do is learn pretty much everything yourself. After all, what you finally do is a decision only you can make. If anyone had told me that at forty I would be painting only in black and white, I wouldn't have believed it. These things happen slowly.

Question: Is there any symbolism in your paintings?

Kline: There's imagery. Symbolism is a difficult idea. I'm not a symbolist. In other words, these are painting experiences. I don't decide in advance that I'm going to paint a definite experience, but in the act of painting, it becomes a genuine experience for me. It's not symbolism any more than it's calligraphy. I'm not painting bridge constructions, skyscrapers or laundry tickets. You know that people have been drawing and painting in black and white for centuries. The only real difference between my work and theirs is that they use a kind of metaphor growing out of subject matter. I don't paint objectively as they did in their period; I don't paint a given object—a figure or a table; I paint an organization that becomes a painting. If you look

at an abstraction, you can imagine that it's a head, a bridge, almost anything—but it's not these things that get me started on a painting.

Question: Why do you avoid direct imagery?

Kline: I don't know. I don't think it's conscious with me. If something happens to look like something tangible, this doesn't bother me —but I myself don't use real objects as models. I just don't work that way. It's not that I don't accept the method; I don't think there's any reason to say "no" to the figure or to the object, but it so happens that I haven't been working with definite figures or objects. I don't see how I could with the kind of painting I do.

Question: Does immediate mood affect you?

Kline: Sometimes I think it must, but not always.

Question: Some artists claim they are painting themselves. How about you?

Kline: I say, if that's me, I suppose, then, that's me. But this is pretty hard to answer. Who knows, but you certainly couldn't be painting somebody else, now, could you?

Question: Do you plan your compositions in advance or do you work directly?

Kline: I do both. I make preliminary drawings, other times I paint directly, other times I start a painting and then paint it out so that it becomes another painting or nothing at all. If a painting doesn't work, throw it out. When I work from preliminary sketches, I don't just enlarge these drawings, but plan my areas in a large painting by using small drawings for separate areas. I combine them in a final painting, often adding to or subtracting from the original sketches. When I work directly, I work fast. I suppose I work fast most of the time, but what goes into a painting isn't just done while you're painting. There are certain canvases here in my studio—the little one over there—that I've worked on for a good six months—painting most of it out and then painting it over and over again. I think I've got it now.

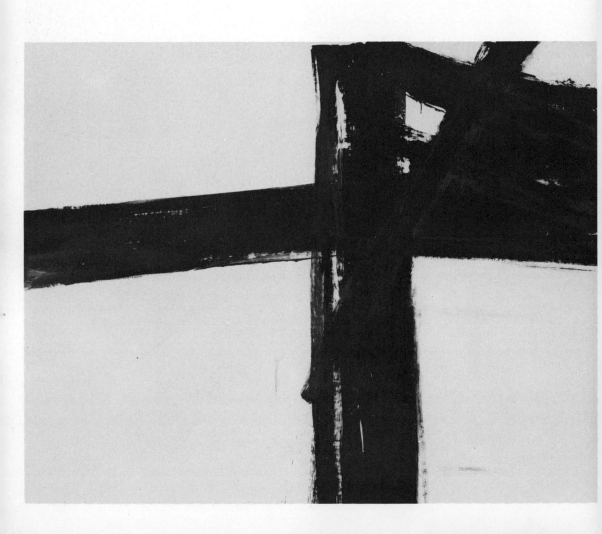

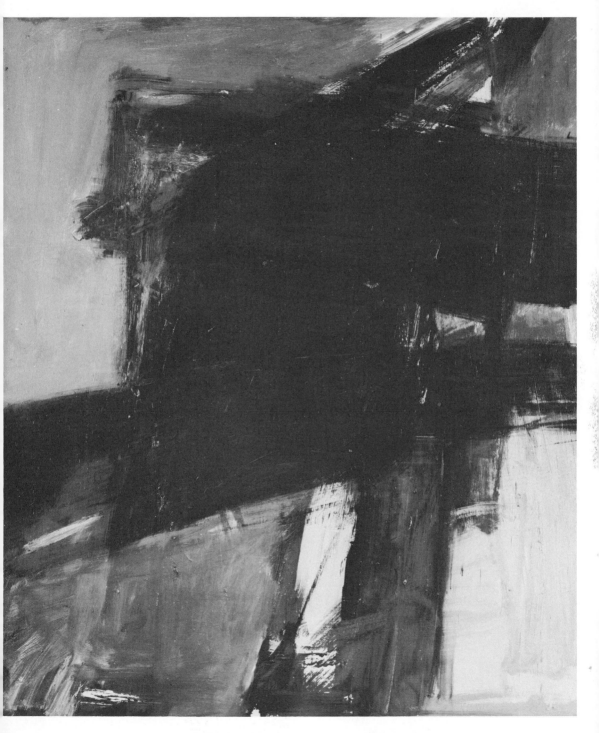

64 Dahlia, 1959 Collection Mr. and Mrs. David M. Solinger

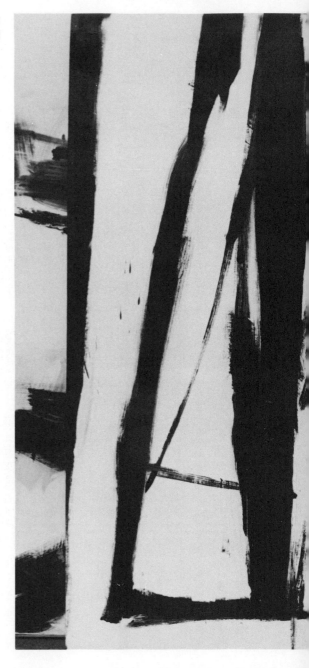

65 *Palladio, 1961*
Collection Philippe Dotremont

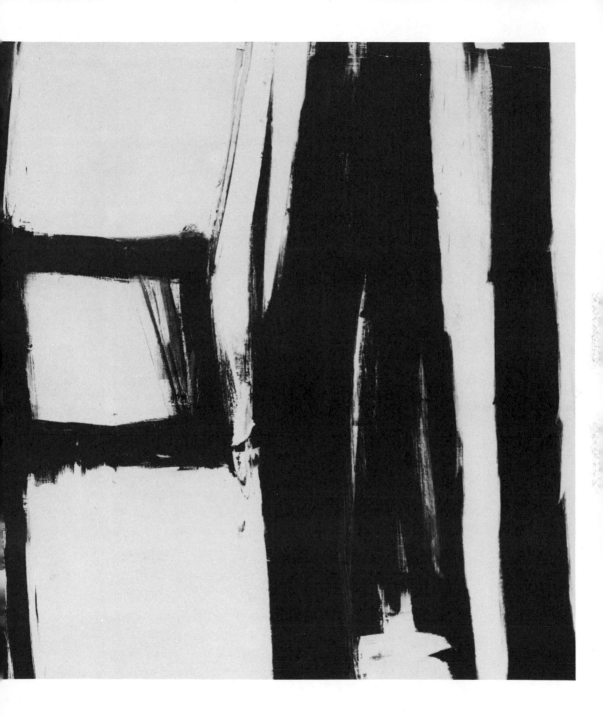

66 *1960 New Year Wall, Night*
Illustration on following pages

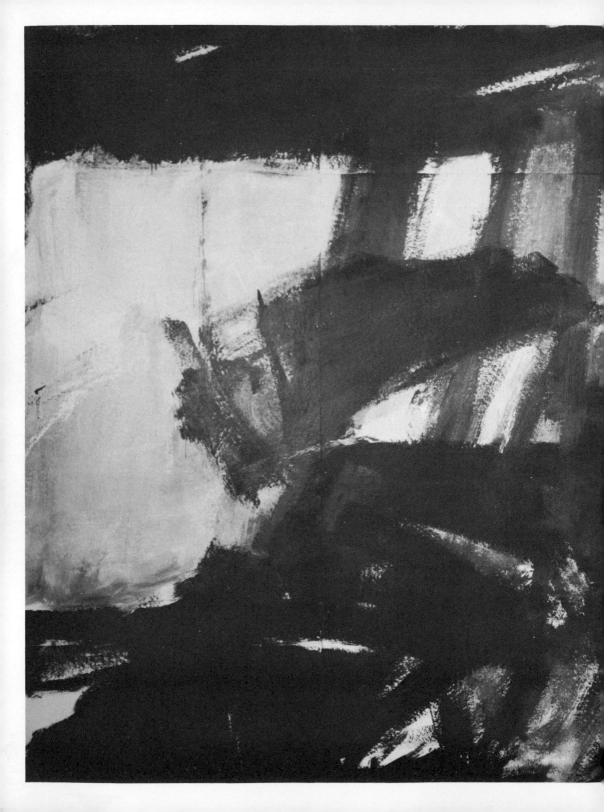

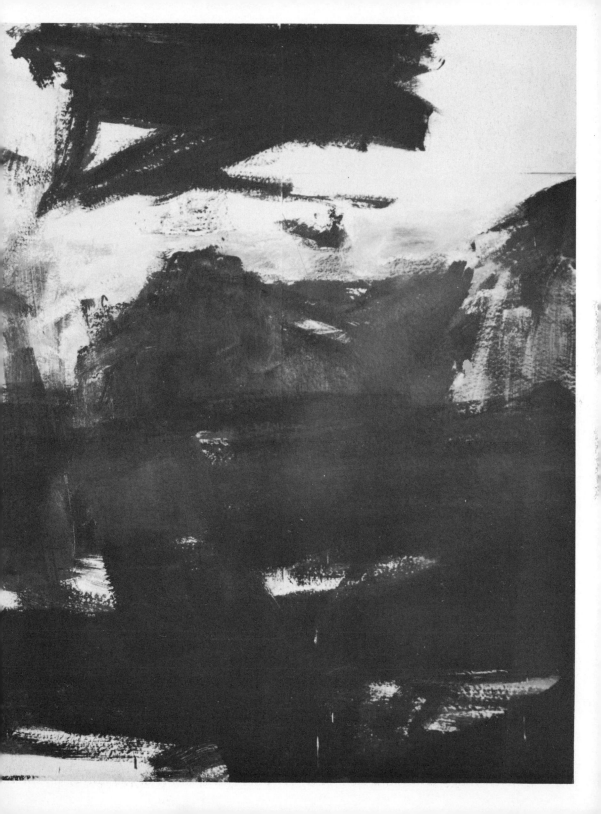

Question: Does size have anything to do with what you want to say?

Kline: I think the presence of a large painting is quite different from that of a small one. A small one can have as much scale, vigor, space, but I like to paint the large ones. There's an excitement about the larger areas, and I think you confront yourself much more with a big canvas. I don't exactly know why.

Question: Do you feel that the addition of color in recent years has changed your work?

Kline: I don't think of this as an addition. I don't think about adding color. I merely want to feel free to paint in color, or in black and white. I painted originally in color and finally arrived at black and white by painting the color out. Then I started with only color, white and no black—then color and black and white. I'm not necessarily after the same thing with these different combinations, for, though some people say that black and white is color, for me color is different. In other words, an area of strong blue or the interrelationship of two different colors is not the same thing as black and white. In using color, I never feel I want to add to or decorate a black and white painting. I simply want to feel free to work both ways. And because someone uses pink, yellow and red doesn't necessarily make him a colorist.

Question: Do you paint in series?

Kline: I don't paint in series but sometimes there are paintings that are similar, related visually more than in meaning or source. After you've thought of, let's say, four titles, that's about as much as you can think of, so when my paintings look somewhat alike I give them similar titles. Now take the paintings I've called Bethlehem [*Plate 63*]. You'll find quite a number of Pennsylvania titles among my pictures because I came from that part of the country. Sometimes it's just that I like the names—the words themselves. For instance, the painting I called Dahlia [*Plate 64*] doesn't have anything to do with a dahlia. The name "Bethlehem" has nothing to do with steel. Some pictures I don't even title, and if I do (as long as six months after they've been

painted) it's only for identification. Often titles refer to places I've been at about the time a picture was painted, like the composition I called Palladio [*Plate 65*]. It was done after I'd been to the Villa Malcontenta near Venice, but it didn't have a thing to do with Palladian architecture. I always name my paintings after I've painted them. For instance, the one called 1960 New Year Wall, Night [*Plate 66*], I painted on a studio wall made of Homosote around New Year's of 1960, and a lot of my paintings have night forms. This particular picture was done in four sections because it was so large—120 x 192 inches. I made innumerable small preparatory drawings for it.

Question: What's happened to the enclosed rectangle you used so much a few years ago?

Kline: The rectangular areas are still there if you look closely. It's just that my paintings have become looser, freer, I suppose, in recent years, so the edges are not always as clearly defined.

Question: How did you happen to go to art school in London in 1937?

Kline: My mother was English. I'd hoped to go to England and then on to study in Paris, but I never got to Paris at that time. As a matter of fact, last year was the first time I ever went to Paris or the Continent.

Question: Do you feel you are very much an American painter?

Kline: Yes, I think so. I can't imagine myself working very long in Europe or, for that matter, anywhere but New York. I find Chicago terrific, but I've been living in New York now for twenty-odd years and it seems to be where I belong.

KLINE

1910 *Born, Wilkes-Barre, Pennsylvania.*
Studied at Girard College, Philadelphia, Boston University and Heatherly's School, England.

1938 Settled in New York City.

1952 Taught, Black Mountain College, North Carolina.

1953 Taught, Pratt Institute, New York.

1954 Taught, Philadelphia Museum School.

1954 One-man show, Institute of Design, Chicago.

1960 One-man show, Biennale, Venice.

JACQUES LIPCHITZ

Question: Do you think that moving to America has influenced you?
Lipchitz: I came here after a tremendous catastrophe in Europe when I was completely worn out. There we were constantly waiting for death. I even carried poison in my pocket at all times. Coming to America was like a new life. I was particularly lucky because I came when I was fifty—at the beginning of my maturity—and I felt injected with youth. When I first saw the harbor of New York I was transported —it was tremendous—I can't explain it—like a bird. You know, I never traveled much before, never even to London, never to Italy. And I hadn't really wanted to come to America because I couldn't speak a word of English and I was afraid I'd find only skyscrapers here —no trees. But I was wrong. Coming gave me back my youth. I found a studio on Washington Square and I started to walk everywhere, day after day, looking—once going even as far as Nyack.

Of course, I was probably formed during my early years in Lithuania but it is to the French I owe everything. You know, I went there when I was eighteen, just out of high school. I feel I was born to life by my parents but I was born to light by France.
Question: Can you explain how your work has shifted from cubism to the freer forms of your later years?
Lipchitz: In my work you can find two streams—one, very planned, worked over and worked out; the other, lyrical and spontaneous. I have been a sculptor for fifty-two years and now as I look back on my work I can see that sometimes it expands, like a heart, and then deflates. When I work for a long period in one of these streams, I suddenly find myself pushed in the opposite direction. But each state nourishes and teaches me because I live through my sculpture. My life

experience is enriched by it and vice versa. For me life and sculpture are one. In that stream of my work which is carefully planned I use preliminary sketches in both clay and on paper, but I don't depend on sketches for my more spontaneous sculpture. About 1951 a friend of mine, a painter, and I were discussing the merits of sculpture and painting. (I personally love oil paintings but I have no talent whatsoever for this medium.) On my desk at that time was a chisel without a handle. My friend held it up and said, "Now that's a sculpture." "No," I said, "that could become a sculpture." I took a little plasticene and added to the chisel until it turned into a kind of figure. "Now it looks more like a sculpture," I said. I became so fascinated that I went to the foundry and ordered a number of wax casts of the chisel. Then I made a series of four variations on it and stopped. I'd had enough. Next came the fire in 1952 when everything in my studio burned, and the bronze foundry offered me space where I could work. At that time I experienced several other severe misfortunes; I had fallen, as it were, from my horse and I began to think that maybe all was finished with me. Then, in order to see what was really happening, I decided to take my creative temperature. I determined to go to the foundry each morning and every day to make a spontaneous sculpture from one of the leftover wax chisels. In twenty-six working days I made twenty-six sculptures. It was a cure. After that I was ready to go on—to go on to more planned work. Several years later, in 1956, a new expansion took place. I had just finished two monumental carefully worked-out pieces—the large Virgin for the chapel at Assy [*Plate 69*], and the sculpture for Fairmount Park in Philadelphia. Then again, I felt the need of nourishment and refreshment, so I began the semi-automatic sculptures [*Plate 70*] which are related to my more lyrical unconscious stream. In this stream, of course, I can work faster. Compare my cubist scupture [*Plate 71*], which was so highly planned that I even used blueprints sometimes.

Question: How do you feel about materials?

Lipchitz: I've been asked whether I prefer stone and bronze to wood and other materials. The answer is no. I'll tell you a little story. One day when I was in my studio on Twenty-third Street a lady came to

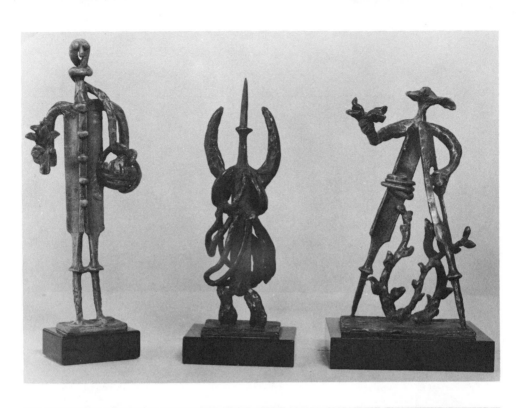

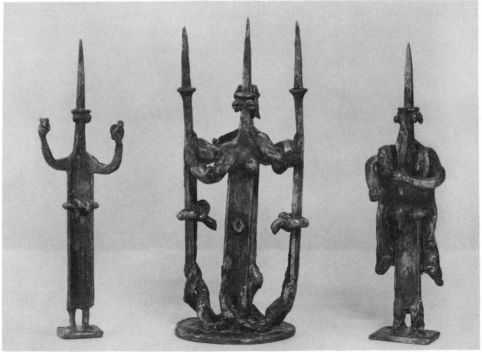

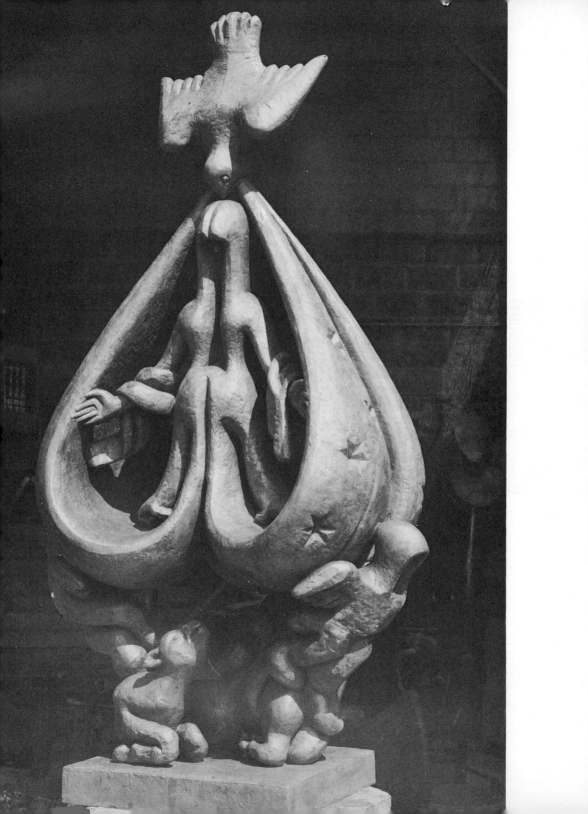

69 *The Virgin of Assy, 1953*

70 *Remembrance of Loie Fuller, 1955–1956*

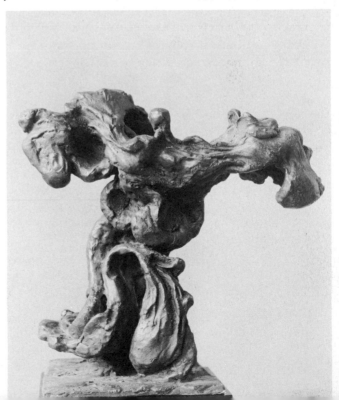

show me several samples of plastics, hoping that I would make a statement about the value of plastics as a material for sculpture. I told her, "Madam, I'm not interested in materials. Let's imagine that Rembrandt found himself on the street without paper, brush, pigment or ink and suddenly wanted to make a drawing. With only a white wall, a filthy gutter and his finger he was able to make a drawing that became pure gold—but you can imagine someone else putting his finger in pure gold and making a drawing that became pure dirt." Earlier I worked a lot in stone but my bursitis prevents this now. As always, no matter what happens, I try to turn everything, even adversity, into profit. And this ailment actually turned out to be providential, because stone takes too much time. The imagination works so fast that it is almost impossible to follow it in stone. I started then to use malleable materials. But no material is better than any other. You work with what you have and what you need. What is really important is the nature of the artist, not the nature of the material.

Question: What subjects interest you most?

Lipchitz: Though I'm a religious man born of an orthodox family, I left the orthodox religion because I couldn't understand it—I couldn't understand an orthodoxy which denies representation. After all, I'm a partisan of my own generation, a generation that believes representation is one of the important elements in a work of art. But still I'm a very religious man who believes in our Lord. When I was asked to make the great Virgin for Assy I was deeply interested. But I also enjoy mythological subjects. I try to bring mythology up to date—to make it reflect our own lives. As a matter of fact, I do this with much of my work. Have you seen the David and Goliath I made in 1933? [*Plate 72.*] I put a swastika on Goliath. Why? I suppose this was wishful thinking. People looked at the sculpture and said, "How can that little David destroy the huge Goliath?" And now you see what did happen. This sculpture was shown in Paris in 1933 and caused quite a furor. I had visualized it on an enormously high column, but unfortunately that never materialized.

Question: How do you feel about portraits?

Lipchitz: My approach to portraiture has always been different from

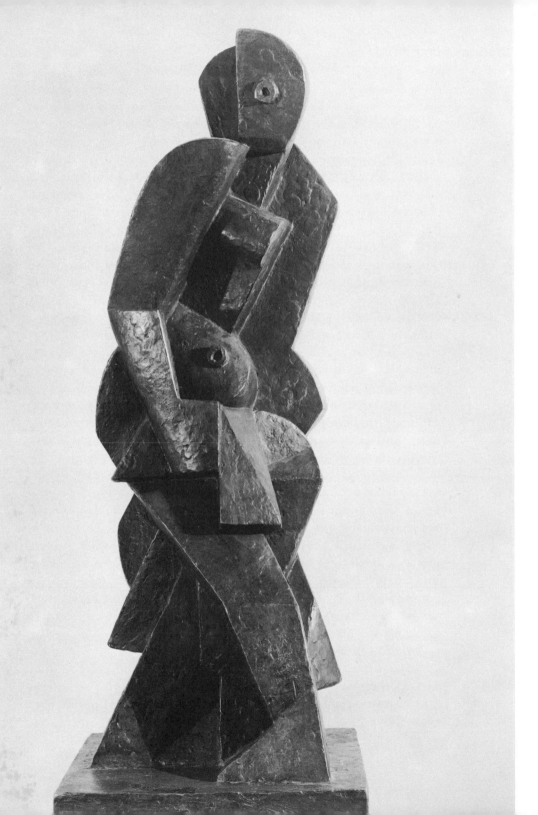

that of colleagues like Picasso and Gris. I talked to both of them at length about this. For me, a portrait is a special thing that is not only a work of art but also has to do with psychology. Making a portrait is like getting married—you need to be nervously connected with your sitter. Sometimes it works; sometimes it doesn't click, again just like a marriage. I feel strongly that the real aspect of the sitter cannot be eliminated from portraiture. When I was doing Gertrude Stein's portrait (you know, she didn't like sculpture at all) we had many conflicts. The first one I did of her in 1920–21 looked like a Buddha [*Plate 73*] but later in 1938 when I made another she had become so shrunken that she seemed like an old rabbi [*Plate 74*]. Also, from a death mask I did two portrait sketches of Géricault [*Plate 75*], an artist I deeply admire. For me, he is the extract of a genius. From his death mask came the features and bone structure—the rest is my admiration, my enthusiasm for him. I agreed to make a portrait of Senator Robert Taft [*Plate 76*] after he died because I was told he had been very influential in helping to establish Israel and I was deeply moved.

Question: What influences, if any, have been strongest in your work?

Lipchitz: I've been influenced by everybody who lived before me, but the painters I particularly love are El Greco and Cézanne. Cézanne was the greatest of them all because he happens to be the latest in the long mainstream of art. He was a tremendous culmination. People say cubism started with Picasso, and of course Picasso is a very great figure, but cubism really started with Cézanne. For me, Gauguin is the announcer of new times—of a new cycle. Have you ever wondered why Gauguin felt impelled to live with primitive people? He was driven by some need within himself, and it was he who has led us forward to primitive people. I admire him more for this than for his painting. I also admire van Gogh, a real genius, but I'd take one square inch of Cézanne for all of van Gogh. At heart I'm moved by Cézanne's kind of spiritual majesty.

Question: Tell me about your work as a cubist.

Lipchitz: I feel that as a cubist I was the Benjamin of my generation. You see, I'm ten years younger than Picasso and most of the others. Our generation felt one must look for the elements of art in one's

own imagination. I don't think the cubists were influenced by Negro art as so many people claim. That's a different thing. True, we shook hands with Negro art, but this was not an influence—merely an encounter. Some superficial artists were, of course, completely influenced by African forms—but not the real cubists who worked with elements from their own imaginations. People don't understand cubism. They constantly talk about the straight line but this was only a human reaction to *art nouveau*—an announcement that this movement was drawing to an end. The straight line was just the beginning, for cubism was a point of view about life, about the universe. I consider that I'm still a cubist.

When I was in school my teachers told me to work from nature. I came to the conclusion that the basis of a work of art is one's point of view about life and the universe. What was the point of view of a Greek? Even his gods were human beings—earthly. But now look at a Virgin on Chartres Cathedral. The Catholic religion teaches that life is a valley of tears and the body a nest of sins. So we conclude that the real life we seek is not here, and thus art seems to teach us to leave the earth and ascend to the sky—the body just doesn't exist. It turns into an elongated column. I have the impression that during this century humanity has reached a kind of adolescence; we've started to fly with our own wings, but adolescence is not maturity. That's why I call myself the optimistic cubist (*le cubiste optimiste*). We cubists chose a man-made language rather than a naturalistic one, for we wanted to find a new language to fit adequately our feelings. Cubism is less attached to Mother Nature; it is more a pure invention of human imagination.

Question: What kind of invention?

Lipchitz: When you observe nature and when you observe what human beings fabricate, you see a great difference. One summer I was in Auvergne and while on a sketching trip I got lost in the mountains. Night came; I was worried and started running around looking for a way back. Then suddenly I saw a little shack and felt at home. This was a revelation to me. You ask, what is a shack compared to a mountain, but at that moment it was more for me. The shack was home; it was

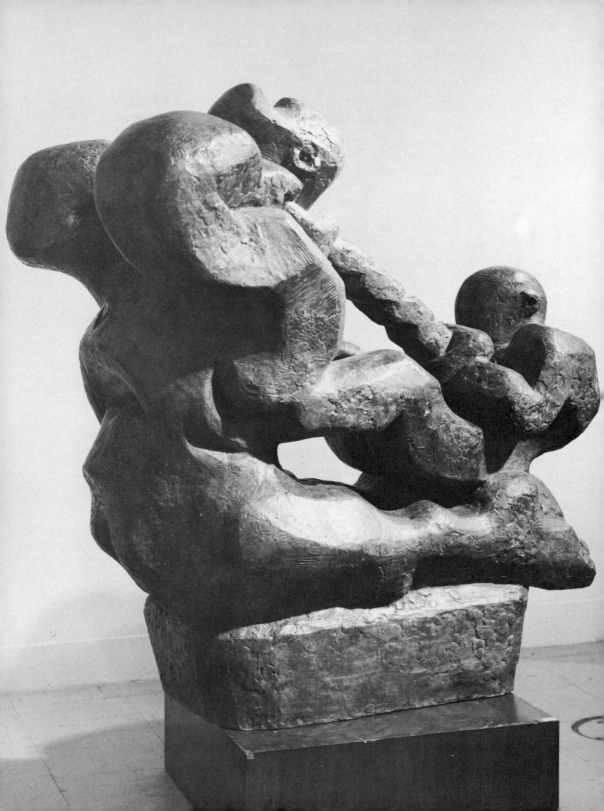

72 *David and Goliath, 1933*

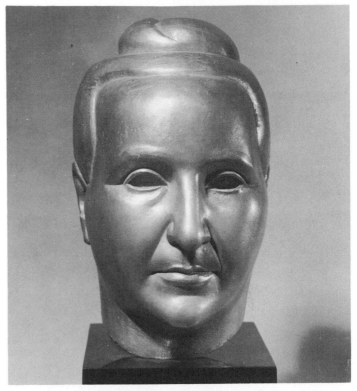

73 *Portrait of Gertrude Stein, 1920*

74 *Portrait of Gertrude Stein, 1938*

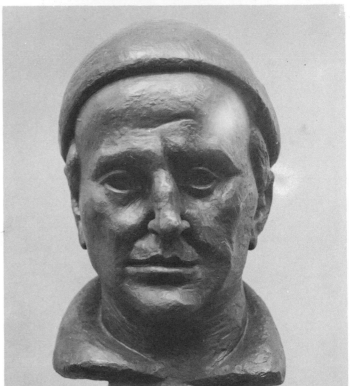

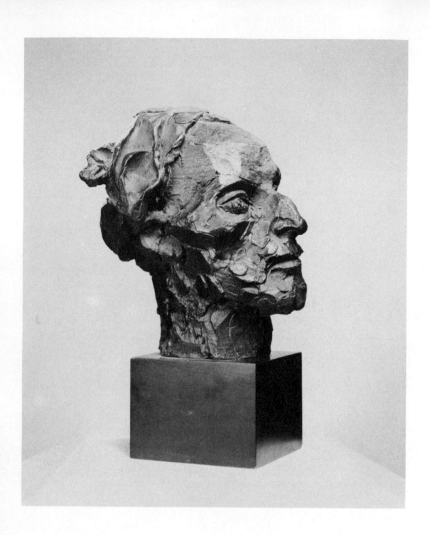

75 *Portrait of Géricault, 1934*

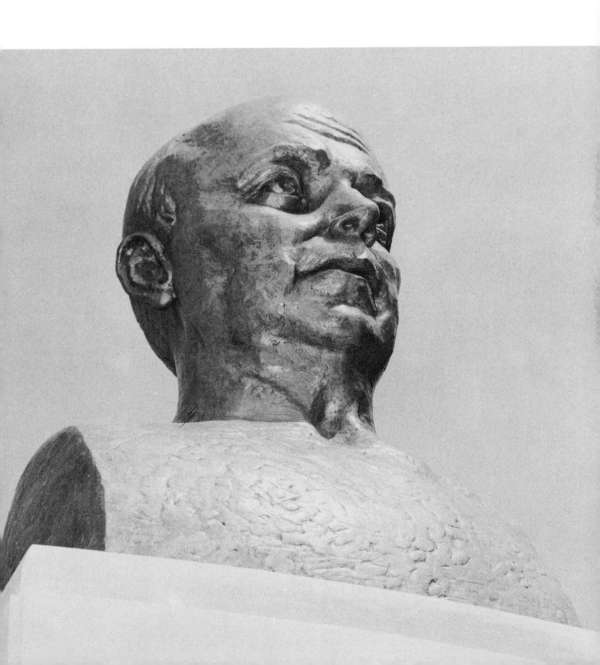

safety; it was my language; it was made by man. The cubists chose a human language.

Question: Why do you say you are still a cubist?

Lipchitz: For me, any artist who works with the elements of his imagination is a cubist. I don't think of the term as meaning orthodox cubism, or of the cubism we connect with works from 1910 to 1920. Cubism is really a point of view that has opened up greater possibilities for artists to use their imaginations.

Question: Why are you so interested in primitive art?

Lipchitz: We need to look for a universal language. Everyone likes his own gravy because he's accustomed to it. If you're on the first floor, it's hard to communicate with people on the second floor. How sad! Now take me—I live more easily with primitive art. I wonder why today we are so attracted by the primitive and by all "beginnings." Is it because we ourselves are in the beginning of a new cycle? When you ask me what kind of cycle, how can I know? A newborn child—what will he turn into? I'm not a prophet, but the "new frontiers" are coming, even in politics.

We're apt to look for simplicity in art, but why should we when life is so complicated? It's not this mechanistic age of ours that I admire but the human spirit which makes it possible. For instance, when human beings invented the wheel, which is really just a synthetic form of walking, the road was already opened to the automobile and then it was only a matter of time until the next invention. But what's important is the spirit of man that invented the wheel and the automobile—not the wheel and not the automobile themselves.

Question: How do you feel about non-objective art?

Lipchitz: I'm opposed to non-objective art because I think it leads to a dead end. Maybe I'm too old to listen to this new music. Maybe it's right, but not for me. As I said before, I belong to a generation that considers the representation of nature as one of the main elements in a work of art. For me, a non-objective work is only the beginning. Art is always a revelation and a clarification because life appears chaotic. I find a non-objective work as chaotic as life itself. And so it doesn't operate, it doesn't work, no matter how gifted the artist who

produced it. Art must illuminate life, must clarify it, like a decanting process.

Question: What are you after next?

Lipchitz: I'm happy to be my age—but not to go back. I'd like to live a long time—as long as possible; I still have so much to do. I might even become a good sculptor. People claim that I have been a pathfinder. I was so busy doing just this that I didn't always find time to caress my findings. I was pushing on—on. Now I'd like to stop and make a summary of all my work.

LIPCHITZ

1891 Born, Druskieniki, Lithuania.

1909–10 Studied, Ecole des Beaux Arts and Académie Julien, Paris.

1911 Developed tuberculosis. Recuperated in Belgium.

1912–13 In Russia.

1913 In Paris.

1914 In Majorca with Diego Rivera and Marie Blanchard. Also in Madrid.

1915–40 In Paris.

1924 Became French citizen.

1930 100 works exhibited at Galerie de la Renaissance, Paris.

1935 First large American exhibition, Brummer Gallery, New York.

1938 Exhibition, Petit Palais, Paris.

1940 Left France for New York.

1946–47 In Paris.

1947 Moved to Hastings-on-Hudson, New York.

1950 Major exhibition, Portland (Oregon) Art Museum, San Francisco Art Museum and other American museums.

1952 One-man show, Biennale, Venice.

1954 Retrospective exhibition, Museum of Modern Art, New York, Minneapolis and Cleveland.

1958–59 Large retrospective exhibition shown in main museums all over Europe.

1960 *Retrospective exhibition, Corcoran Gallery, Washington, D.C., and Baltimore Museum.*

1961 *Retrospective exhibition—"Fifty Years of Lipchitz Sculpture," Otto Gerson Gallery, New York.*

Lives in Hastings-on-Hudson, New York.

ISAMU NOGUCHI

Question: What made you the kind of artist you are?
Noguchi: Primarily, what we carry around with us is a memory of our childhood, back when each day held the magic of discovering the world. I was very fortunate to have spent my early childhood in Japan. I don't mean to belittle other places, but one is much more aware of nature in Japan—not a vast panorama of nature but its details: an insect, a leaf, a flower. Nature is very close, a foot away. Then later I came to America at the age of thirteen, carrying a suitcase full of carpenter's tools on my way to high school in Indiana—and so I got the feeling of America superimposed on the old Japanese. It was a view of nature which was quite different. Here nature is appreciated for its vastness, its sweep, the panorama of that open Indiana country-side. . . .

My mother was probably my strongest influence. She was a Bryn Mawr graduate who was teaching English literature in Japan. I re-member that when I was about five years old I made a sculpture of a wave; it was much talked about in kindergarten and my mother never forgot it. She kept hoping I would eventually become an artist. When I was about ten she apprenticed me to a Japanese cabinetmaker who instilled in me a great feeling for materials and the use of tools—the use of the clean one-cut instead of the dirty two-cuts. This appreci-ation of materials and tools was further enhanced in my case by Brancusi, when I received a Guggenheim Fellowship in 1927 and went to Paris to work with him. He had the same kind of love for material, the pristine, original, basic material. It was the wood itself and its contact with the chisel that he liked—not something faked up, painted, or ill-treated. With metal it wasn't some sort of patina he

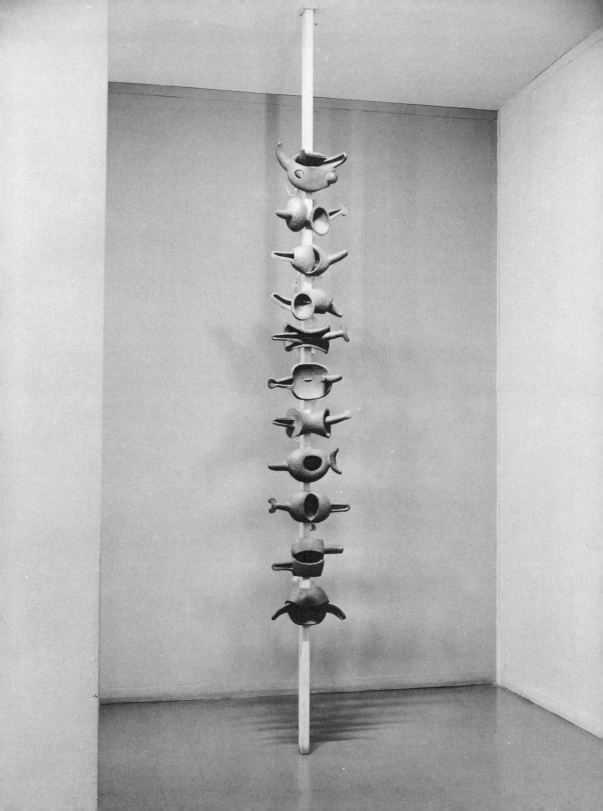

was after, or something applied with acids. He wanted to scrape away all the excrescences on the surface and get back to the original nudity of the metal itself—which for him was polished metal, of course. I too have a distrust of pictorial qualities in sculpture, of those eroded, decayed surfaces one associates with painting. What Brancusi does with a bird or the Japanese do with a garden is to take the essence of nature and distill it—just as a poet does. And that's what I'm interested in—the poetic translation.

For instance, once a few years ago when I was living in Japan our house was filled with centipedes. I became rather fond of them; I lost my fear. You know, when you kill a centipede, the two halves just walk off. This gave me the idea for the Centipede at the Museum of Modern Art, a sculpture in sections, each a separate thing, though in actual fact the individual ceramics are tied onto a two-by-four. What happens is that your eye jumps from one image to the other and your subconscious supplies the connection. I also liked the rather quixotic notion of dignifying the centipede by making a sculpture of him— thus indicating that the centipede can aspire to humanity, or even to God. The work is a shrine to the centipede. Or rather the centipede is now enshrined at the Museum of Modern Art.

Question: What more did you learn from Brancusi?

Noguchi: One of the most important things I learned from him was the immediate value of the moment. I remember he used to say: "Never make things as studies to be thrown away. Never think you are going to be further along than you *are*—because you are as good as you ever will be at the *moment*. That which you *do* is the thing." But at the end of his life he was changed—impatient and bitter, as a god must be. I suppose old age and the incapacity to work, to express himself, was part of the trouble. The last time I saw him before his death he had a stainless steel circular disk (for his Fish) made in Germany. No one in Paris could do it properly. It came back machine-ground and polished, but he was quite unhappy with it and decided to do the whole thing over by hand. Of course, you do feel the perfection in his work. I personally wouldn't go so far. I'm a perfectionist too, of course, but not that much and in a different way.

Question: Are you talking about technique?

Noguchi: Not exactly. I'm always looking for a new solution. I'm not interested in producing things I've done before. I've heard it said I'm something of a technician, but I'm not, really. I'm more interested in *what* I'm *expressing* than how I express it. If I became too involved with how, the work would become separated from the fundamental question of art—which for me is the *meaning* of a thing, the evocative essence which moves us.

Question: But isn't meaning revealed by execution?

Noguchi: That's true, too. You need technique to express what you have to say. But I'm afraid of technique getting in the way—that is to say, if you have too facile a technique, then you express only those things which the technique permits you to express. You find yourself limited—to spiky forms, for example, or soft things. But what is the point of soft without hard, or weight without lightness? In Japan the philosophy of the relative value of things is carried so far that in ceremonial tea-making there's a little cloth they use, which they handle as if it were the weightiest thing in the world. Light things are handled as if they're heavy, heavy things as if they're weightless—in this way one finds an almost complete control over nature instead of being dominated by it.

Question: What did you have in mind when you made the sculpture Kouros at the Metropolitan? [*Plate 78.*]

Noguchi: At the time I was carving Kouros I was working with thin sheet material. First I started with metal, then wood, and later slate and marble. What I like about working with slate and stone is the quality of the material itself. A minimum of the material is necessary, and you can use the space in between. The structure of Kouros defies gravity, defies time in a sense. The very fragility gives a thrill; the danger excites. It's like life—you can lose it at any moment. . . . You think, oh my God, it's going to go any minute.

Question: Did you make sketches for it?

Noguchi: Yes. I made drawings and then models—in this case, paper models. You have to consider the weight of the material, the forces that conspire to hold up the figure—engineering problems, essentially.

Everything I do has an element of engineering in it—particularly since I dislike gluing parts together or taking advantage of something that is not inherent in the material. I'm leery of welding or pasting. It implies taking an unfair advantage of nature. In Kouros there are no adhesives of any kind—only the stones holding themselves together.

Question: Does Kouros represent a human figure?

Noguchi: Yes. A purely cold abstraction doesn't interest me too much. Art has to have some kind of humanly touching and memorable quality. It has to recall something which moves a person—a recollection, a recognition of his loneliness, or tragedy, or whatever is at the root of his recollection. In the case of Kouros, I was after the effigy of man. I've always been interested in Greek art, in which the image of Kouros, the Apollonian figure, is one of the basic and standard forms.

Question: Why did you depart so far from the human figure?

Noguchi: It's the privilege of the artist to make his own translation, his own distillation of what moves him. I try to say what I *have* to say—in sculpture, not in words. I suppose what really moves me is trying to put down, to find my own image, in a search tied up with a lot of infantile memories. That Humpty Dumpty [*Plate 79*] of mine in the Whitney Museum, for instance, and the Centipede. And other things that happen at night, somber things. I think of that table I made. I call it Night Voyage [*Plate 80*]. It's an image of people in bed.

Question: Really? I thought it was a landscape.

Noguchi: It is a landscape in the sense that you can think of people as landscapes—a human landscape. Of course, there's bound to be much diversity in setting down your own image. There are many sides of me I want to express—the loneliness, the sadness, and then something about me which you might call precise and dry that I want to express as well. I wouldn't want to express only my serious side —I'm also playful sometimes—and then again completely introspective.

Question: Is there any relation between your moods and the materials you prefer?

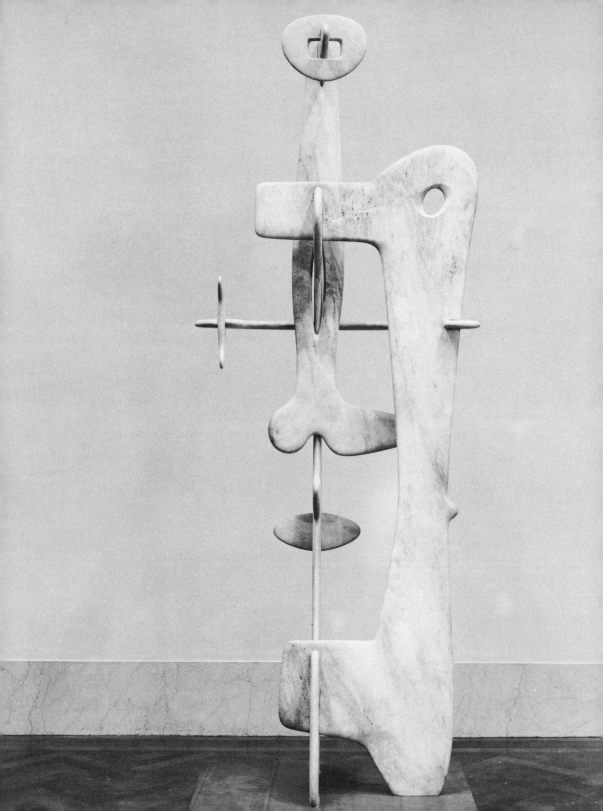

79 Humpty Dumpty, 1946 Whitney Museum of American Art

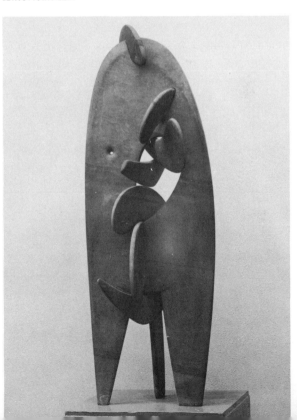

Noguchi: I always work with whatever medium is at hand. I don't believe in sticking to one medium. I'm afraid of its dominating me and becoming my trademark. If I'm in a place where there's clay but no wood, I work with clay. I have no personal technical method or set of tools without which I cannot work; but, of course, I am influenced by the material to the extent that when I work in heavy granite, I become heavy in thought and emotion; I don't think of flying. Now take a Japanese garden [*Plate 81*]—like the one I made for UNESCO in Paris. The Japanese, you know, think of rocks as the bones of a garden—the plants simply come and go. For me a garden is a highly sculptural affair, this three-dimensional arrangement of forms and shapes in a sculptural group. Contrary to most Japanese gardens, the UNESCO garden is intended to be walked in. The vista constantly changes and, everything being relative, things suddenly loom up in scale as others diminish. The real purpose of the garden may be this contemplation of the relative in space, time, and life.

Question: What about the bridges you made in Japan?

Noguchi: They came about, you might say, from a sense of guilt. As an American, and as a Japanese, too, returning there for the first time after the war, Hiroshima meant something to me. I had suggested doing a bell tower filled with bells from all over the world. Then Kenzo Tange, who was at that time doing one of the islands in the Peace Park, suggested that I design two approach bridges. The one that looks like a skeletal boat derives from the idea of Egyptian boats for the dead—for departing, as we all must. The other, with its end round like a globe, or sun, I call by the Japanese word "to live" [*Plate 82*]. Both were made of reinforced concrete, as is true of all postwar construction in Japan. The beautiful granite of Hiroshima was pulverized by the blast and only concrete endures—as if *that* is any consolation.

Question: To what do you attribute the enormous influence the Orient has recently had on our art and architecture?

Noguchi: In this country we appreciate doing more with less, and that is one of the appealing things about Japan—a compensation the

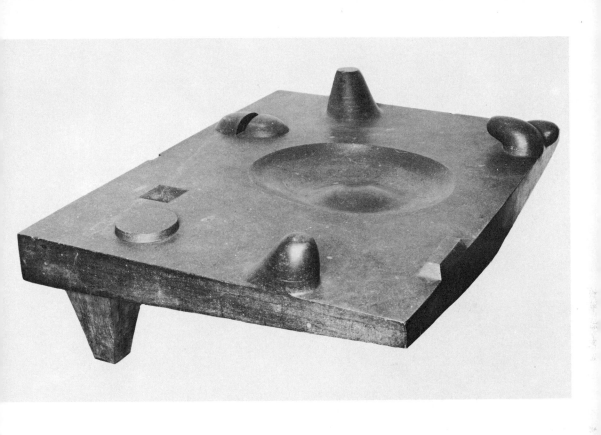

80 *Night Voyage, 1947 Collection Mr. and Mrs. Arnold Maremont*

82 *Ikiru, 1951*
Sculpture for bridge in Peace Park,
Hiroshima

Orient has given us for the opulence we have derived from Europe.

Question: In Japan has there been an equivalent interest in American art?

Noguchi: To the point where it's being imitated. Which is outlandish, of course. I mean if you must imitate, it's better to imitate yourself. Fortunately, we're so busy imitating the Japanese that when they imitate us they get a certain amount of their own artistic tradition back—twice removed, of course, like premasticated food, but at least they get it back.

Question: What about architects? I know that you have done considerable work for them.

Noguchi: Though I'm not interested in making monuments, I have a certain love of scale in relation to man—which comes, of course, with architectural sculpture. But I prefer to be in complete control of the work, simply because the work, whatever its scale, must be relative to everything else—like the component parts of a symphony.

Question: Tell me about your portrait heads.

Noguchi: Originally I was interested in portrait heads partly as a means of making a living. Then I got into the habit and kept on much longer than I should have. I don't think portrait heads are a complete sculptural expression. It's difficult to express what you want when you are mixed up with another personality—the sitter. After a while, it all seemed to be nothing more than a tour de force —whatever medium I used. At one time I made heads directly in wood with the sitters there in the studio and the chips flying all over the place; then when I started doing them in stone, I found that the type of translation was one I didn't like. Working in clay did not satisfy me.

Question: Why not?

Noguchi: Because in a medium like clay anything can be done, and I think that's dangerous. It's too fluid, too facile. For example, Rodin had a tremendous freedom of expression—he was actually an expressionist—but I wonder if it is the most sculptural sculpture. It's more like painting. The very freedom is a kind of antisculpture to me.

83 Portrait of Murdock Pemberton, 1932
Collection Mr. and Mrs. Murdock Pemberton

When I work with a material like stone, I want it to look like stone. You can make clay look like anything—that's the danger.

Question: Do you find that your own work stems almost entirely from personal experience?

Noguchi: Yes, but not literally or specifically. In a sense, I feel the more one loses oneself, the more one *is* oneself. Work is something like having a conversation with oneself—a personal soliloquy in which through argument and trial you try to nail something down —express the inexplicable. You can't tell quite what's going to happen when you start, but then *after* the work is done recognition comes: certain things affect you; and then you recognize that the work is really yourself.

Question: What kind of art do you admire?

Noguchi: Actually, the older it is, the more archaic and primitive, the better I like it. I don't know why, but perhaps it's simply because the repeated distillation of art brings you back to the primordial: the monoliths, the cave paintings, the scratchings, the shorthand by which the earliest people tried to indicate their sense of significance, and even further back until you get to the fundamental material itself.

NOGUCHI

1904 *Born, Los Angeles, California. Father, Yone Noguchi, the Japanese poet; mother an American.*

1906 *Moved to Japan. Grammar school in Japan.*

1917 *Sent alone to experimental school in Rolling Prairie, Indiana, which was shortly taken over as army training center.*

1917–21 *High school, La Porte, Indiana.*

1921 *Worked for a short time with Gutzon Borglum.*

1922–24 *Premedical student, Columbia University, New York.*

1924 *Apprentice to Onorio Ruotolo, Director, Leonardo da Vinci Art School, New York. Decided to become sculptor.*

1927–28 *Guggenheim Fellowship. Worked with Brancusi, Paris. Started to work with sheet metal abstractions.*

1928–30 *New York. Made portraits for a living.*

1930–31 *Japan and China. Made large drawings and terra cottas.*

1935 *Mexico. Made large wall sculpture in cement, Mexico City.*

1938 *Won competition for plaque, Associated Press Building, Rockefeller Center, New York.*

1942 *Voluntarily entered War Relocation Camp, Poston, because of sympathy for Nisei during war.*

Since 1942 has traveled widely and frequently all over the world. Has lived and worked for a considerable time in Japan. Executed numerous architectural commissions. Designed sets for Martha Graham. Lives in Long Island City, New York.

84 *Patio with Cloud, 1956 Milwaukee Art Center*

GEORGIA O'KEEFFE

Question: What do you feel has been the strongest influence on your work?

O'Keeffe: Some people say nature—but the way you see nature depends on whatever has influenced your way of seeing. I think it was Arthur Dow who affected my start, who helped me to find something of my own. I also studied with Chase and loved using the rich pigment he admired so much, but I began to wonder whether this method would ever work for me. You know, Chase believed in Meissonier; he bought many, and was convinced this artist would make a comeback. Now we have photographs so I guess we don't need Meissoniers, though of course there's a great sound of battle in them. They were painted in masterly fashion—if that's what you want. Imagine—Chase came to his class in a tall silk hat and light spats and gloves! He was most elegant. I was only twenty, so when somebody dressed up like Mr. Chase told me that this was *it,* I was naturally apt to believe it. I was given the prize in his class for a painting of a dead rabbit with a copper pot. But I began to realize that a lot of people had done this same kind of painting before I came along. It had been done and I didn't think I could do it any better. It would have been just futile for me, so I stopped painting for quite a while.

Later at the University of Virginia I was impressed when I heard a follower of Dow's talking about art. It was Alan Bement. After that I worked with him that summer and supervised art in Amarillo, Texas, during the winter for two years. I couldn't believe Texas was real. When I arrived out there, there wasn't a blade of green grass or a leaf to be seen, but I was absolutely crazy about it. There wasn't a tree six inches in diameter at that time. For me Texas is the same big wonderful thing that oceans and the highest mountains are.

Bement taught Dow's ideas, but if I'd followed Bement's advice you would never have heard of me. He was a very timid man, yet he was an important note in my life. Eventually I came back to New York (as Bement had constantly urged) to study with Dow. This man had one dominating idea: to fill a space in a beautiful way— and that interested me. After all, everyone has to do just this—make choices— in his daily life, even when only buying a cup and saucer. By this time I had a technique for handling oil and watercolor easily; Dow gave me something to do with it.

Question: Why have you always been so interested in simplifying and eliminating detail?

O'Keeffe: I can't live my life any other way. My house in Abiquiu is pretty empty; only what I need is in it. I like walls empty. I've only left up two Arthur Doves, some African sculpture and a little of my own stuff. I bought the place because it had that door in the patio, the one I've painted so often. I had no peace until I bought the house. They didn't want to sell—it was given to the church and I was ten years getting it. Those little squares in the door paintings are tiles in front of the door; they're really there, so you see the painting is not abstract [*Plate 84*]. It's quite realistic. I'm always trying to paint that door—I never quite get it. It's a curse—the way I feel I must continually go on with that door. Once I had the idea of making the door larger and the picture smaller, but then the wall, the whole surface of that wonderful wall, would have been lost.

Question: Why do you suppose the door interests you so much?

O'Keeffe: I wish I knew. It fascinates me. The patio is quite wonderful in itself. You're in a square box; you see the sky over you, the ground beneath. In the patio there's a plot of sage, and the only other thing in the patio is a well with a large round top. It's wonderful at night —with the stars framed by the walls.

Question: Has your use of isolated, blown-up details been influenced by photography?

O'Keeffe: I'll tell you how I happened to make the blown-up flowers. In the twenties, huge buildings sometimes seemed to be going up overnight in New York. At that time I saw a painting by Fantin-

Latour, a still-life with flowers I found very beautiful, but I realized that were I to paint the same flowers so small, no one would look at them because I was unknown. So I thought I'll make them big like the huge buildings going up [*Plate 85*]. People will be startled; they'll *have* to look at them—and they did. I don't think photography had a thing to do with it. At about the same time, I saw a sky shape near the Chatham Hotel where buildings were going up. It was the buildings that made this fine shape, so I sketched it and then painted it. This was in the early twenties and was my first New York painting. The next year I painted more New York scenes. At that time people said, "You can't paint New York; you're well launched on the flowers." For years I lived high up on the thirtieth floor of the Shelton Hotel [*Plate 86*] and painted from the window. This was an endless source of interest for me.

Question: People say you have been influenced by Oriental art. Is this true?

O'Keeffe: I enjoy Oriental art very much and prefer traveling in the East than in Europe. But tell me, can you find anything in my work that shows an Oriental influence? I had an important experience once. I put up everything I had done over a long period and as I looked around at my work I realized that each painting had been affected by someone else. I wondered why I hadn't put down things of my own from my own head. And then I realized that I hadn't done this because I'd never seen anything like the things in my own head.

Question: Why do you paint in series so often?

O'Keeffe: I have a single-track mind. I work on an idea for a long time. It's like getting acquainted with a person, and I don't get acquainted easily. Take that ladder painting [*Plate 87*]; I still think I'm going to paint more ladders. I don't know what interrupted me. In Abiquiu we need ladders to get up on the roof of the house. Ladders are wonderful things—very important in the world. They were the way man first got into his house. I'm also fascinated by the shadows a ladder can make against a wall. I've never been able to get anyone to build me exactly the kind of ladder I want—two very tall poles with flat steps that reach above the roof.

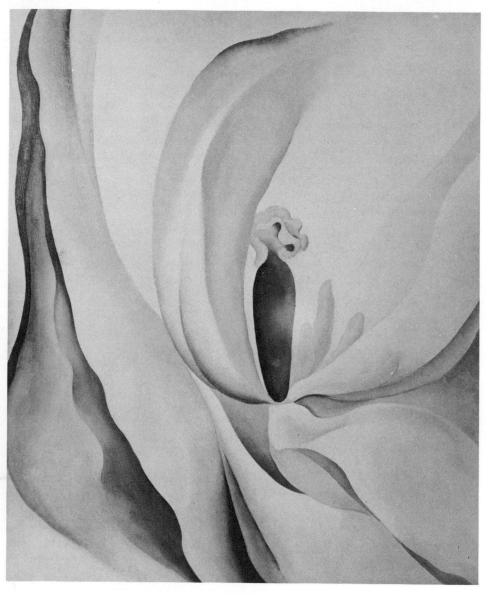

85 Tulip, 1926 Collection Mabel Garrison Siemonn

86 The Shelton with Sunspots, New York, 1926
Collection Inland Steel Company, Chicago

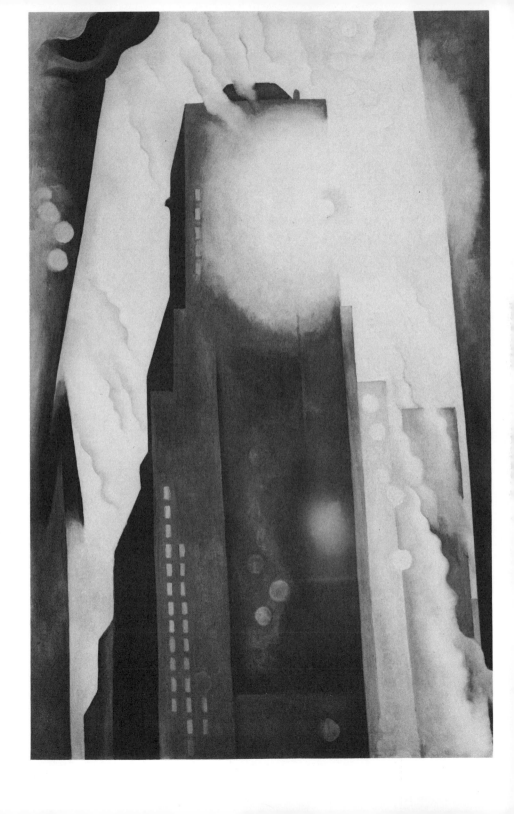

Question: Has the idea of symbolism been tacked onto your work by others?

O'Keeffe: Certainly. I've often wondered where they got the idea and what they were talking about. The wife of a senator from Colorado (I can't remember her name) once said to me years ago, "With all this talk that's going around and with all the things people are saying about you, I can't see that your sex is bothering you very much."

Question: What about the pelvis bones? [*Plate 88.*] I read something you wrote about them in 1944 when you were showing the series at An American Place.

O'Keeffe: I still agree entirely with what I said then. You can quote it if you want.

"When I started painting the pelvis bones I was most interested in the holes in the bones—what I saw through them—particularly the blue from holding them up in the sun against the sky as one is apt to do when one seems to have more sky than earth in one's world—

"They were most wonderful against the Blue—that Blue that will always be there as it is now, after all man's destruction is finished."

You see, I knew for a long time I was going to paint those bones. I had a whole pile of them in the patio waiting to be painted, and then one day I just happened to hold one up—and there was the sky through the hole. That was enough to start me. At first these paintings were all blue and white—finally I tried red and yellow. I probably did between fifteen and twenty of them. They made a pretty exhibition. I'm one of the few artists, maybe the only one today, who is willing to talk about my work as pretty. I don't mind it being pretty. I think it's a shame to discard this word; maybe if we work on it hard enough we can make it fashionable again.

Question: Does the accidental have any place in your work?

O'Keeffe: Once in a while there's a good accident. However, I rarely start anything that isn't pretty clear to me before I start. I know what I'm going to do before I begin, and if there's nothing in my head, I do nothing. Work brings work for me. I have a lot in my head right

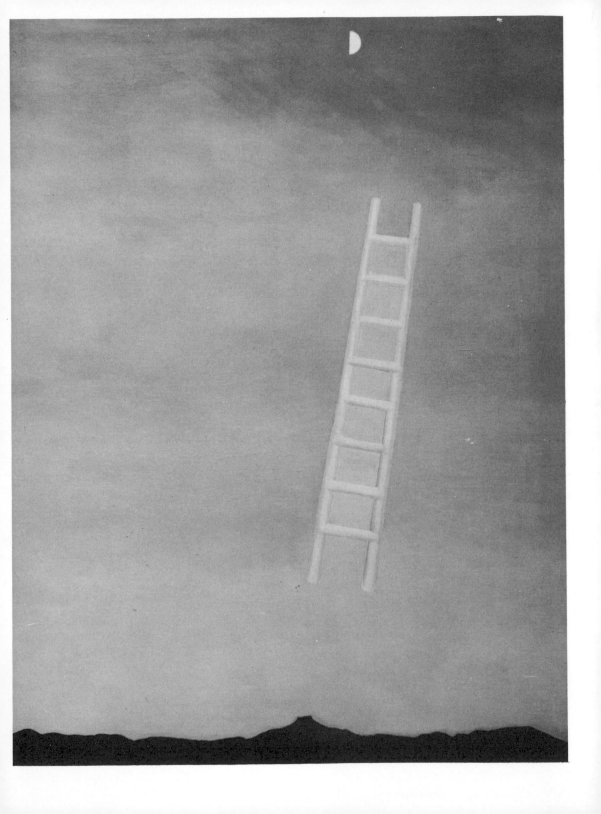

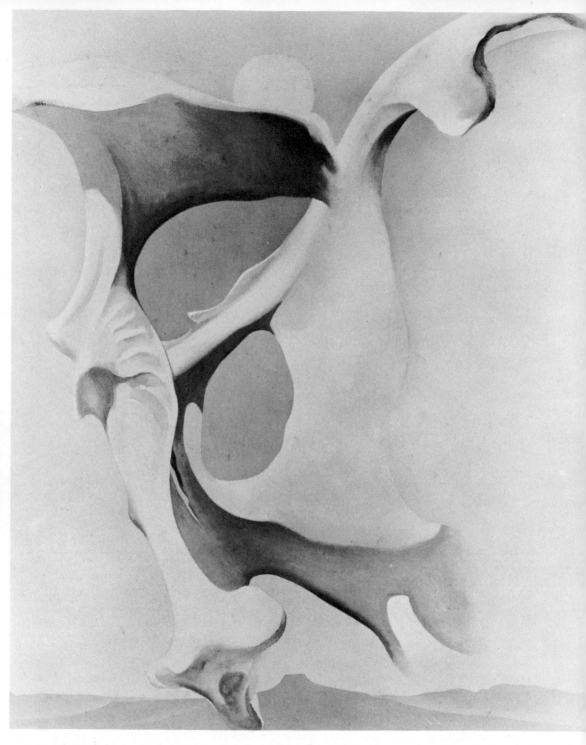

88 *Pelvis with the Moon, 1943 Norton Gallery, West Palm Beach*

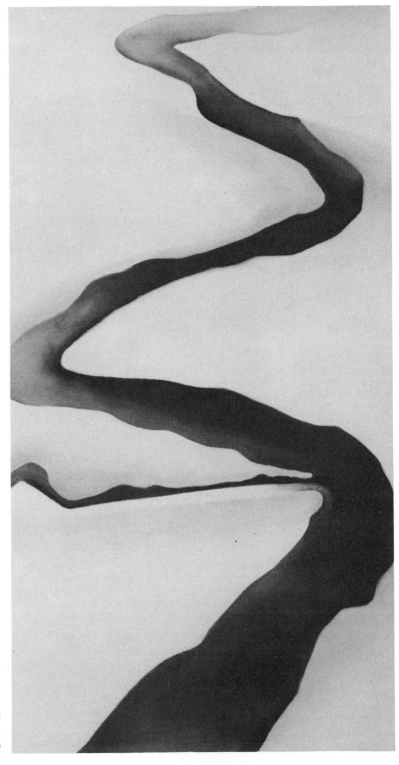

89 *Pink and Green, 1960*
Collection
Chauncey L. Waddell

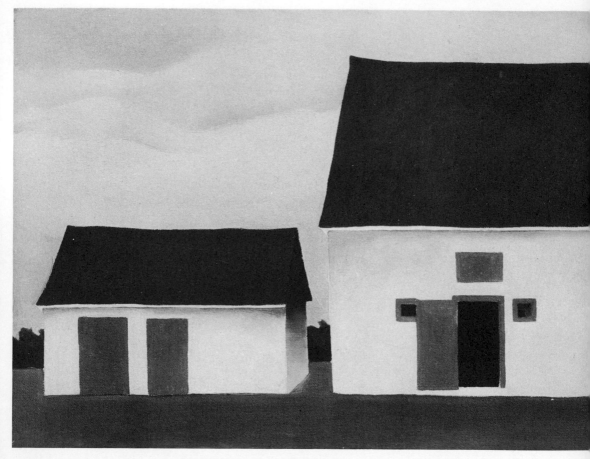

90　Stables, 1932　The Detroit Institute of Arts

now. I've spent a great deal of time and energy this year on two exhibitions, packing, shipping, writing letters, supervising. Can you imagine what it's like to pack an exhibition in a tiny remote New Mexican town? I have to do most of it myself. I say to myself that I'm not going to have any more shows; I've had enough. They interrupt my work. For most people a show is a joy; for me it's a bore, a headache, and it's the kind of work an artist shouldn't be doing. Then there's the danger, almost the certainty that something will be damaged.

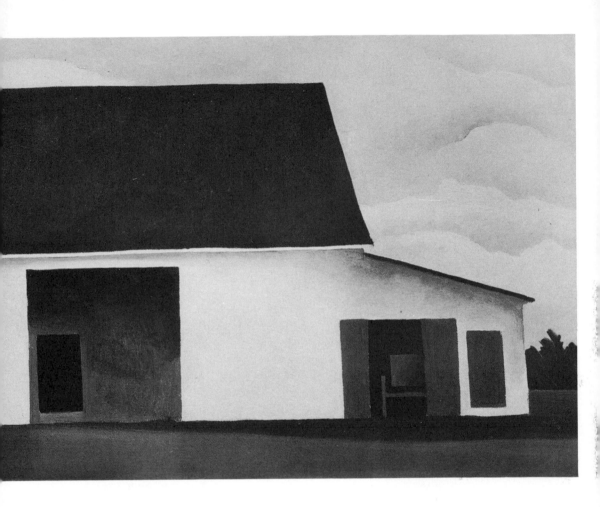

Question: Do you make preliminary sketches?
O'Keeffe: I make little drawings that have no meaning for anyone but me. They usually get lost when I don't need them any more. If you saw them, you'd wonder what those few little marks meant, but they do mean something to me. I don't think it matters what something comes from; it's what you do with it that counts. That's when it becomes yours. For instance those paintings in my present show—they are all rivers seen from the air [*Plate 89*]. I've been flying a lot lately—I went around the world—and I noticed a surprising number

of deserts and wonderful rivers. The rivers actually seem to come up and hit you in the eye. There's nothing abstract about those pictures; they are what I saw—and very realistic to me. I must say I changed the color to suit myself, but after all you can see any color you want when you look out the window.

Question: Why have you avoided the human figure?

O'Keeffe: I've had to pose for too many people myself. It's a hard business and I haven't what it takes to ask someone else to do this for me.

Question: Do you ever work directly out of doors?

O'Keeffe: I bought a car to do just this, to work out of doors, but I haven't used it once this year. I have two dogs that want to go every-where with me, but I can't take them along when I paint and haven't the heart to leave them at home. I have painted many of my oils out of doors. The Tree series I did from my window in Abiquiu—looking down into the valley. Some of these I also did in the car. I like to work out of doors; there's no one there to disturb you, but I've dis-covered that I can only work in one spot for about three days running; by the fourth day people stop and ask questions.

Question: Do you always paint what you see? What about changing light?

O'Keeffe: You paint *from* your subject, not what you see, so you can't be bothered with changes in light. I rarely paint anything I don't know very well.

Question: What artists do you most admire?

O'Keeffe: The Chinese. Also, by the time I was through worrying about getting rid of the Stieglitz collection, I think it was probably the Rodin watercolors I enjoyed the most and could have stayed with the longest. In the beginning I wouldn't have thought so—they're slight and of another time. It would never have occurred to me that these drawings could have stood up so well. Among the American painters I've best known, Demuth was the most civilized as a person. He had strong opinions about the theater and literature—opinions he was willing to fight for. He left me all his oil paintings when he died. One day he came to see us and told me that he was willing

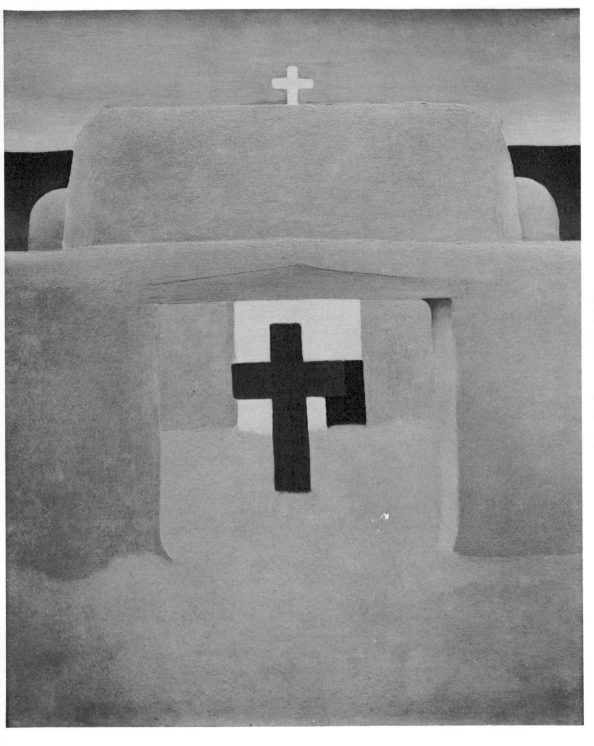

91 Gate of Adobe Church, 1929 Collection Edith Gregor Halpert

his oils to me (he'd only sold one before he died) and that I could do anything I wanted with them—sell them—keep them—give or throw them away.

Question: Do you consider yourself a "precisionist," as a recent exhibition labeled you?

O'Keeffe: I think that was an absurd idea. What can you do if people who own your pictures are willing to lend them to any exhibition? I was in the surrealist show when I'd never heard of surrealism. I'm not a joiner and I'm not a precisionist or anything else. It's curious that the show didn't stress what really might have been called precise in my work—the Canadian barns [*Plate 90*]. Alfred [Stieglitz] had a niece, a most amusing girl with whom I sometimes traveled—once to the Gaspé. My barns were painted there. The southern side of the St. Lawrence River was lined with hideous houses and beautiful barns. The barns looked old, as if they belonged to the land, while the houses looked like bad accidents. That was a wonderful trip to the Gaspé. The soil there was a marvelous deep black after it had been turned over, and there were beautiful blossoming potato flowers—very lush. I remember I got interested in painting a cross. In New Mexico the crosses interest me because they represent what the Spanish felt about Catholicism—dark, somber—and I painted them that way [*Plate 91*]. On the Gaspé, the cross was Catholicism as the French saw it—gay, witty. I made two paintings of crosses when I was there in 1932. I would have been willing to stay on in Canada if it hadn't been so terribly cold.

Question: What do you think of the news this morning, that a man has been in orbit around the earth for the first time?

O'Keeffe: Well, you see, we really haven't found enough dreams. We haven't dreamed enough. When you fly under even normal circumstances, you see such marvelous things, such incredible colors that you actually begin to believe in your dreams. Flying around the world so fast to me seems a dream, even if I know it is probably a reality. I was three and one half months flying around the world, but of course we stopped often and spent time on the ground. To do it in a day seems a dream.

O'KEEFFE

1887 *Born, Sun Prairie, Wisconsin.*

1904–05 Studied, School of the Art Institute of Chicago.

1907–08 Studied with Chase at Art Students League, New York.

1909–10 Freelanced as commercial artist, Chicago.

1912–16 Supervisor of Art in public schools, Amarillo, Texas. Taught, Summer School, University of Virginia and Columbia College, South Carolina.

1916 *Studied with Arthur Dow and Alan Bement at Columbia College. Head, Art Department of West Texas Normal College, Canyon, Texas.*

1923 *Retrospective exhibition, Anderson Galleries, New York.*

1924 *Married Alfred Stieglitz. Lived in New York.*

1943 *Retrospective exhibition, Art Institute of Chicago.*

1946 *Retrospective exhibition, Museum of Modern Art, New York.*

1947 *Elected member National Institute of Arts and Letters.*

1953 *Retrospective exhibition, Dallas Museum of Fine Arts.*

1960 *Retrospective exhibition, Worcester Museum of Art.*

Has traveled widely all over the world including Europe, Mexico, Peru, Hawaii, Canada and Japan. Lives in Abiquiu, New Mexico.

BEN SHAHN

Question: Do you feel it is important that your work have meaning for large numbers of people?

Shahn: I do not; I work first for myself. Yet I've often said I work for some six people. If I find approval from them, I'm pretty happy about it, but if I sense disapproval—and I think the artist can sense this very quickly—I begin to question myself. The six people, you understand, are a kind of mythical group. However, I must add that there's rarely a single artist in the group. It's more the people I come across in the world—a group, of course, that is constantly shifting. When I say six people, I'm really saying I can't know all the people who see my pictures. In the last analysis, it's an inner critic that finally tells me: this is about as far as you can go, this is where you stop—dissatisfied always. The imagery that exists in your mind is a multiplicity of images, but what finally results has to be a single image, so it's inevitable that dissatisfaction results. I'll tell you what I'm satisfied with—with the body of my work or, at least, that part of it done when I ceased to be a student and began to be myself. Until then, I was an echo of whatever influences were around me.

Question: Have you been influenced by folk art or folk songs, as so many critics claim?

Shahn: No, I don't think so. Folk art and folk songs entered my consciousness, I believe, when I was a fully mature person. I've used them—but I don't consider this an influence. It's quite a different thing; folk art and folk songs have acted as subject matter in my work rather than as influences. I've been influenced very strongly by early Sienese paintings but they never supplied subject matter for my work. Sienese art, as an influence, was a way of looking at things

intensely—directly, with an intensifying simplicity. Like everyone else, I had many influences during my schooling which went on long after I left school. I underwent a multiplicity of influences—from my teachers at the Academy [National Academy of Design], one of whom told me very directly, "When in doubt, use purple." I tried to do that. Others told me I must draw with bravura; I tried to do that, too. I came to a point where I began to question myself, who I was, what my antecedents were, what my interests were, and the answers to all these questions did not square with my strongest influence at that time—Cézanne. Cézanne's father, I've read, was a banker; my father was a woodcarver. Cézanne's schooling was classical—Greek, Latin; mine was the Bible and the Talmud. Cézanne's surroundings had remnants of Roman architecture; mine had just pathetic little run-down homes. I don't know whether Cézanne loved to tell stories, but I always did. However, I learned very quickly in my art education that art does not tell stories.

Art, as I saw it one day when I helped to hang a National Academy show while I was a student there, was about cows. In those days, early in the twenties, there were many cow paintings. More than that, the cows always stood knee-deep in purple shadows. For the life of me I never learned to see purple where there was no purple—and I detested cows. I was frankly distressed at the prospects for me as an artist. But there came a time when I stopped painting, stopped in order to evaluate all these doubts. If I couldn't see purple where there was no purple—I wouldn't use it. If I didn't like cows, I wouldn't paint them. What then was I to paint? Slowly I found that I must paint those things that were meaningful to me—that I could honestly paint in the shapes and colors I felt belonged to them. What shall I paint? Stories. I knew all the time from my previous teaching that this was considered wrong. Moreover, I could not accept the whole theory of color as the impressionists had evolved it. Much later I learned that their scientific explanations were wrong, because they based them all on Helmholtz, and he was working with light, while the impressionists were working with pigment—something entirely different. In the same way I began to doubt many other established

aesthetic theories, such as the antagonism to storytelling in art, though all the ancestors of my teachers had been storytellers from Giotto on down. I leaned on these ancestors for support and corroboration. I was so unsure of the reception my Sacco and Vanzetti paintings would receive from my contemporaries that during the whole time I worked on them and for half a year afterward I refused to show any of them to a soul. I simply didn't want to be shaken in what I was doing. While I was at work on the series, a friend brought Paul Burlin, a distinguished artist whom I respected, to see my paintings. I stood in the door of my little Truro studio and refused to let him in, saying arrogantly, "You won't understand." Years later he told me he'd come pretty close to socking me in the face.

With the Sacco and Vanzetti paintings I began to feel confident of my own direction, but not of each individual work. Twice before this series, I went off timorously in search of myself, but then pressure from the School of Paris detoured me from my search and from my convictions—and for a time I turned to Rouault.

Question: Do you always work directly from a model?

Shahn: With the Sacco and Vanzetti pictures I worked from newspaper photos and clippings or whatever I could find, but of course only when a given personality was involved. I remember I ran across a letter that Sacco's wife had written him after a visit to the prison. And there was one line that said, "Be of good courage; victory is surely ours." This became the title of one of the paintings. That particular picture has been lost along with several others. In this case I needed no photograph. I imagined the situation—a little woman's figure standing outside the prison waving a white handkerchief.

Question: Do you consider yourself a realist?

Shahn: I not only consider myself a realist, I consider this one of the noblest designations an artist can be given.

Question: Do you consider yourself essentially an American artist?

Shahn: I certainly do. I think I am one of the most American artists painting today.

Question: Has your training as a photographer affected your painting?

Shahn: I was not trained as a photographer. I took it up to help me sharpen my vision of the specific. I felt very strongly that I could

92 *Bartolomeo Vanzetti and Nicola Sacco,*
1931–1932 **The Museum of Modern Art**

93 *Handball, 1939* **The Museum of Modern Art**

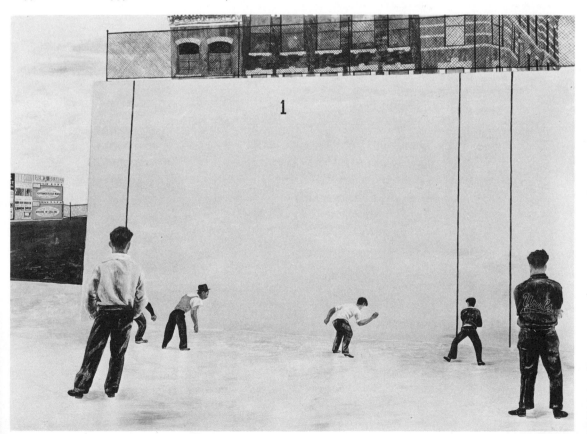

arrive at broad generalizations about human beings through sharpened observation of the specific. For example, for the painting called Handball [*Plate 93*] I made many photos of handball players in the slum playgrounds of New York. As a matter of fact, about six years ago I took my son Johnny to that part of town and showed him the very area I'd worked in. He was somewhat disappointed because the ball court, as he remembered it in the painting, was enormous—the players too small in comparison, he felt.

Question: Would you say that drawing is the basis of your work?

Shahn: Drawing for me is one of the most important tools an artist has. That it is being abandoned today doesn't particularly distress me, but it particularly distresses me that it is being abandoned in our schools. As for my work, drawing is basic.

Question: Do you use drawings as studies for paintings?

Shahn: Not directly. I stop often in the middle of a painting—to clarify certain areas. At such times I'm apt to make many drawings of minor areas before I go on. When an area becomes vague and foggy—that's when I stop and draw. Sometimes these are little more than notes; sometimes they become important enough to be elaborated into finished drawings. However, the fireplace gets most of them.

Question: What part does color play in your work?

Shahn: Recently I was asked, "What are you working on now?" and I said, "A painting in blue." At that point, color had become the most important element in the painting, and the fact that the theme was a man consoling a weeping woman was unimportant. There was a similar situation when I said to myself once, "The next picture I do must be in yellows—I want to see if I can lick this problem of yellow." When you work in a very high key it tends to become sentimental. Now the picture I called Beatitudes was all in yellow. I'd like to tell you about that because it's important. You can see that I have no unfinished pictures around my studio, but sometimes I struggle with one for as long as a month and then in desperation, having failed, wash it away, scrape it away and destroy it. This happened with Beatitudes. Four successive years I started that painting and it wouldn't work because I didn't face up to the problem. The problem was

94 *Beatitudes, 1952 Collection Mr. and Mrs. David Harris*

yellows. When I finally decided that the painting must be yellow, I was with it. Until then it just didn't work. The sky had to be yellow, the man had to be yellow, the earth had to be yellow—everything had to be yellow. But how do you paint yellow wheat against all this yellow? You paint it jet black. When I began to think in color, only then did I give meaning to the picture. It was one of the first landscapes I ever made. Before that it had always been the city for me.

Question: Do you use architecture symbolically in your paintings, for instance, in works like Vacant Lot and Willis Avenue Bridge?

Shahn: The kind of architecture I paint was really the environment I grew up in, but it was years before I dared to paint it. The brick wall in Vacant Lot was a symbol, a symbol of my own terrible loneliness, of my sense of imprisonment as a child. But I must be honest with you about Willis Avenue Bridge [*Plate 96*]. At the time I painted the picture I was working on a mural for the Bronx post office and I used to walk home every day—about four or five miles. It was spring and the Willis Avenue Bridge was getting a coating of red lead. That's all there was to it—no symbolism in the red crosses as you might have thought.

Question: How did you come to paint Death on the Beach? [*Plate 97.*]

Shahn: I worked in the Office of War Information during the war and when the better news began to arrive—about our successful landings on the beaches—I started to think how it must feel to be felled by a bullet and fall on a stony beach. All I knew personally about this came from stepping gingerly on a pebbly beach and finding it uncomfortable. How did it feel, I wondered, to fall face down on a stony beach?

Question: Why do you suggest music in so many of your paintings?

Shahn: Mostly because I'm unmusical, I suppose. It's simply frustration and suppressed desire. My children are all musical. I'd give my right arm (I'm left-handed) to be able to sing like a third-rate imitation of Frank Sinatra. Recently I was in a cab in Washington, sitting beside the driver, and when some of his unpleasant passengers got out, he began to sing, "It Might as Well Be Spring." And it was May. At that moment I felt I would have been willing to give anything to sing

95 *Vacant Lot, 1939 Wadsworth Atheneum, Hartford*

96 *Willis Avenue Bridge, 1940* *The Museum of Modern Art*

97 *Death on the Beach, 1945*
Collection Mrs. Rosalie Berkowitz

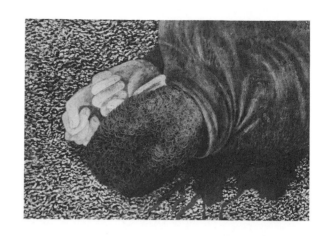

98 *Seurat's Lunch, 1939* *Collection Mr. and Mrs. Earle Ludgin*

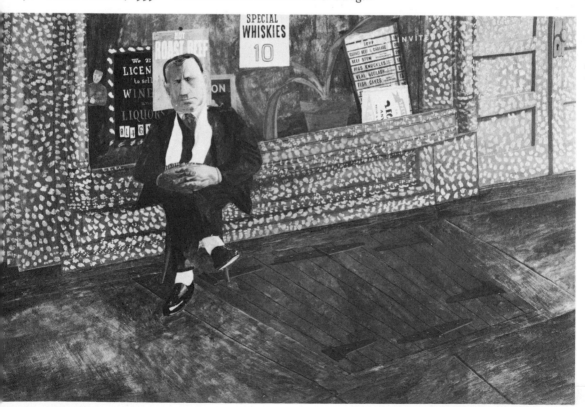

as he did. Then I started to think—what is this strong desire? It's nothing more than the wish to imitate an imitator. And isn't this exactly what motivates a beginner to paint—to imitate the imitator? Then I thought to myself, would I, as a singer, have been content to imitate an imitator, and I said to myself, probably not for long. As a singer I would probably have had the same struggle to find myself that I'd had as a painter.

Question: Do you deliberately use printed words in your paintings?

Shahn: How can an artist help it? He's constantly surrounded with the printed word, from the commercials on Dave Garroway's show in the morning to the *Times* or *Daily News* at breakfast to *Art News* or *The Arts* in the afternoon. When I was a student I often noticed that when painters did a cityscape they usually obliterated words, street signs and ads. And it was then I made a secret vow that one day I'd have the courage to depict sharply all those words they had so carefully removed [*Plate 98*].

Question: Have you ever painted a picture without human beings?

Shahn: Yes, several times. One I particularly remember I made when I felt a kind of loneliness after the children grew up and began to leave. I painted a still-life of the guitars, banjos and other musical instruments they had left behind. I've even done a few flower pieces recently. And don't forget the large composition with only chairs and music stands that Duncan Phillips has in Washington. I've painted God, too, and that's not man.

Question: Did working with Diego Rivera in 1933 influence you much?

Shahn: I think he did influence me for a short time when I began to crowd my compositions somewhat the way he did, but that actually happened in only one fresco, the one I made right here for our school in Roosevelt. I used to argue endlessly with Rivera about crowding his compositions. I'd ask him why he didn't appreciate space if for nothing more than emphasis, but his answer was always the same, "Look around you—can you see space? You only see things."

Question: I hear you're designing the costumes and sets for a ballet.

Shahn: Yes—I consider myself a "pro" and undertake a diversity of projects, but only on one condition, that each one involves me. I've

Ben Shahn

done posters, ballet sets (I'm doing one now with Jerome Robbins and Robert Prince), illustrated books, murals and all kinds of prints.

Question: How about the paintings on atomic destruction you made in Japan?

Shahn: All of us are completely aware of this menace whether we think we ought to abandon atomic experiments or whether we think it's better to be destroyed by the bomb but hold on to our concept of freedom. I'm influenced, as you know, by my immediate environment. First I began to read about the tragic story of the ill-named *Lucky Dragon,* the Japanese fishing boat that got into the path of fall-out from our early experiments with the hydrogen bomb in the Bikini area. Actually I was assigned to illustrate a series of articles that Ralph Lapp was writing for *Harper's Magazine.* He spent close to a year in Japan speaking to nearly every individual who'd been on the fishing boat, and to the people who first broke the story in the Japanese press, and to the doctors, to the families of the sailors, to the Japanese scientists who first suspected that this might be hydrogen bomb fall-out, to the officials in our government who denied the fact, and to the Japanese, who in a different way were affected because they were afraid to eat their staple diet—fish. For a time, it seemed that the whole economy of Japan was shaken by this single incident—somewhat as if we in America suddenly suspected that every bit of available meat in the country was poisoned. I made endless drawings—many more than were necessary for the articles—mostly from imagination. And here I come to a very important point, the crux in the change my work has taken. When I did the Sacco and Vanzetti series and also the Mooney series, I was very careful to document my work with newspaper photographs and clippings, but with the Japanese paintings I no longer felt the need of such documentation. The radio operator on the fishing boat, who subsequently died of radiation poisoning, was a man like you and me. I now felt it was unnecessary to paint him, but to paint us. The man consoling the wife of the radio operator was a man consoling a woman in agony. The radio operator playing with his child was any father playing with his child. The Japanese Nobel Prize-winning physicist, who first suspected the truth, was a scientist. He might have been any

scientist. I no longer felt the need to document him specifically. The terror of the beast that enters every one of the six paintings is the terror that now haunts all of us.

SHAHN

1898	*Born, Kaunas, Russia.*
1906	*To the United States with family. Lived in Brooklyn.*
1913–17	*Employed as lithographer's apprentice during day, attended high school at night. Supported himself as lithographer until 1930.*
1919–22	*Attended New York University and City College of New York.*
1922	*Studied, National Academy of Design.*
1925, '27, '29	*Traveled in Europe and North Africa.*
1932	*Series of twenty-three gouaches on trial of Sacco and Vanzetti.*
1933	*Worked with Diego Rivera on murals for Rockefeller Center.*
1935–38	*Photographer and designer for Farm Security Administration.*
1942	*Designed posters for OWI.*
1944–46	*Designed posters for CIO.*
1947–48	*Retrospective exhibition, Museum of Modern Art and Institute of Modern Art, Boston.*
1950	*Taught, Boston Museum Summer School, Pittsfield, Massachusetts.*
1950–51	*Taught, Brooklyn Museum.*
1951	*Taught, Black Mountain College Summer School, North Carolina.*
1953	*Award, International Exhibition, Museum of São Paulo.*
1954	*Award, Biennale, Venice.*
1956	*Temple Gold Medal, Pennsylvania Academy of the Fine Arts.*
1956–57	*Appointed Charles Eliot Norton Professor at Harvard University.*
1958	*Medal, American Institute of Graphic Art.*
1960	*In Japan.*

Numerous one-man shows all over the world. Lives in Roosevelt, New Jersey.

DAVID SMITH

Question: Do you use either signs or symbols in your sculpture?

Smith: Those two words don't mean a thing to me. I don't use them in my vocabulary. They're not even in my consciousness. Under cross-examination I might possibly understand what the words mean. As far as I know, I don't consciously use either signs or symbols, but if they appear to be used in my work, then they've arrived in my mind as exchange images.

Question: What do you mean by exchange images?

Smith: I mean dream images, subconscious images, after-images. They're like the series of paintings I made where the image was the hole from which the sculpture was removed. What was formed there was the after-image.

Question: Does innovation play an important role in your work?

Smith: We are all subject to our own time and to our own history. The best artists are probably both innovators and children of their parents. My parents were every artist before me whose work I knew. There are first your immediate parents, your blood family who directly influence you, and then there are relatives you adopt and feel close to. Even the artists you don't like influence you. But you can't leave your own world; you're born into it. You're always stretching to reach beyond yourself—you make a little stretch each time, but you always remain yourself. Art is made by people. It's not made by German art historians. What is interesting is the artist, and what is interesting about the artist are his own convictions. There are no rules or principles. My world has been broadened when a painter like Jackson Pollock comes along, though I fail to see how he influenced me directly.

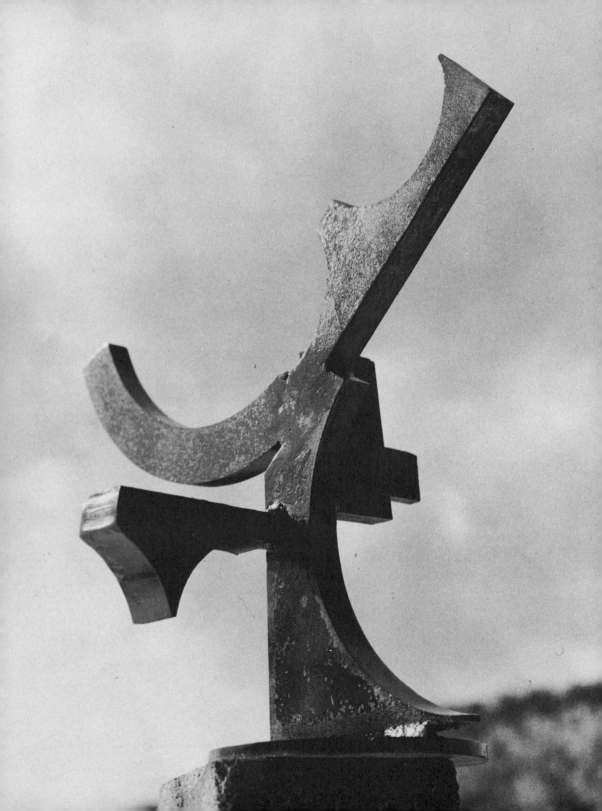

Question: How did you happen to start with metal sculpture?
Smith: Most sculptors have had training in sculpture. I had training in painting, none in sculpture. I arrived at sculpture through montage and cubism—you notice I paint my sculpture. I've always made painted sculpture; not one year that I've worked have I failed to do this. Take the Albany series—there are about ten or eleven in that series, all painted black except the last two, where I introduced varied color areas.

Question: Why did you call it the Albany series?
Smith: Actually I suppose because I bought the steel from the Albany Steel and Iron Works and because Albany is kind of a dirty place, especially the parts I know best—along the river where there are steel mills and casting plants.

Question: Do you still use both iron and steel in your work?
Smith: Iron and steel are about the same. Iron is an old-fashioned term I use in an affectionate way. Cast iron and steel are something different. The process of working with them is different. I've used both in my work. The average person can't pick up a bar and tell whether it's iron or steel; you can only tell by analysis.

Question: But you haven't told me how you got started with metal sculpture.
Smith: Between my first and second years in college I spent a year working in the Studebaker plant in South Bend, in Department 348, Steel Frame Assembly. Before that, I'd worked as a telephone lineman. At these times I always thought of art as oil painting. After that I spent one semester at George Washington University in Washington, where, by the way, I took only poetry courses and worked at the same time at the Morris Plan Bank. Later I came to New York and started studying painting at the Art Students League with Lahey. The next year I met Jan Matulka, the abstract painter, who had just come to the Art Students League to teach. It was from him in 1928 that for the first time I learned of cubism and constructivism. Then the world kind of opened for me. I also learned a lot at that time from just looking at reproductions, mostly in European magazines. I first saw Picasso—then his iron construction in *Cahiers d'Arts*—and I realized

that I too knew how to handle this material. At about the same time I saw reproductions of the Russian constructivists in some German magazines. I couldn't read the texts in either the French or German magazines, so my acquaintanceship was purely visual—from reproductions, and of course from the explanations of Matulka. Matulka was the most notable influence on my work—I was going to say "life," because my work is my life. I could also say that he probably had the same influence on I. Rice Pereira, Burgoyne Diller, Dorothy Dehner, George McNeil and a dozen others who studied with him. It was a little later that I met Xceron, John Graham and Stuart Davis, from each of whom I learned further about cubism and Paris. I didn't go there myself until 1935.

Question: How did you happen to do the Medals for Dishonor?

Smith: The idea developed in Europe, really in Greece, from my interest in Mesopotamian cylinder and coin intaglio seals. Mostly I guess I was interested in the idea of intaglio—as a reverse process. The theory is that you're on the opposite side pushing the walls out. The immediate reason for doing the Medals for Dishonor probably grew out of a series of postcards I bought at the British Museum, showing special war medallions the Germans awarded in the First World War, medallions for killing so-and-so many men, for destroying so-and-so many tanks, airplanes, et cetera. That aroused my interest in medals. From a naturally anarchistic, revolutionistic point of view, the idea of "medals for dishonor" became my position on awards. From a strictly humanistic point of view, medals are always about the same. It only depends on where you were born, where the killing is done. I believe in any revolutionary idea when it's necessary—in any push against what I believe is wrong. You do it in defense of your own convictions, even if you feel it won't work. Revolutionary action is never lost. Something comes out of it finally.

Question: Critics say you've been influenced by American folk art. It this true?

Smith: No, absolutely not. It wasn't American folk art; it was cubism that awoke me. I don't know who the hell says it was American folk art. I don't have any particular admiration for American folk art

102 *Medal for Dishonor*
Death by Bacteria, 1939

103 *Medal for Dishonor*
Death by Gas, 1939

and I fail to see where it's been involved in my concepts. Mondrian, cubism, constructivism and surrealism all came on me at one time, without my even knowing the difference between them.

Question: Have you ever worked in anything but metal?

Smith: The first constructions that grew off my canvas were wood, somewhere between 1930 and 1933. Then there was an introduction of metal lines and found forms. The next step changed the canvas to the base [of the sculpture]. And then I became a sculptor who painted his images.

Question: I notice you often work in series.

Smith: Yes, in this way I try to get out all I have to say. I may be working on three different series at the same time. I've just started some very large pieces—painted ones—called Ziggurats. No one knows what a ziggurat is; we've only seen reconstructions of them. No one knows the purpose of a ziggurat; for that matter I don't know the purpose of mine. The title is just an affectionate reference, because these are my own, and I call them Zig I, Zig II, III, et cetera. I've just finished the third, but during the same year I've been working on Tank Totem XII. I started the Tank Totems [*Plates 105 and 106*] about ten years ago and I'm still working on them and don't rule them out until the day I die—that is, as long as concave and convex are still a mystery. My Tank Totems are relationships to the end of tanks. [The tanks were boiler heads, and boiler heads are stock items in the steel data book from which Smith frequently orders his materials. Ed.] I'm still working on the stainless steel pieces too. These I just call Unities, and they are further identified by the number of planes they have [*Plate 107*]. I have absolutely no tangible word relationships with subject matter where these are concerned. They're completely visual.

Question: Aren't some of the recent ones related to semaphores?

Smith: Never. I have no spiritual affinity with semaphores.

Question: What about some of your other series, like the Agricola sculptures? [*Plate 108.*]

Smith: The Agricola series is comprised of many found objects, like hand-forged parts of agricultural implements, that have functioned

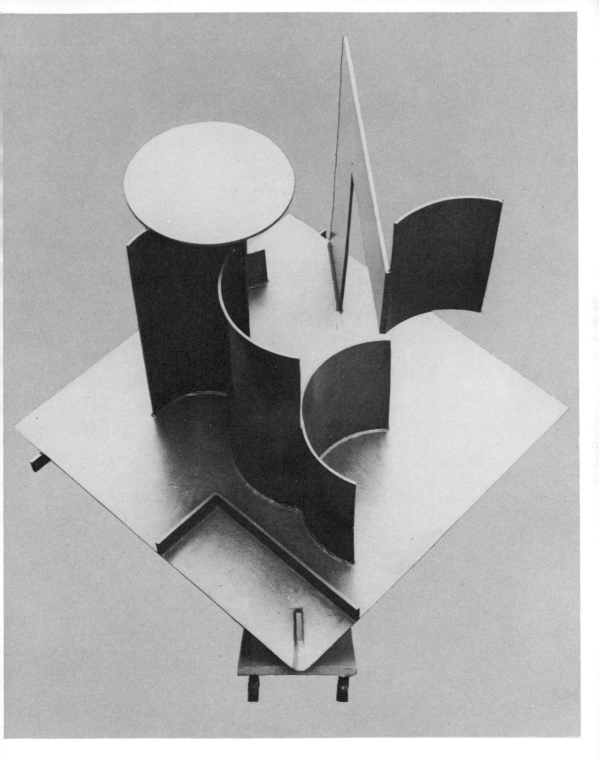

104 Zig IV, 1961

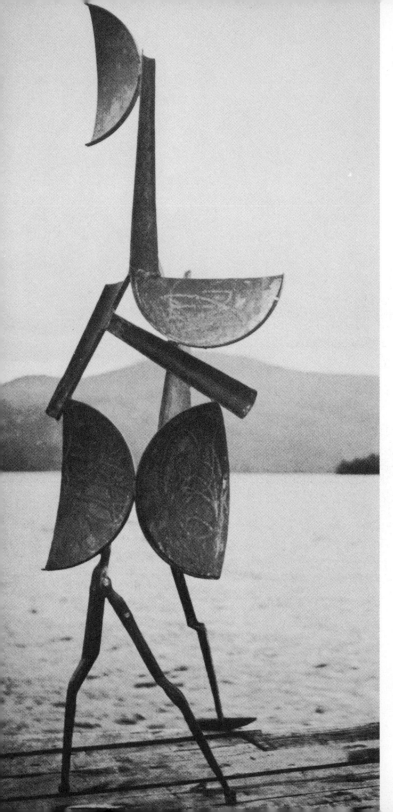

105 *Tank Totem IV*
Albright-Knox Gallery, Buffalo

106 *A group of recent sculpture,*
photographed on the terrace of
Smith's home at Bolton Landing,
New York. Reading from left
to right, Tank Totem VII,
Nolands Blues, Rebecca Circle.

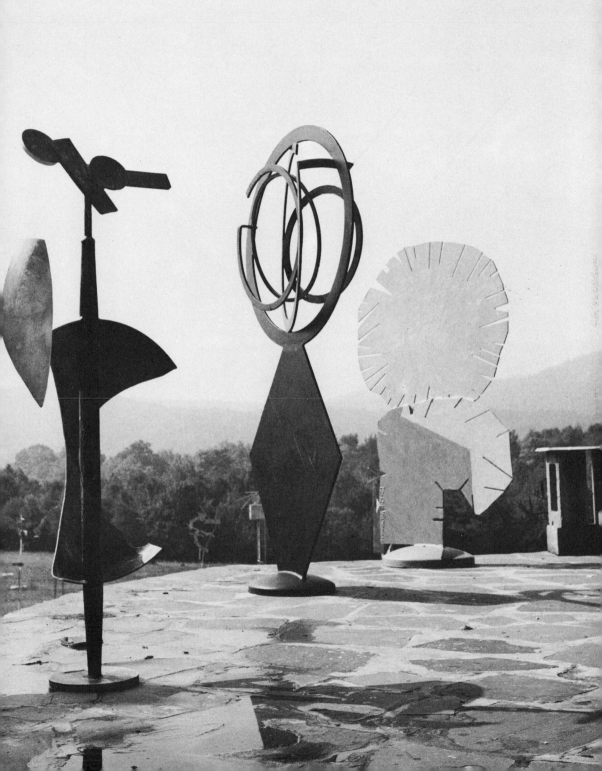

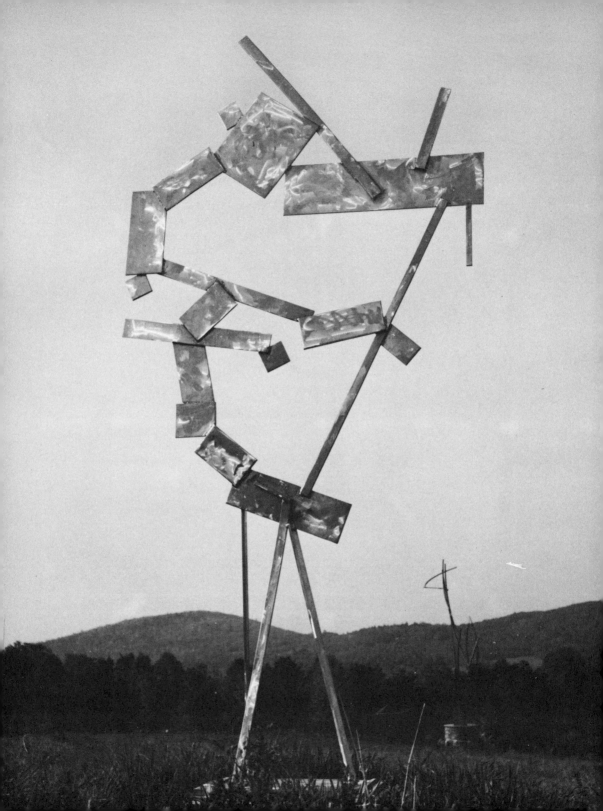

in a past era. The first two iron heads I made in 1933 were essentially part of the Agricola series, but I hadn't named them that yet. They were mostly made from found objects—wagon parts, and one was made from a slaw cutter, a piece of binder chain and a piece of cut-metal plate. I never think of my series as variations on a theme. That's not in my lexicon.

Question: If they're not variations on a theme, what are they?

Smith: They're continuous parts of my concept.

Question: How do you feel about materials?

Smith: I don't particularly want the material to show. Now steel, that's a natural thing for me. I buy it in flat plates—that's the way I use it. After cubism, who cares about form? It's planes.

Question: How about space?

Smith: How about space? Who knows where space stops and what isn't space? "Space" means nothing just as "nature" means nothing, because all is space and all is nature unless you have defined limitations. Space is like sex; it has a different qualification for each one of us. Otherwise we'd all be pursuing the same woman. I'm not worrying about space. It's not my problem.

Question: What is your problem?

Smith: My problem is to be able to work every day and to press my limitations beyond their endurance.

Question: What are these limitations?

Smith: They're me.

Question: Do you think of certain of your works as drawings in the round, like Australia or Hudson River Landscape?

Smith: You use your words. I made the work. And about words— I think we artists all understand English grammar, but we have our own language and the very misuse of dictionary forms puts our meaning closer in context. I think we're all closer to Joyce, Genet and Beckett than to Webster. But you ask about Australia [*Plate 109*]—I gave it to my two daughters. That gives you some idea what I think of it. I was never in Australia; that's why I called the piece Australia. It's made up of somewhere I've never been. Hudson River Landscape [*Plate 110*] was made after I'd done more

108 Agricola V, 1952 Otto Gerson Gallery

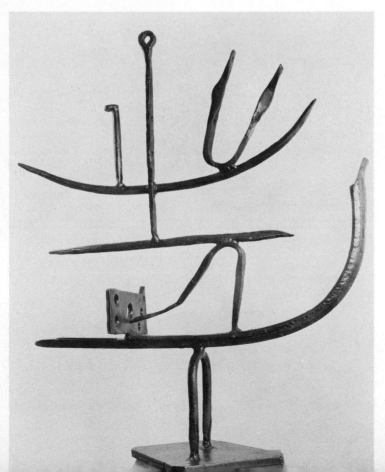

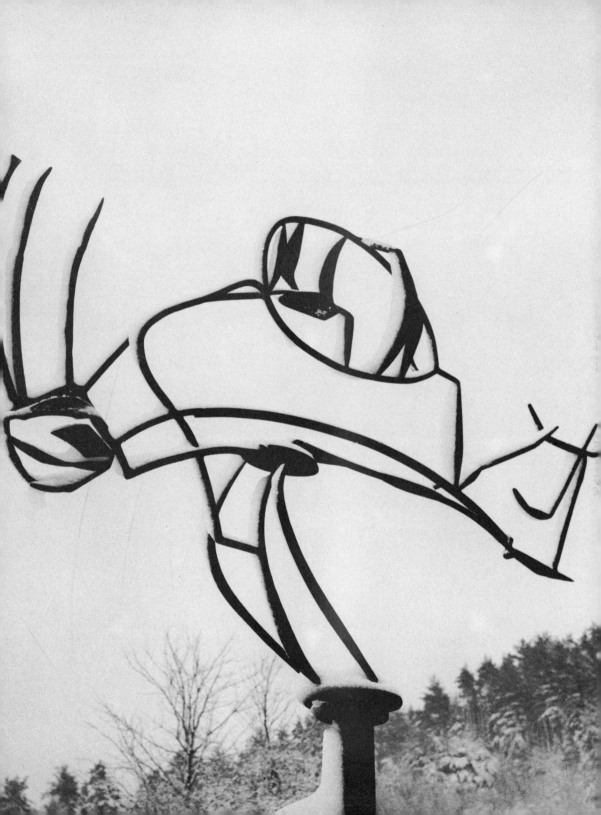

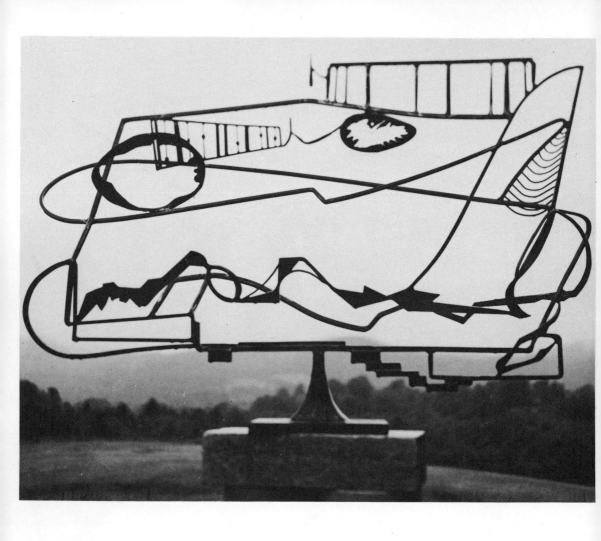

110 *Hudson River Landscape, 1951 Whitney Museum of American Art*

than a hundred drawings of the Hudson River while riding on the train between Albany and New York when I was teaching at Sarah Lawrence.

Question: Has the sculpture anything to do with the drawings?

Smith: Yes, it's the after-image of all those drawings.

Question: Are you interested in architectural sculpture planned for a specific place, like the stair rail you did for David Thompson?

Smith: There were no architects involved in that job. I did exactly what I wanted. Also you must remember that I owed a lot of money then; I had a mortgage and loans at the bank. I believe that out of all the architectural sculpture I've seen, the same artists have always made greater works of art on their own. Personally, it's too late for me to make money; I'm interested in concepts now and, as I said before, I'm interested in pushing my own limits.

Question: How do you get started on a sculpture?

Smith: There's no one way, and if I found myself resorting to a repeated approach, I'd change it.

Question: Why?

Smith: No why. That's just the way I live. The trouble is, every time I make one sculpture, it breeds ten more, and the time is too short to make them all. And don't forget, there's a lot of damn labor in making a sculpture.

SMITH

1906	*Born, Decatur, Indiana.*
1921	*Moved to Paulding, Ohio.*
1924	*Studied, University of Ohio.*
1925	*Riveter in Studebaker plant at South Bend, Indiana.*
1926	*Worked in Washington, D.C., for Morris Plan Company. Took evening courses at George Washington University.*
1927–30	*Studied, Art Students League, New York, with John Sloan and Jan Matulka. Odd jobs as taxi driver, seaman, carpenter, salesman.*
1933	*Made first welded iron sculpture.*

1935 *Visited Europe.*

1938 *Worked on Federal Art Project of WPA—also in Section of Fine Arts of U.S. Treasury Department.*

1940 *Moved to Bolton Landing, New York.*

1944 *Defense job as welder of M-7 tanks and locomotives in Schenectady.*

1947–48 *Taught, Sarah Lawrence College.*

1950–51 *Two Guggenheim Fellowships.*

1953 *Taught, University of Indiana.*

1955 *Taught, University of Mississippi.*

1957 *Retrospective exhibition at Museum of Modern Art, New York.*

1961 *One-man show, Carnegie International Exhibition, Pittsburgh.*

Lives in Bolton Landing, New York.

MARK TOBEY

Question: I notice you seem particularly concerned about what you call "a growing impersonalism" in America. What exactly do you mean?

Tobey: I mean the way landmarks with human dimensions are being torn down to be replaced by structures that appear never to have been touched by human hands. There seems a talent today for picking the most beautiful and personal places to destroy—what might be called an aesthetic destructive sense. Often the defense for this is built into the word "progressive." It's my opinion that when people obliterate the past too quickly they don't know where they are in the present. It seems a phenomenon of our time—this impersonalism—and must be a child of our overindustrialization and our belief in the material man.

Question: How does it show itself?

Tobey: For one thing, in the prevalence of uniform boxlike buildings which seem poor orphans of the once-promising Bauhaus tradition. The sense of present-day speed is also impersonal. There's no doubt that we worship the Queen of Death, the automobile. Already today the newspapers tell us we can expect about four hundred auto deaths over what a taxi driver aptly mentioned to me as Memorial week end.

When I was in China I learned the character called "Chung," which means "the middle." The Chinese have a quotation, "The middle of everything is the best." We don't have any sense of this middle ground any more because we're either racing forward too quickly or reacting backward too quickly, thus making extremes meet. And then there's no movement in the circle; the goals become the same.

Question: How does all this affect present-day art?

Tobey: Many paintings today seem mere fragments and therefore just promises without fulfillment. The cursory methods now so popular are indicative of this very haste. I believe that painting should come through the avenues of meditation rather than the canals of action. Only then can one have a conversation with a painting. If I find no content there's no communication.

Question: Surely you are not referring to all the leading American abstract painters?

Tobey: No. All the great ones give their work a presence of its own. I'm only speaking of the general trend.

Question: What do you mean by the content of a painting?

Tobey: The content of a painting is tied up with time, place and history. It is always related to man's beliefs and disbeliefs, to his affirmations and negations. How we believe and disbelieve is mirrored in the art of our times. For those who can read it, the sources reveal themselves.

Question: What are your sources?

Tobey: Mine are the Orient, the Occident, science, religion, cities, space, and writing a picture instead of building it up in the Renaissance tradition. In the forties I created a sensation of mass by the interlacing of myriad independent lines. In their dynamics and in the timing I gave to the accents within the lines, I attempted to create a world of finer substance. But I do not think I pursue conscious goals. The only goal I can definitely remember was in 1918 when I said to myself, "If I don't do anything else in my painting life, I will smash form."

Question: You are referring to your "white writing," aren't you?

Tobey: "White writing" appeared in my art the way flowers explode over the earth at a given time. With this method I found I could paint the frenetic rhythms of the modern city, something I couldn't even approach with Renaissance techniques. In other words, through calligraphic line I was able to catch the restless pulse of our cities today. I began working this way in England—in Devonshire in 1935— when I returned from the Orient, where I'd studied Chinese brushwork. So in gentle Devonshire during the night, when I could hear the horses breathing in the field, I painted Broadway [*Plate III*]

and Welcome Hero. In the process I probably experienced the most revolutionary sensations I have ever had in art, because while one part of me was creating these two works, another part was trying to hold me back. The old and the new were in battle. It may be difficult for one who doesn't paint to visualize the ordeal an artist goes through when his angle of vision is being shifted.

Question: What was Welcome Hero about?

Tobey: About the hullabaloo of great parades down Fifth Avenue in the twenties—the sirens, bells, horns, cheers, the cacophony of the whole experience.

Question: Did you name your new technique "white writing"?

Tobey: No. It was a term given to my work. I never thought of it as "white writing." People are apt to consider "white writing" typical of Tobey. You know, an artist can easily die twice, first in his work and then in the usual way. Success is his test, for if he succumbs to the outer pressures of success—to any one demanded or so-called typical style—then he repeats himself and dies on the vine.

Question: Do you relate your work to the past in any way?

Tobey: I comb museums because history shows that often in the past those artists who were considered not of their own time have remained in the front line longest.

Question: For instance?

Tobey: Bach, late Turner, Cézanne, late Rembrandt—in fact, as soon as a man became himself, off went his head. Mozart once said in a letter, "I have never sought originality." After all, the cult of the trademark is an integral part of the market place. When I look at Grünewald's Crucifixion, the sky grows darker, the Christ is never quite dead and the terrible anguish of the Magdalene with her soft white wringing hands—this for me is experiencing content in a painting. It would be very rewarding after climbing the long ramp at the Guggenheim Museum to find something like Grünewald's Crucifixion.

Question: You said religion has influenced your work. How?

Tobey: I've been influenced by the Bahai religion, which believes there has been but one religion, which renews itself under different names. The root of all religions, from the Bahai point of view, is based on the theory that man will gradually come to understand the unity

111 *Broadway, 1937 The Metropolitan Museum of Art*

112 *The 1920's, 1936* *(Destroyed by fire)*

of the world and the oneness of mankind. It teaches that all the prophets are one—that science and religion are the two great powers which must be balanced if man is to become mature. I feel my work has been influenced by these beliefs. I've tried to decentralize and interpenetrate so that all parts of a painting are of related value. Perhaps I've hoped even to penetrate perspective and bring the far near.

From a Letter to K. K., October 28, 1954, Paris
"Already in New York in 1919 I began to react to the Renaissance sense of space and order. I felt keenly that space should be freer. As I remember, I really wanted to smash form, to melt it in a more moving and dynamic way. I also remember a painting of this period called Descent into Forms.

"In 1922 I went to Seattle for the first time and for the first time began teaching [at the Cornish School]. That was a period of much experimentation for me. It was here I finally realized I could penetrate forms. In 1934, while living in England at Dartington Hall, Devonshire, I made a trip to China and Japan, where I studied brushwork and acquainted myself with some of the Oriental masters. But it was always with a detached interest—never with a conscious idea of imitating. In the early twenties I had studied brushwork in Seattle with Teng Kisei, a student at the University of Washington, and found that one could experience a tree in dynamic line as well as in mass and light. It was however only after returning to England in 1936 that I began the style called 'white writing' with the painting Broadway—now owned by the Metropolitan Museum. After my return to Seattle in 1939 I gradually got down to expressing myself in this style, and in the forties brought it to its highest peak in a painting called New York, a composition of great luminosity.

"Line became dominant instead of mass but I still attempted to interpenetrate it with a spatial existence. 'Writing' the painting, whether in color or neutral tones, became a necessity for me. I often thought of this way of working as a performance, since it had to be achieved all at once or not at all—the very opposite of building up as I had previously done.

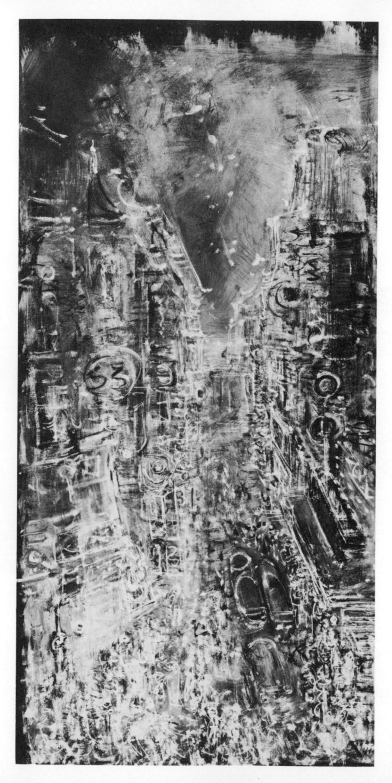

114 *San Francisco Street, 1941 The Detroit Institute of Arts*

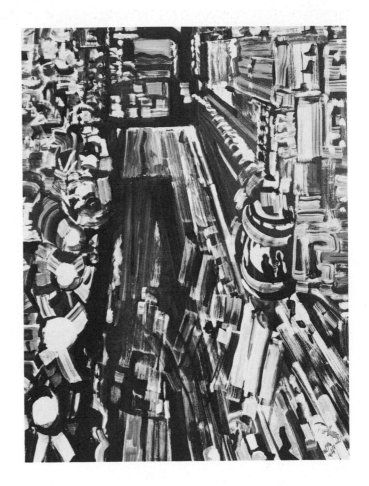

115 Neon Thoroughfare, 1953
Collection Mr. and Mrs.
Alan H. Rosenthal

"While sitting on the floor of a room in Japan and looking out on a small garden with flowers blooming and dragon flies hovering in space, I sensed that this small world, almost under foot, shall I say, had a validity all its own, but must be realized and appreciated from its own level in space. I suddenly felt I had too long been exclusively above my boots.

"Earlier I got the idea of 'writing' cities and city life. At last I had found a technical approach which enabled me to capture what specially interested me in the city—its lights—threading traffic —the river, of humanity chartered and flowing through and around its self-imposed limitations, not unlike chlorophyll flowing through

the canals of a leaf. Naturally I didn't consciously know what I was doing. The fact that I had to express things in this way often resulted in denying the way even while or after doing it, as there were no existing standards to give me support. I couldn't use much color, any more, I suppose, than the cubists could in the first years of cubism, for the problems were already complicated enough. Naturally color came back. During the forties and fifties my work varied from the use of a direct dynamic brush to the use of white dynamic flashes of line married to a geometry of space.

"I have never wished to continue in any particular style. The path has been a zigzag—in and out of old cultures, seeking new horizons—meditating and reviewing for a better position to see. Subject matter has changed from the Middle West to the most microscopic worlds. On pavements and the bark of trees I have found whole worlds. I know very little about what generally is termed abstract. Pure abstraction for me would be a painting where one finds no correspondence to life—an impossibility for me. I have sought a unified world in my work and use a movable vortex to achieve it."

From a Letter to K. K., November 9, 1961, Basle
"As to the Sumi paintings [*Plates 116 and 117*]—you ask how I came to do them. Well, if I look back over my life I often wonder how I came to do this or that. Of course, there are signposts, hints, that one can talk about. It seems to me that questions are asked and answered as though there were no growth periods—or rather, as though nature had stopped functioning. Offhand, I don't know really how I began this period—it happened one day, a suggestion from a brown-black painting which I felt could be carried on in blacks. How long I had these Sumi paintings in cold storage or had the delayed-unrealized desire to paint them I don't know. It was a kind of fever, like the earth in spring or a hurricane. Of course I can give many reasons, that they were a natural growth from my experience with the brush and Sumi ink in Japan and China, but why did I wait some twenty years before doing them? There are so many suggestions on this question I could fill a book.

"Perhaps painting that way I freed myself or thought I did. Perhaps I wanted to paint without too much thought. I don't think I was in the Void, that rather popular place today. But then maybe I wanted to be—it's difficult to be faster than thought. Which screen of ourselves comes first—the inner when one wants to state an inner condition, knowing it has to take flesh to be understood and knowing also that, because of the outer covering, it will be side-tracked and sit there for eons understood as a symbol without reality? Already I have gone too far, but I feel I have kept the problem in view.

"How can I state in an understanding way why I did the Sumi paintings? Then, too, why after white writing should I turn to black ink? Well, the other side of the coin can be just as interesting, but to make myself simple I should remain a coin with only one side showing the imprint of man. It wouldn't be necessary to turn me over then—no need to wonder nor compare. Ibsen expressed it very well when he said, 'Where I was ten years ago, you are now there but I am not with you.'

"I was in Cairo when they were unearthing the 'hidden' side of the Sphinx. I sat down on the hot sand—an old Egyptian suddenly appeared before me with all the materials for a hot Turkish coffee. Boys in white gowns were rising like specters from the depths around the Sphinx with bales of sand in their hands. Two musicians were keeping up their spirits. A huge Egyptian stood by with a black whip curled in his hand. He looked like Simon Legree. The mystery of the Sphinx was being revealed. All was being exposed. But was it? Today it looks out upon the world, a tired image one sees too much; the mystery is no longer there. The head rising above the sand rises no more. Perhaps now it is nearer to a surrealist's dream.

"If your house has a northern exposure and you find it too cold you can go and sit in the back yard. There might be a garbage can or two—little Sphinxes, of course, as this is a new age and we even have built-in incinerators to give us more time. There's a mystery in fallen leaves, although we are told the tree is getting rid of its poisons, but the knowledge of a thing is only one aspect—how we feel about the leaves is another. I believe most artists are concerned with

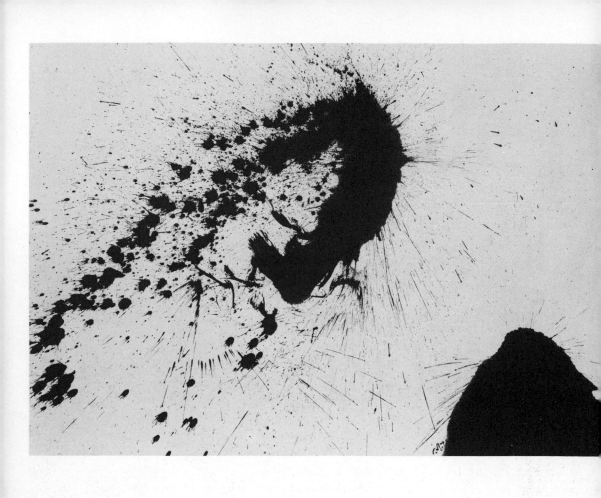

116 Space Ritual, No. 4, 1957 (Sumi painting) Collection Mr. and Mrs. Sigmund Kunstadter

117 *Robber Barons, 1957 (Sumi painting)* *Collection Mr. and Mrs. Solomon B. Smith*

this mystery. Perhaps that is why they rather grudgingly talk about their work or refuse to talk at all.

"I have always found alleys interesting to walk in, particularly today when the contents of shop windows are so standardized. In alleys one senses the other side of the residences or shops. (Of course, alleys are on their way out.) The two faces of Janus are seen everywhere. I have a terrible time trying to get my two into focus. Offhand I would say the artist paints to live. Divide the words 'to live' into as many facets as you can. The answer must be there. I could say I painted the Sumis to experience a heightened sense of living."

TOBEY

1890 *Born, Centerville, Wisconsin. Grew up in Trempealeau, Wisconsin.*

1917 *First one-man show at Knoedler and Co.*

1922 *Taught, Cornish School, Seattle.*

1925–27 *France, Greece, Turkey and Near East.*

1931 *Resident artist, Dartington Hall, Devonshire, England.*

1934 *Studied Chinese calligraphy with Teng Kwei in Shanghai and brush-work in Zen monastery in Japan.*

1935 *First "white writing" paintings made at Dartington Hall.*

1951 *Retrospective exhibition, San Francisco Palace of the Legion of Honor; Santa Barbara Museum; University of Washington and Whitney Museum.*

1955 *Exhibitions, Kunsthalle, Berne; Bucher Gallery, Paris; Institute of Contemporary Art, London; Art Institute of Chicago.*

1956 *Elected member National Institute of Arts and Letters. Awarded Fine Arts Medal, American Institute of Architects. National Award, International Exhibition, Guggenheim Museum.*

1958 *One-man show and International Prize, Biennale, Venice.*

1959 *Retrospective exhibition, Seattle Art Museum.*

1961 *Retrospective exhibition, Musée des Arts Decoratifs, Paris.*

1961 *First prize, Carnegie International Exhibition, Pittsburgh.*

Has been living in Basle, Switzerland, for the last two years.